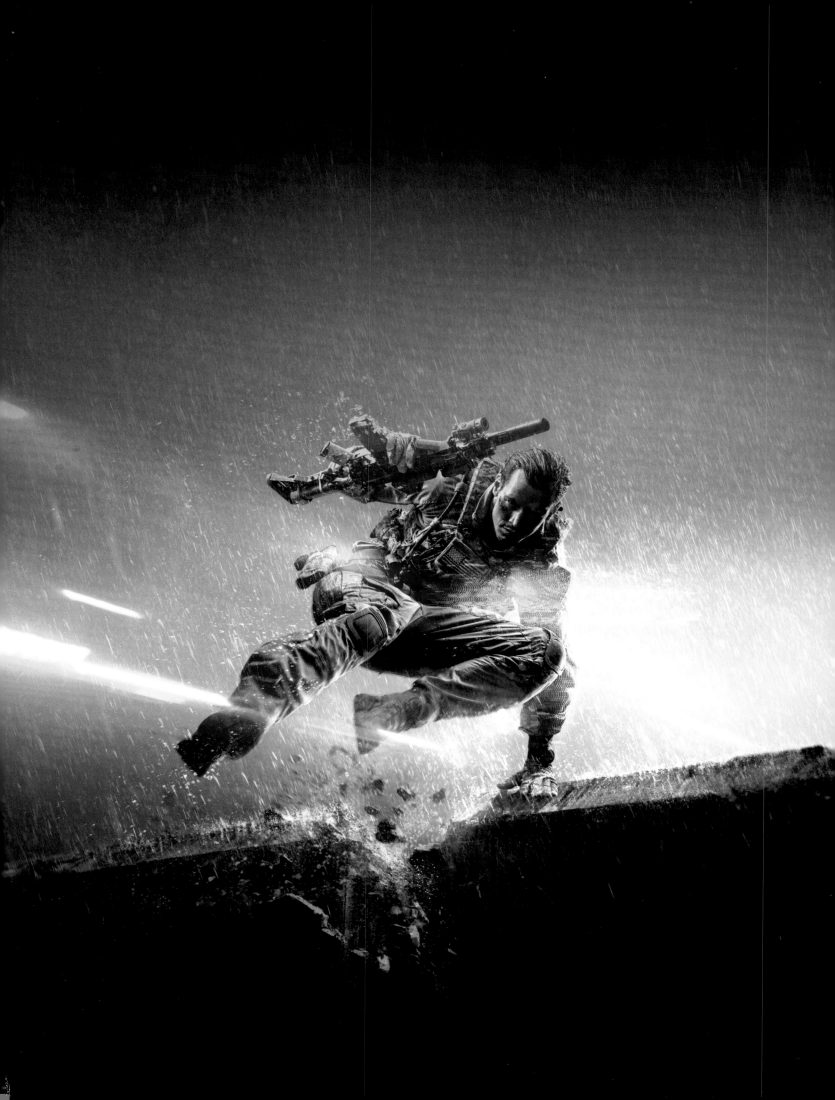

THE ART OF
BATTLEFIELD 4

ISBN: 9781781169285

Published by Titan Books
A division of Titan Publishing Group Ltd.
144 Southwark St.
London
SE1 0UP

First edition: November 2013

10 9 8 7 6 5 4 3 2 1

To receive advance information, news, competitions, and
exclusive offers online, please sign up for the Titan newsletter
on our website: www.titanbooks.com

Did you enjoy this book? We love to hear from our readers.
Please e-mail us at: readerfeedback@titanemail.com or write to
Reader Feedback at the above address.

A CIP catalogue record for this title is available from the British Library.

Printed and bound in The United States of America.

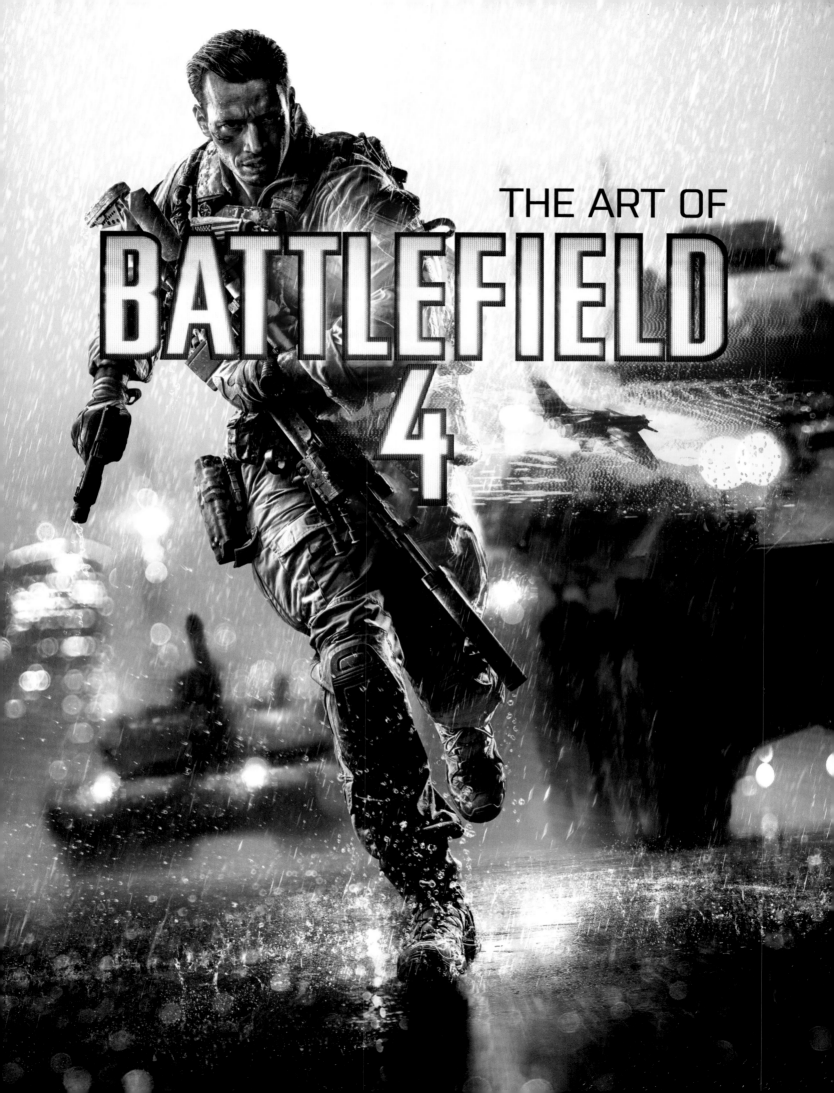

THE ART OF
BATTLEFIELD
4

CONTENTS

//

As I am writing this the summer will soon be upon us here in Sweden. Sunny days with a lovely warming sun and endless nights are rare for the people up here in the North. Meanwhile the Battlefield team is starting to finalize what will be the best game ever made in the history of Battlefield, we would rather spend these last couple of months indoors in front of computers to make sure that this game will give our gamers the best Battlefield moments ever!

Almost two years ago, a small part of the Battlefield 3 team sat down and said: "How can we make a better game than Battlefield 3, how can we give our fans a better game and greater experience?" At this point in time we had just finalized Battlefield 3 and most people at DICE were working on patches and making sure that the launch would run as smooth as possible. A group of 10-15 people booked a big conference room and occupied it for several months. I still remember like it was yesterday, the "War Room" full of whiteboards with ideas, scribbles, names, pictures and maps. The glass walls were completely covered with hundreds of concept images, you could not even see who was in the room anymore, but when passing by you could always hear a mix of; yelling, screaming, laughing, arguing and cheering. That's just the way it is at DICE, we develop games with love and passion. This group grew every week, more and more people joined the team and after a while we had something that we knew would be a great game. We were certain that this would be the best single- and multi-player game ever made by DICE. The "War Room" expanded into the corridors and slowly took over the entire eighth floor at the DICE office, and for you who have ever been able to visit our office, you know it is a big space, simply huge. Almost every wall was plastered with everything from storyboards, character concepts, mission overviews, mood boards, vehicles and amazing new multiplayer maps. Walking through the office was like playing the game, seeing new maps for the first time or getting a glimpse of how cool the levolution actually would be in the game, it was just an amazing experience!

This book will show you a small sample of all the concept art that was made during the last two years. Some of the concepts are from the first meetings in the «War Room», some are rough five-minute sketches, some are more polished concepts that are the result of many iterations. Some images in this book are just ideas that never made it into the game, or made it to the game for a while but were later removed since they didn›t really make the game better. The majority of the images were selected to give you a better understanding and a great insight into the Battlefield 4 universe.

It has been a great journey, filled with laughs, challenges and hard work. However, the great pleasure to work with this talented team here at DICE is more than anyone could ask for, I would not change this for anything in the world, it›s an honor.

After over a decade of Battlefield games, DICE finally release a book full of concepts. I really hope you enjoy this trip into the world of Battlefield 4, just as much as we do!

Robert Runesson
Chief Content Officer

DICE – June 2013

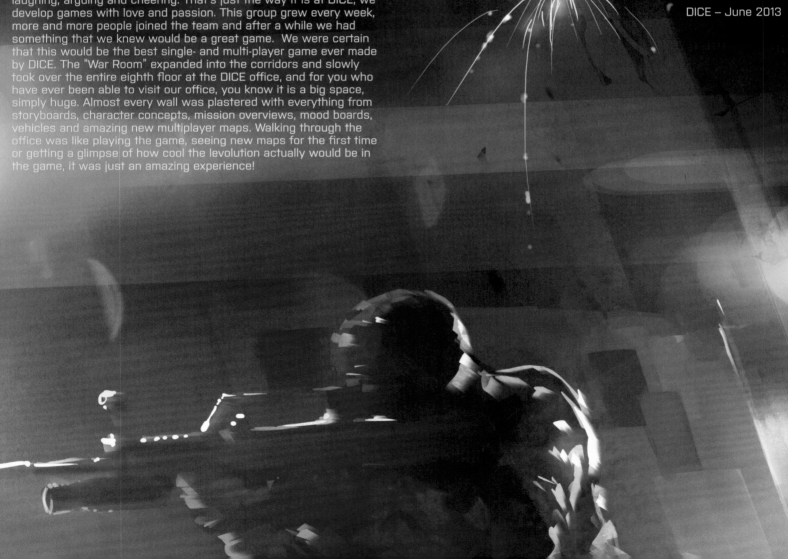

INTRODUCTION
//

Today, *Battlefield* is on the verge of becoming one of the biggest properties in entertainment, an explosive blockbuster that's about to set the world of video games alight once more. Not much longer than 13 years ago though, it was all so very different. This booming behemoth began as nothing more than a playful dream of a small group of friends working out of a cramped Stockholm apartment.

"It was a small place that was full of computers, and so it got really sweaty," Lars Gustavsson, a part of the Battlefield phenomenon since before its inception, fondly recalls. "There were around eleven of us, living the game development dream of working when you want to - which turns out to be *a lot* - and partying together, gaming and just having lots of fun."

That team was Refraction Games, a small developer based in Sweden's capital, working on its first ever game. *Codename Eagle* was coming at a time when the first-person shooter was just beginning to take shape. In Twycross, England, Rare had recently redefined the genre with *GoldenEye 007*, and across the globe a small team in Kirkland, Washington was about to change the world of gaming forever with the very first *Half-Life*.

In Stockholm though, the dream was very different. Inspired by the success of simulators that recreated the art of piloting a tank or flying a plane, as well as the instant thrills of shooters such as *Unreal Tournament*, a team at a local university worked on building a 3D engine that combined all the things they loved.

"They always had this dream of merging this into one big battlefield, where all types of vehicles and soldiers were battling it out," says Gustavsson. "That was interesting - there was a lot of focus on physics and networking to make this work. I remember many years before this reading magazines that said the flight simulator of the future would have real people fighting on the ground. To be at the company that had the dream to do this felt really exciting, and as we started to play it really started coming together."

Codename Eagle was an ambitious project for anyone, let alone for a young bunch of developers attempting their first game. Its campaign was set in the 1917 of an alternate timeline, in which the events of World War I never took place. An interesting premise was matched by unprecedented gameplay mechanics, with the multi-vehicle warfare a feat that had never really been attempted, let alone mastered.

NAVIGATION

But there was something else to *Codename Eagle*. Despite the muted response from the media, a small but exceptionally dedicated fanbase was building up. "We got a community of around 300 people who played our multiplayer day and night," remembers Gustavsson. "Its whole reason for being was really the multiplayer experience. We saw this, and we had a very tight connection with the community."

Internally, the multiplayer had always been the focus, but a change of heart meant it was never to be. "We never really had ambitions in the way of taking over the world - it was just about building the perfect game that we wanted to play. When we worked on *Codename Eagle*, it was felt that the market wasn't ready for a multiplayer only project."

Following the release of *Codename Eagle*, Refraction were bought by fellow Stockholm developers DICE, and soon began working on an even more ambitious project that would build on the strengths of the first game - and would stick more closely to the original ideas. "We worked on a prototype with submarines and bombers, but we had a hard time selling it to people. A lot of them didn't believe in the concept. But when we became part of DICE we were up to 50 people in all, and it felt like we had all the resources in the world. So we started to build the Refractor 2 engine - and that was the foundation for *Battlefield 1942*."

Inspired by films such as *Kelly's Heroes* and *The Guns of Navarone*, the team decided to switch from the po-faced alternate reality of *Codename Eagle* to a take on the Second World War touched with light heroism and a sense of adventure. "We got heavily inspired by these films we'd been brought up on, and wanted to build this epic game with all these vehicles we knew from when we were kids, building plastic models and God knows what."

"I remember early design documents where we talked about 128 players, tiling worlds - there were high ambitions. But we struggled a bit building the engine, and when we went to show off the game that spring the reception was lukewarm." The showing that year at the tradeshow ECTS didn't go down well. With its less than stellar reputation earned from Codename Eagle preceding it, many questioned the possibility of the team being able to realize their dream of 64 players battling against each other at the same time.

Dice's attention was focused on *Rallisport Challenge* as it worked towards getting the game ready for the original Xbox's launch. For the Battlefield team it was to be a lonely year, but the team kept pitching *Battlefield 1942* - more often than not to publishers who didn't believe the high concept could be fully realized. Fortunately for Gustavsson and co., someone had already seen how powerful the concept could be first hand.

"The manager of EA Redwood Shores, he saw his testers playing this game every lunch. He knew they were usually very picky, and for a group of testers to stick with a game meant there was something in it. He found out it was *Codename Eagle's* multiplayer, so they got in contact with us and asked if we could recreate this in a WW2 setting. And oddly enough we said that's kind of our intention."

Gustavsson was placed as producer on the game, and work began in earnest. The backing of a big publisher like EA didn't necessarily mean making the *Battlefield* dream a reality would be any easier, though, and its production was fraught with problems and delays. One of the very first demos was held together with the coding equivalent of sticky tape and plaster,

and it took great faith from EA to keep its weight behind the project.

"They said, 'We believe in you', but by summer we needed something good and playable. We got started, but quickly realized that we weren't getting there. The initial launch date of October of 2001 quickly became early 2002, and we kept struggling. It wasn't until just after Christmas of 2001 that we were able to even play the game, and able to prove that we were on to something good.

Internally EA set a final date of June - jokingly saying that it would be D-Day or die for DICE - and against all odds the team pulled through. Having glimpsed at the possibilities of the concept with *Codename Eagle*, the world was about to get its first look proper at the grand scope of *Battlefield*.

At E3, the games industry's large-scale tradeshow in Los Angeles, *Battlefield 1942* made a stirring debut. "We showed the game, and it took the world by storm. While we were at home working, Patrick Soderlund, our CEO, came back with awards, super-happy but was also cautious - this new game *Medal of Honor* was coming out, and it looked so much better."

They needn't have worried. *Battlefield 1942's* release in September that year proved to be a phenomenal success, the game becoming an instant classic - and to this day hundreds of players still drive, fly, run and swim across Wake Island, the idyllic horseshoe island that's become one of multiplayer gaming's most iconic maps. For Gustavsson, the enormity of DICE's achievement only sunk in against the most bizarre of backdrops, as he witnessed 64 people playing the game at once at its launch on a USS Naval Carrier.

"That's when it dawned that it was going to be good. We knew we were on to something. We were never afraid of not having a good game - it was just a case of wrapping it up and getting it out there."

There wasn't much time to celebrate though. Despite being broken by the toil and trouble involved in shipping *Battlefield 1942*, DICE soon realized there would be little respite. "We were all exhausted after *1942*, and we had another team working on an expansion pack," Gustavsson wearily recalls. "Me and the lead designer sat down and looked at what we could do for the future. We had EA coming round to celebrate the success of *1942* - and then saying now we just need to do a sequel that needs to be better. We had just been to hell and back, and it felt like an overwhelming task to succeed the miracle of our lives. It was a pretty horrific experience."

The first big decision was where to set the next *Battlefield*. The Second World War had provided the perfect backdrop for the first game, and there was some deliberation whether to simply shift the timeline up a little to the Vietnam conflict of the 60s. That setting would eventually be tackled by an offshoot of DICE dedicated to making expansions, but for the first proper sequel to Battlefield the team had to look elsewhere.

Battlefield 1942's success was so extensive that a dedicated community soon built up around it. These were people who were doing more than just playing the game - they were building upon it, modifying the brilliant foundation DICE had provided to create new experiences and entirely new scenarios.

"We were really inspired by the reception of *Battlefield* and the whole mod community, especially ones like *Desert Combat*. I think we all learned from that and we were also highly encouraged to keep on pushing for something new."

With its modern day setting, more expansive maps and the introduction of more tactical play through innovations such as the Commander mode, *Battlefield 2* was another instant success. In the month after its release in June 2005 it sold a staggering one million copies - but despite such an incredible reception, DICE still wanted to push the series in new and fantastic directions.

A more experimental air set into the series in the following years, first with the outlandish science fiction of *Battlefield 2142*, a game that propelled the winning formula into the far future. "After *1942* and *Battlefield 2*, and building a lot of games based on real world events, hardware and locations there was a need in the studio for unleashing creativity and getting to do something that didn't have so many fixed boundaries," Gustavsson explains. "And by going futuristic on it we basically let the team go crazy in what was possible. That was a great motivator for the team at that time after two really tough projects."

A more modest success than its predecessors, *Battlefield 2142* nevertheless allowed the team some welcome breathing space before it would take on its next big challenge - conquering the world of consoles. A few half-hearted ports aside, the series had been exclusive to PCs for much of its life, but with first-person shooters blossoming on the PlayStation 3 and Xbox 360 DICE realized it needed to stake its claim. It did so with a new spin-off

series, *Bad Company*, and a new graphics engine that allowed for a feature that had been years in the planning.

"Frostbite was built with an emphasis on consoles and on destruction, which for me is a dream we've been chasing since *Battlefield 2*. I remember a meeting around then when we said we wanted to do that and I just got laughed at, so I put that wish in the drawer. But when we started building *Bad Company* all of these wishes and dreams came alive. It was a tough project, building the engine while building the game, but we learnt a lot in terms of our preconceptions."

It took two games to fulfil the promise of the *Battlefield* formula on console, but when it was finally accomplished with 2010's *Bad Company 2* the result was one of the greatest shooters of the generation, and certainly one of its most entertaining multiplayer experiences. At long last console players had the chance to taste the expansive maps, the open-ended action and the thrilling sense that anything could happen - a taste that PC players had been savoring for years.

With the appetite in place, DICE then set about making the first true *Battlefield* sequel for nearly six years - and it set about making it for both console and PC players. The release of *Battlefield 3* in 2011 did more than cement the series' reputation as the premier shooter - it also elevated it to global superstar status as it went from a fan favourite to a global phenomenon and currently has over 20 million players worldwide.

"The sheer numbers of those who've picked up and played this game, and how many are playing this game, has been amazing, and beyond our biggest hopes ever," Gustavsson beams. "While not thinking too much of the core concept of *Battlefield*, we wanted to keep on pushing the boundaries on things that people liked - the whole concept of destruction and the dynamic battlefield was something that we wanted to do early on."

And now there's a new challenge for DICE, and the chance for the *Battlefield* series to reach new heights. With new consoles emerging, and with new players always rushing in, *Battlefield 4* comes at the crest of the next generation, bringing with it new technology, new experiences and new ways to engage with the winning formula that's been captivating people since it first took shape with *Codename Eagle*.

All these years later, though, and Gustavsson is taking nothing for granted. "It's just like we said when we started designing *Battlefield 2* - it's the mixed feeling of being on to something great, but at the same time wondering what will people think. And as always you have to bet on a number of horses and hope they win the race for you. It's healthy to be nervous, to make sure you're making the right thing."

And where can this series be in another decade? "I think it can continue for a while, as long as we don't get content, and as long as we don't stop pushing the boundaries. I've been part of the franchise since the first prototype, which is around 14 years ago. People have been working so hard to ship something that will make jaws drop, and it takes a toll. As long as we manage to keep allowing people to be creative, to twist and turn standards, I think we have open minds and think we can stay there for a very long time." Here's hoping it will be.

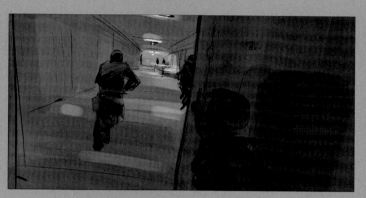

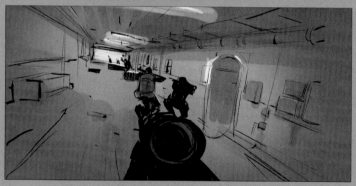

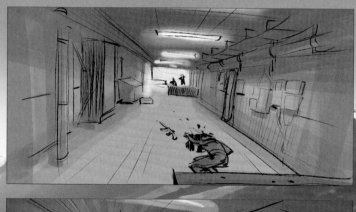

CHARACTERS

//

PERSONEL

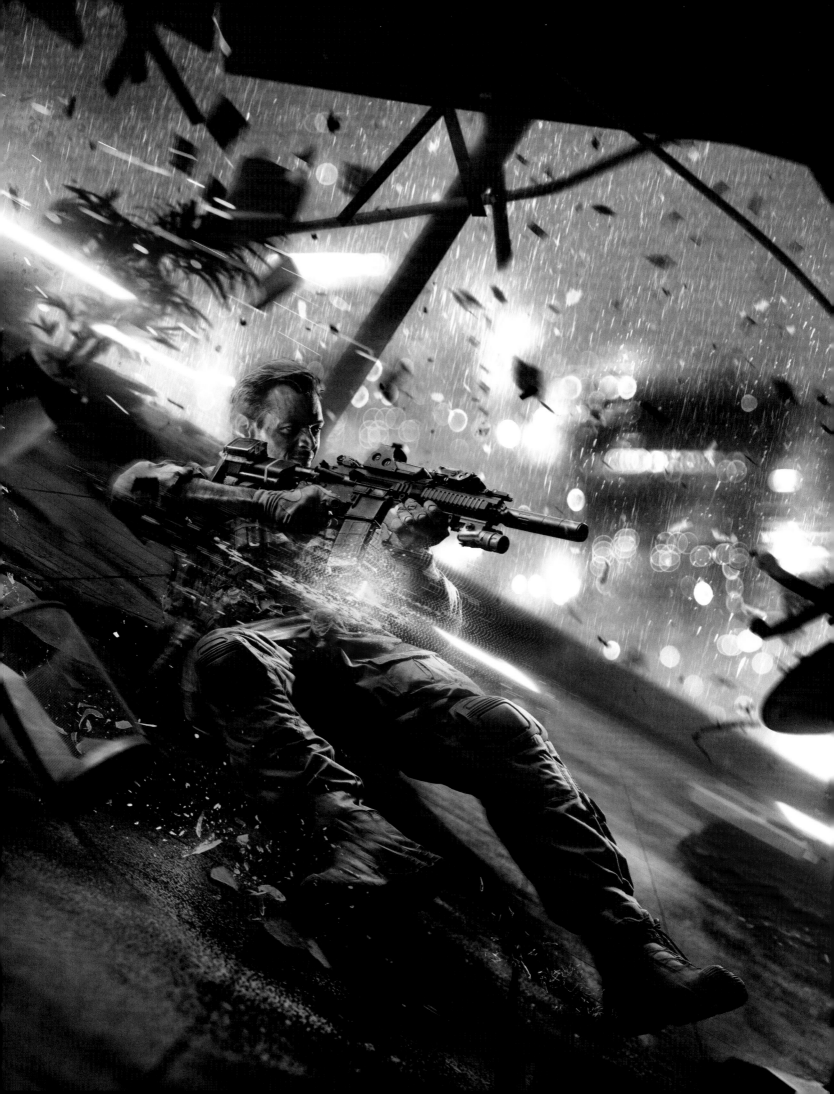

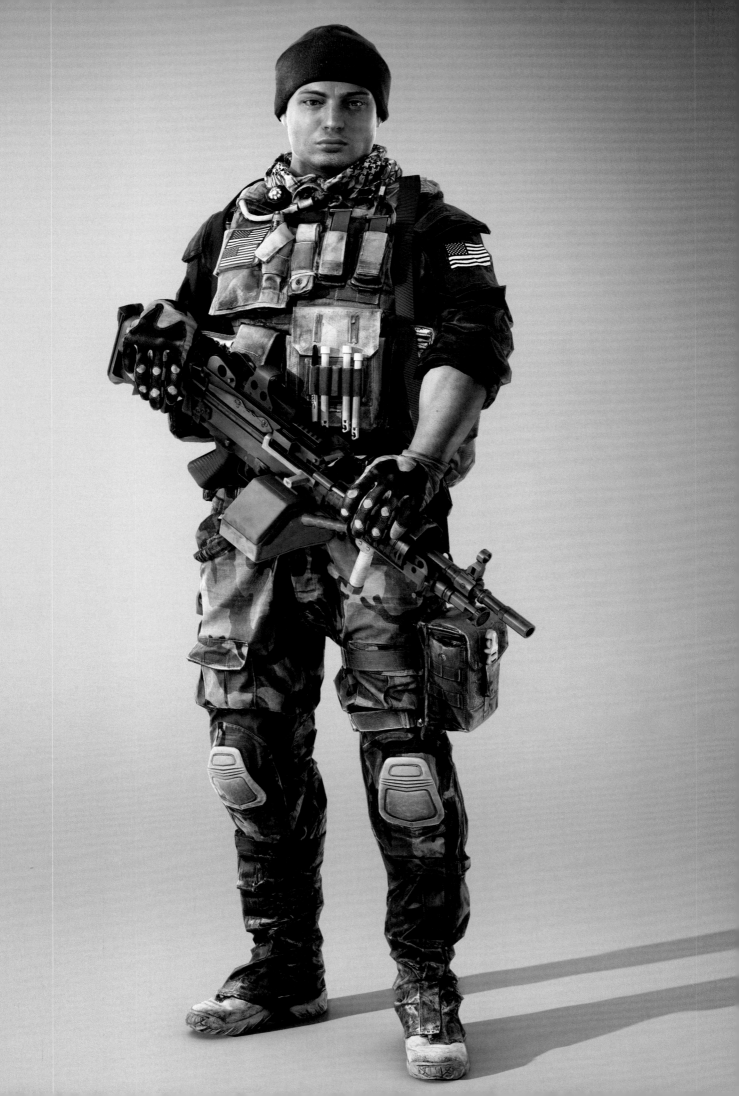

The near future setting allows *Battlefield 4* to play a little loose with its character designs, though their uniforms still have a foundation in military uniforms in use around the world. DICE brings in real uniforms to the office for reference, as well as a military advisor who informs them on what's right and wrong and what additions may be made over the next few years. "We insert these small details into the gear and equipment that aren't widely used now, but that our advisor predicts will be in a couple of years," says lead concept artist Robert Sammelin.

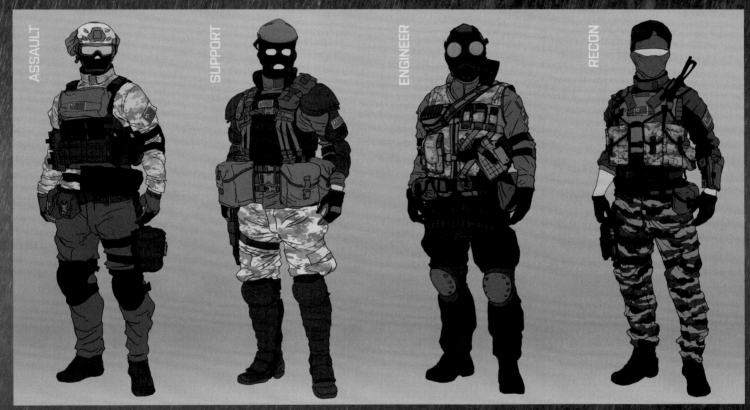

ASSAULT SUPPORT ENGINEER RECON

"We have to clearly signal what class a character is and what gear you suspect him to have and so it is a big challenge to have instantly recognizable silhouettes for different classes," says Sammelin.

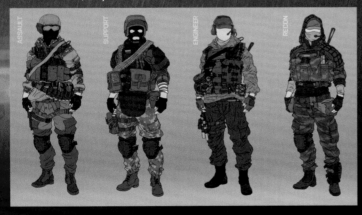

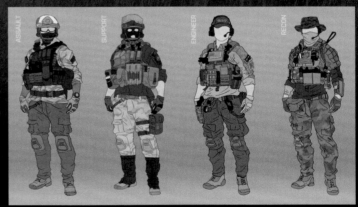

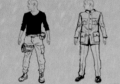
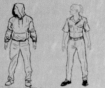
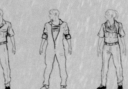
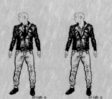
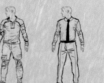
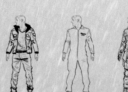

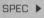 SPEC ▶ *Battlefield 3* used actors as the basis for its lead characters, but *Battlefield 4* brings in some instantly recognizable faces. Michael Kenneth Williams, whose role as Omar in *The Wire* turned him into a 21st Century cult icon, plays Kimble 'Irish' Graves, a coolheaded Sergeant who accompanies the player throughout the campaign. Williams was scanned into the game, his performance digitally captured to bring vivid life to the role.

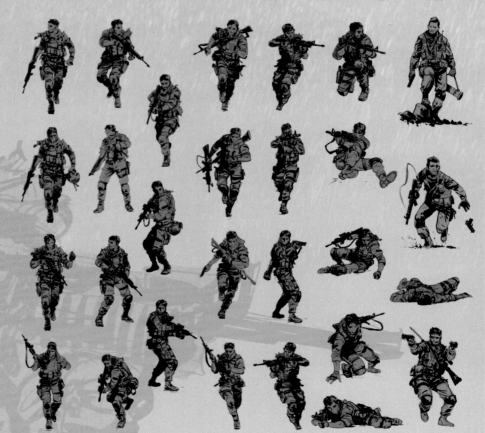

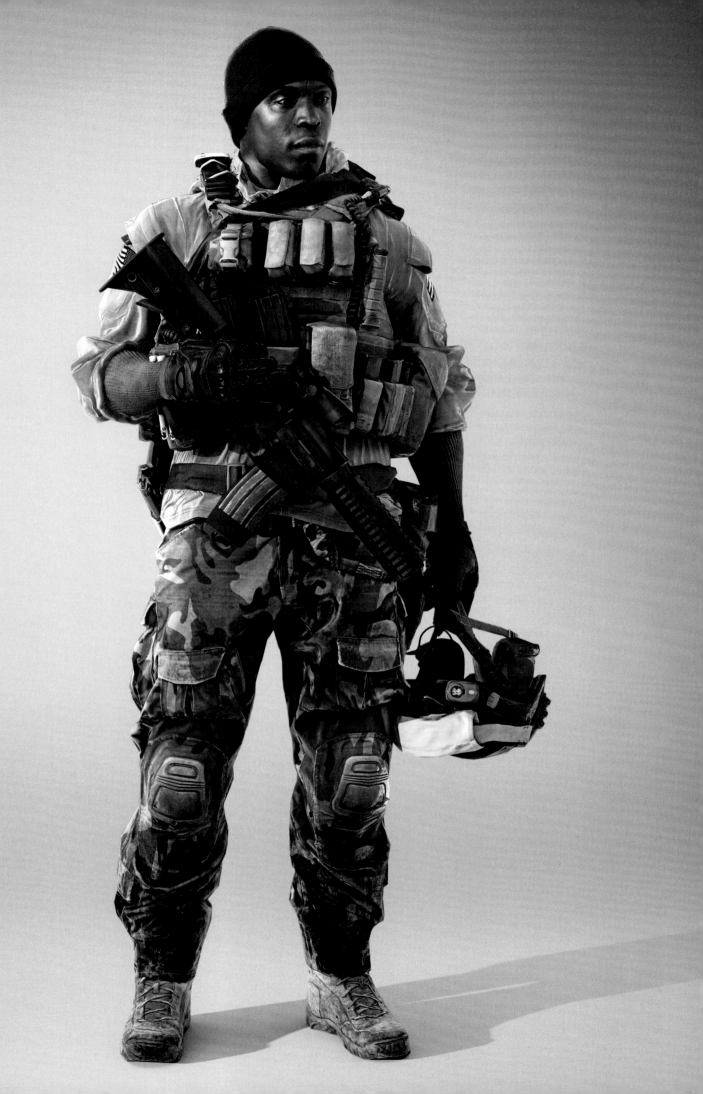

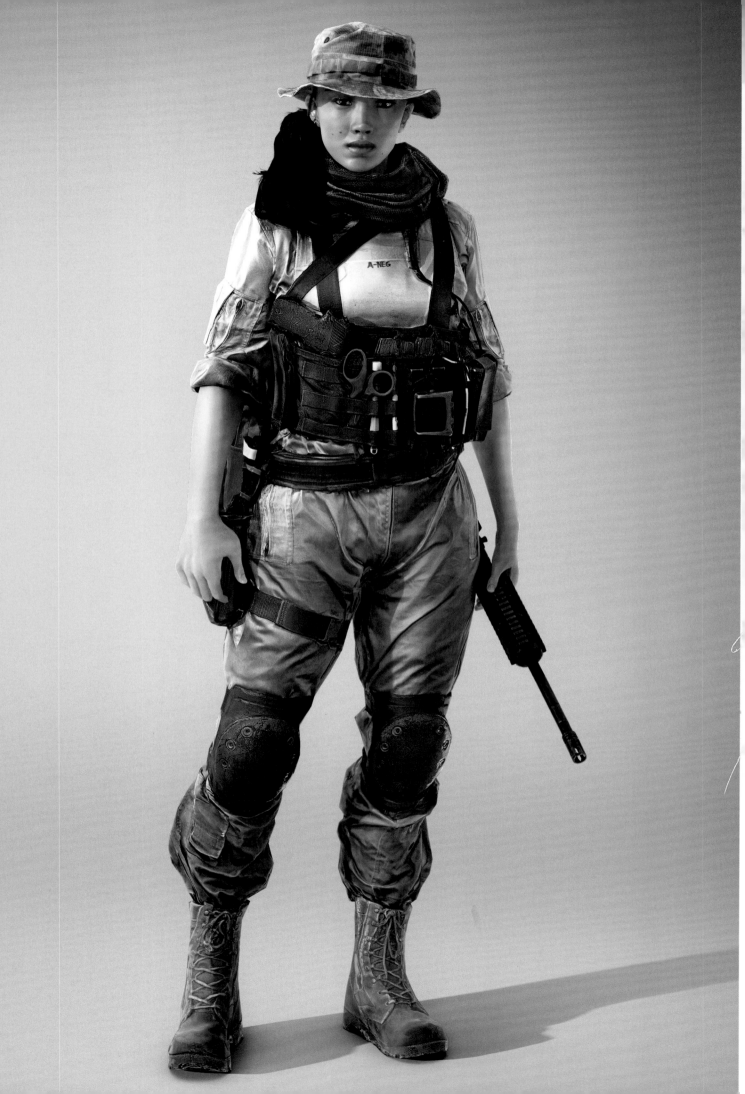

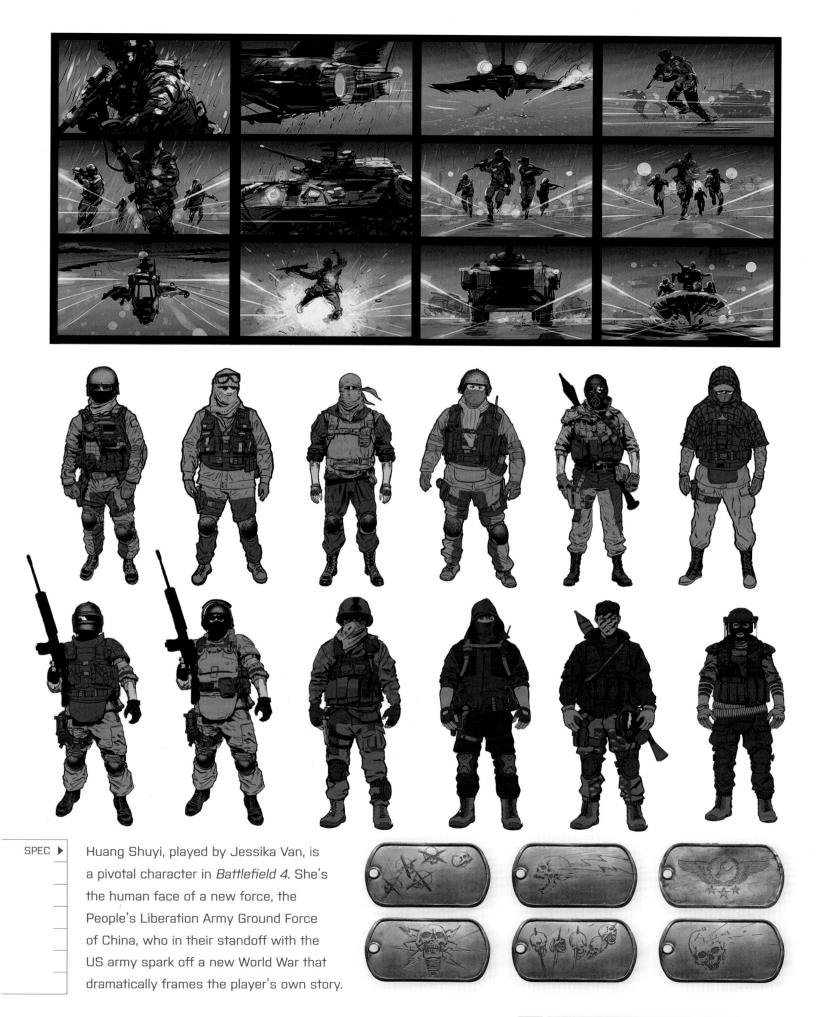

Huang Shuyi, played by Jessika Van, is a pivotal character in *Battlefield 4*. She's the human face of a new force, the People's Liberation Army Ground Force of China, who in their standoff with the US army spark off a new World War that dramatically frames the player's own story.

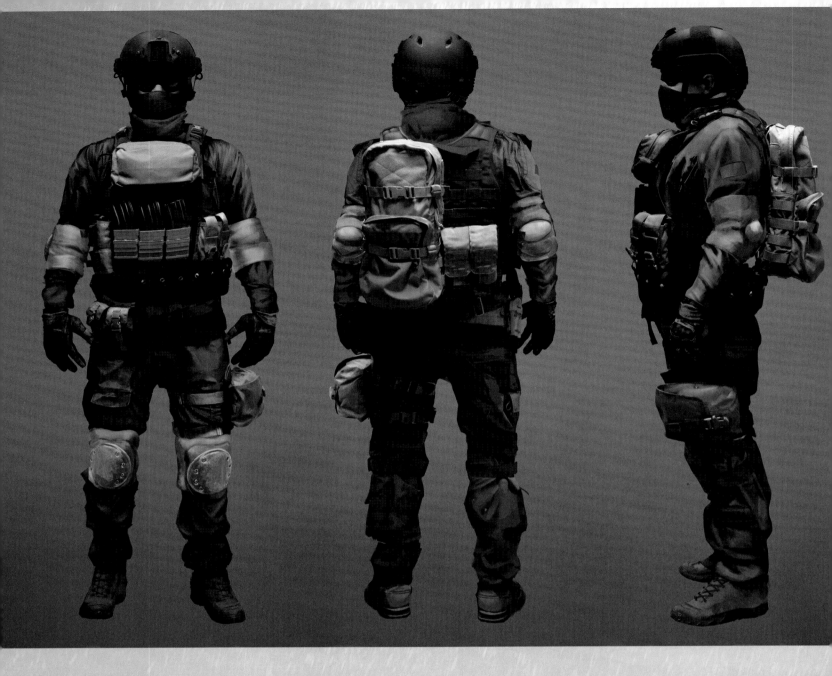

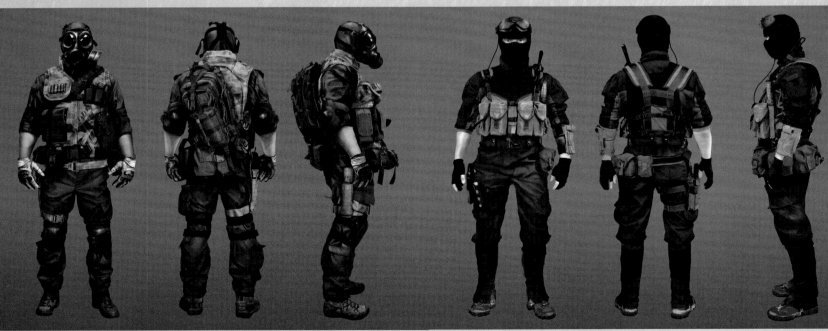

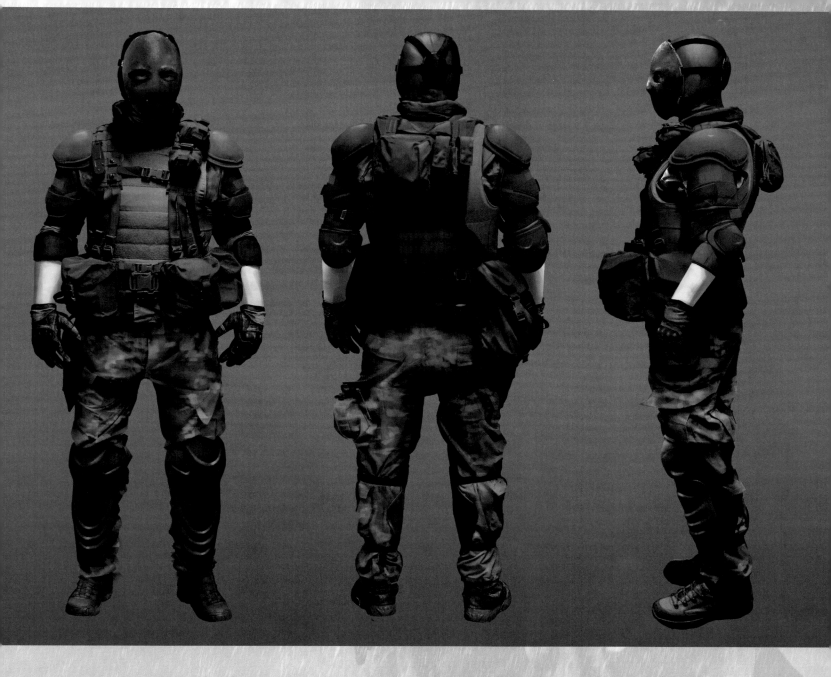

SPEC ▶

Battlefield 3 saw a simple face-off between US and Russian soldiers, but for the sequel it's a three-way affair as the Chinese join the fray. There's a certain amount of artistic license used in their design to ensure they each have their own recognizable look when in play. "Now we have three teams, so we've set out to have themes on each team," explains Sammelin. "Most armies look exactly the same nowadays, they use the same equipment, weapons, gear.

"The camouflage is the thing that differs between armies, so we take some liberties with that. For instance the Russian soldiers are what we call Movie Russians, they kind of mix 60s and 80s action movie Russians. Whereas in the Chinese, so little is known about the actual Chinese fighting army, that we've completely made them up, from qualified guesses, some input from consultants and photo material but it's definitely a choice to have this kind of special ops look to them."

PROLOGUE
//

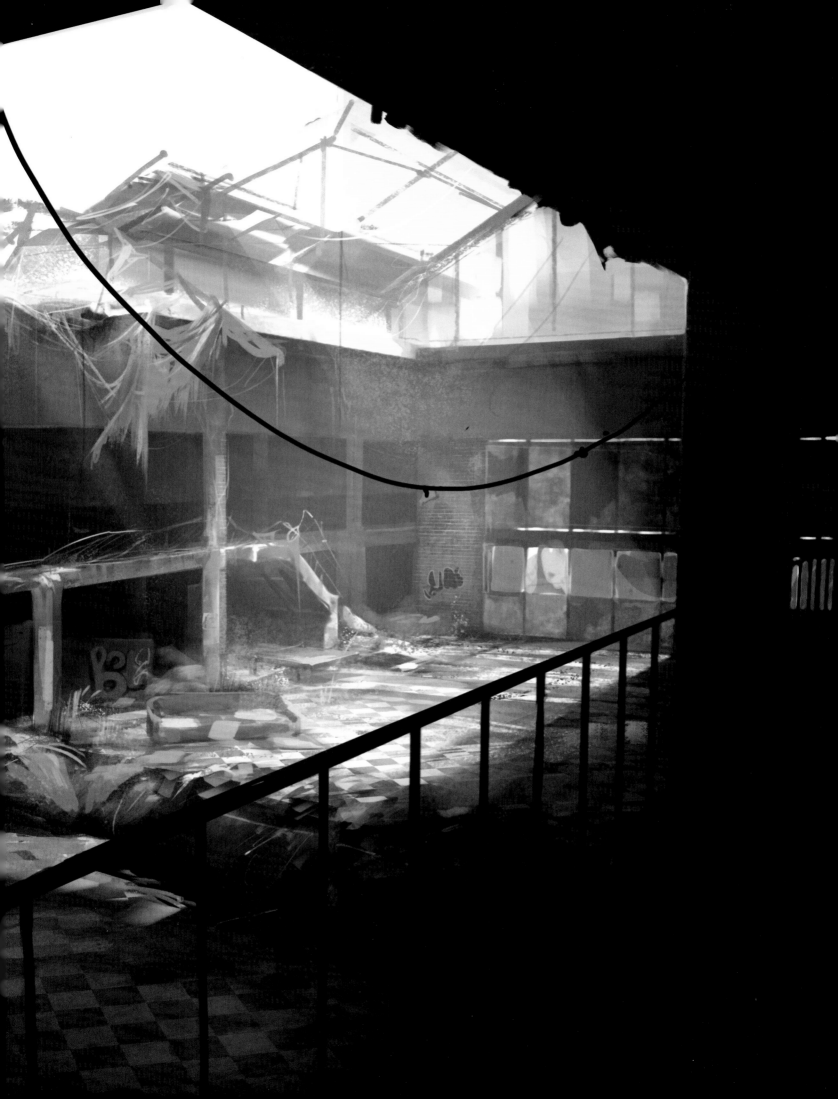

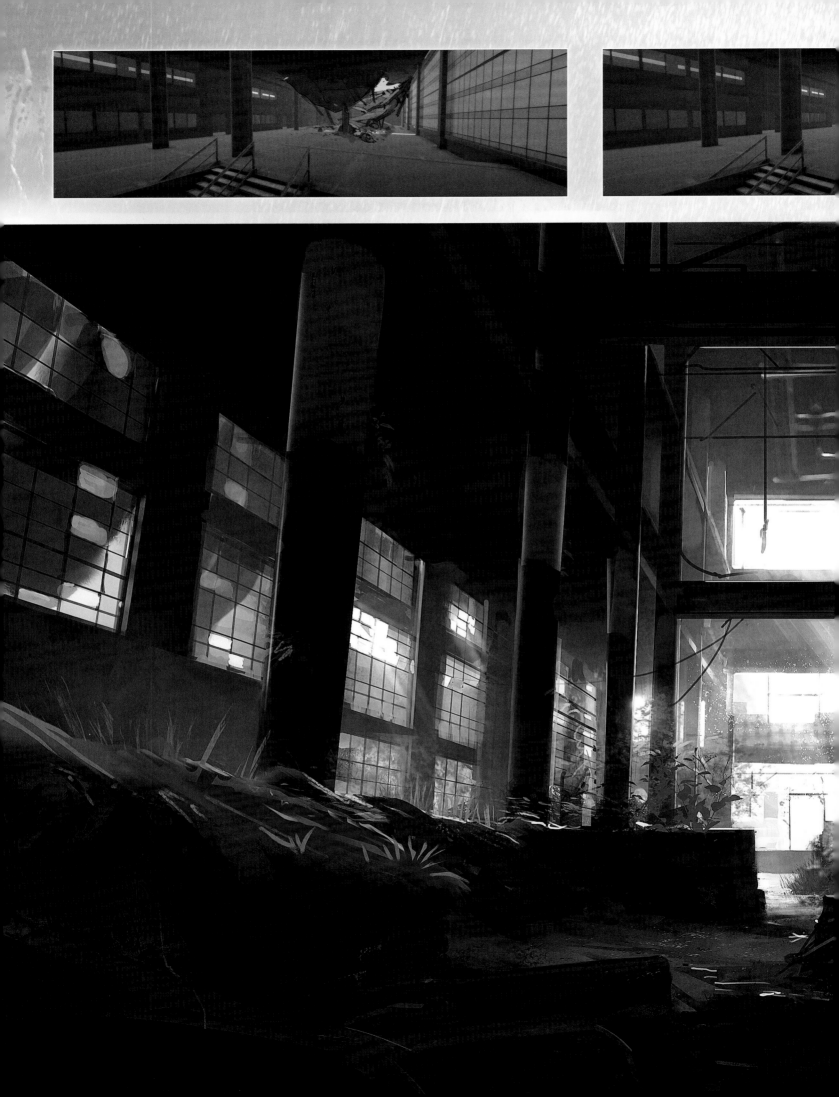

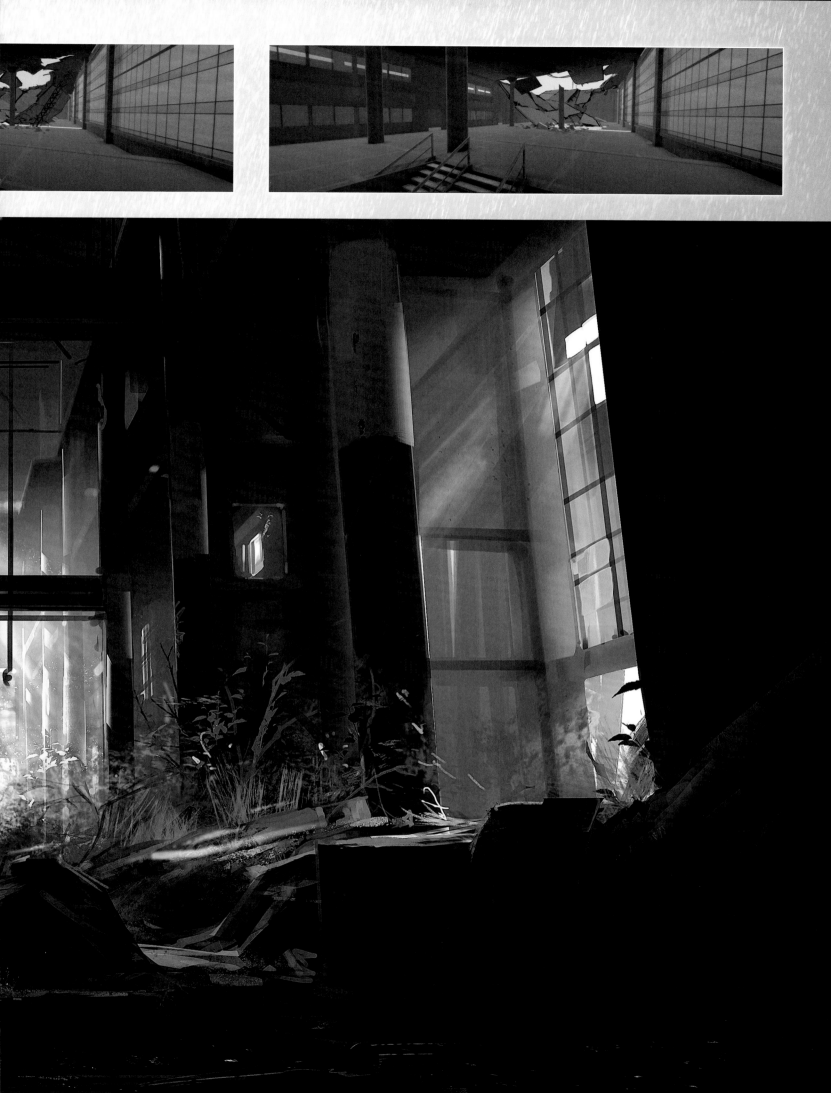

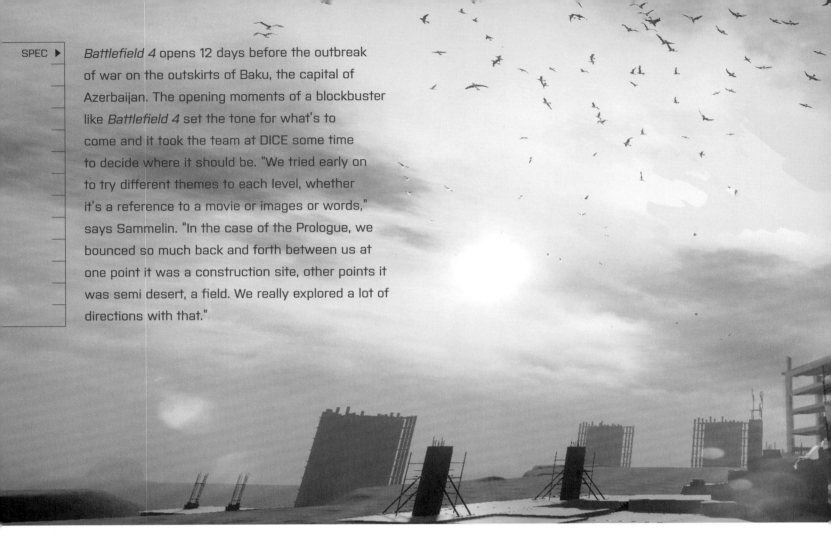

Battlefield 4 opens 12 days before the outbreak of war on the outskirts of Baku, the capital of Azerbaijan. The opening moments of a blockbuster like *Battlefield 4* set the tone for what's to come and it took the team at DICE some time to decide where it should be. "We tried early on to try different themes to each level, whether it's a reference to a movie or images or words," says Sammelin. "In the case of the Prologue, we bounced so much back and forth between us at one point it was a construction site, other points it was semi desert, a field. We really explored a lot of directions with that."

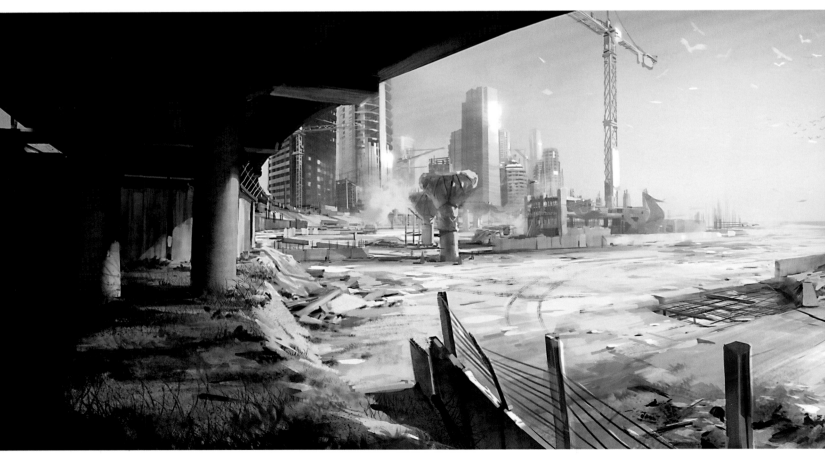

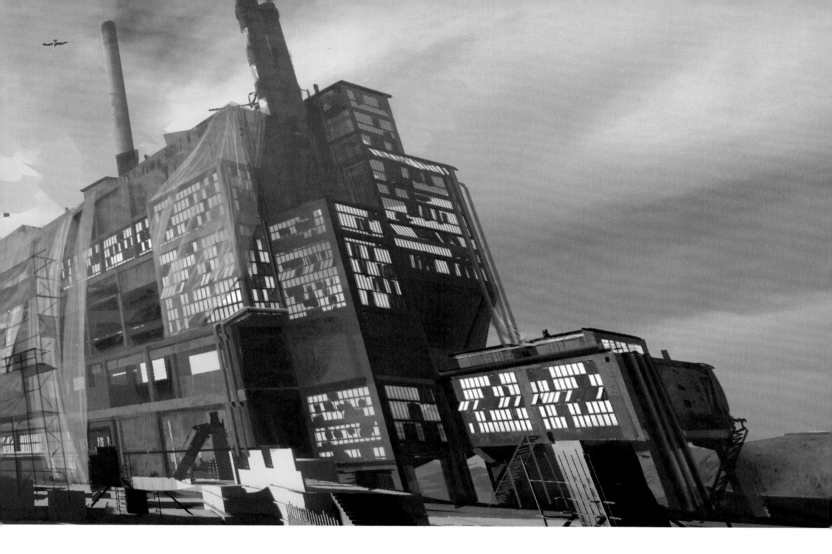

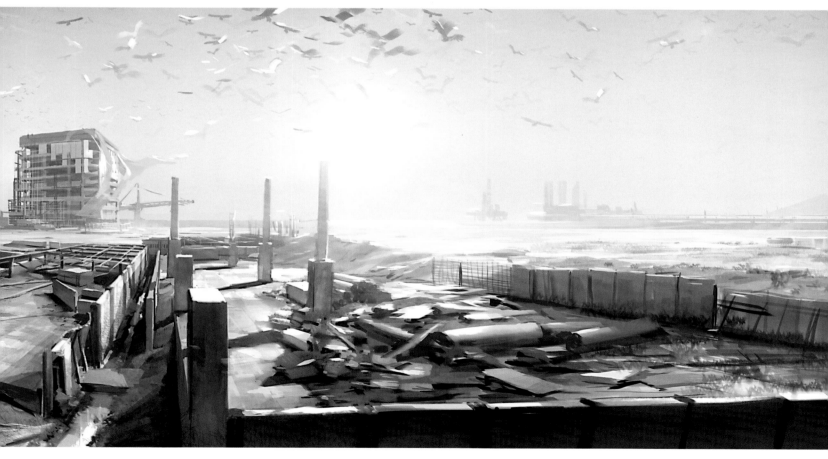

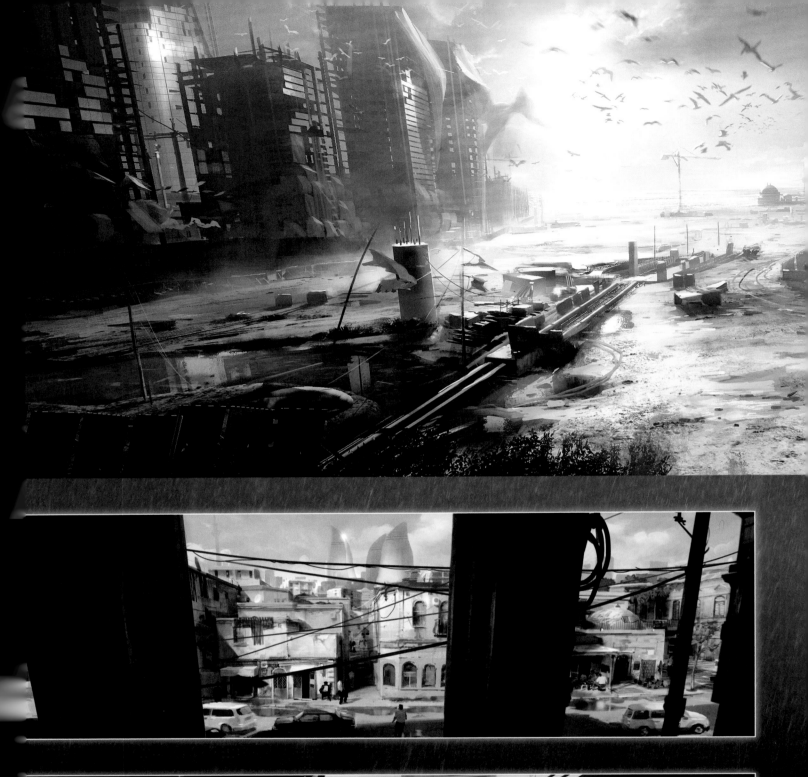
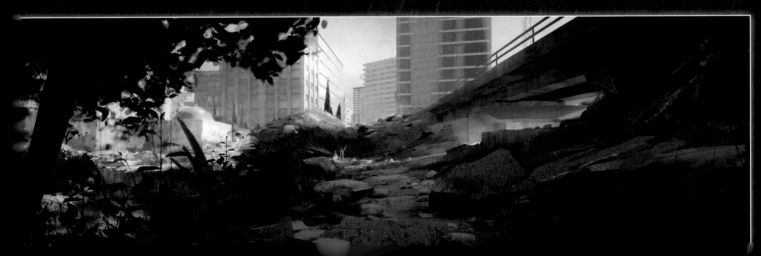

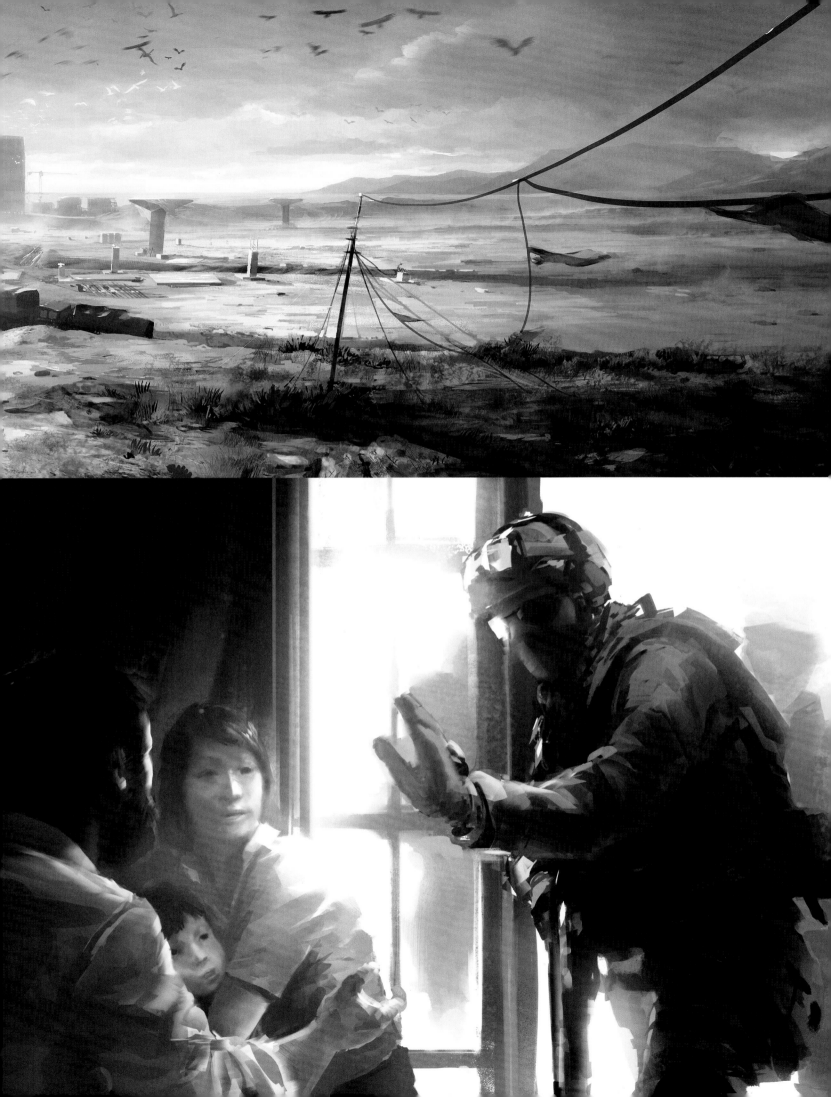

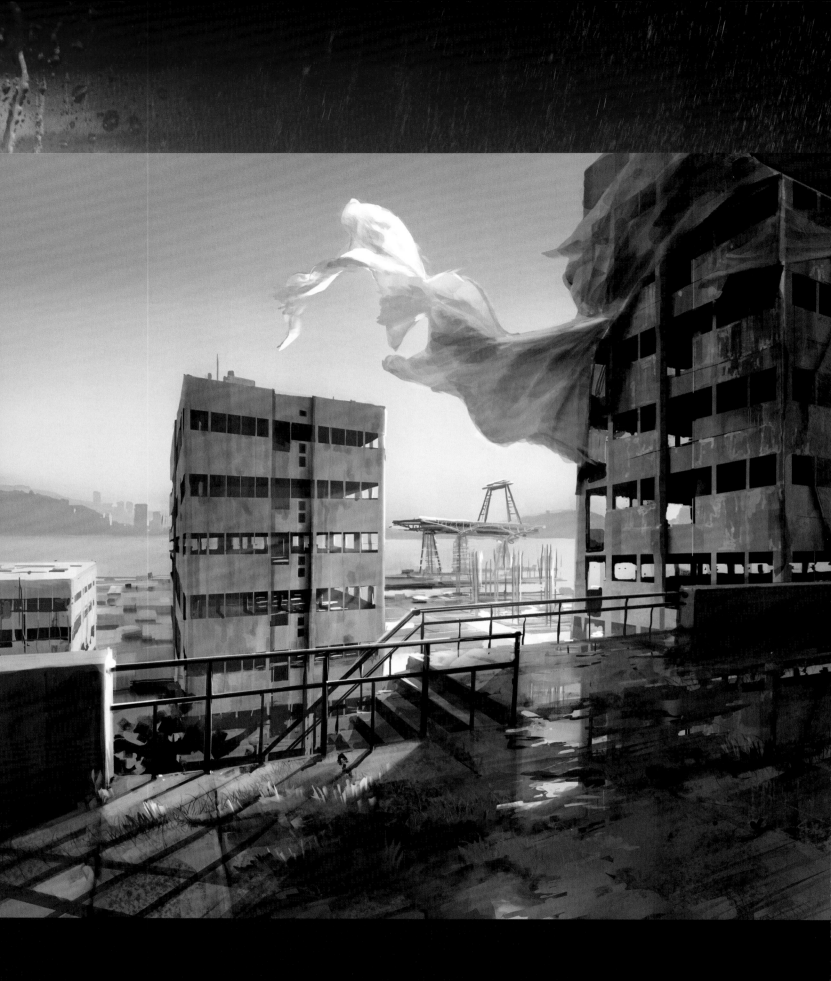

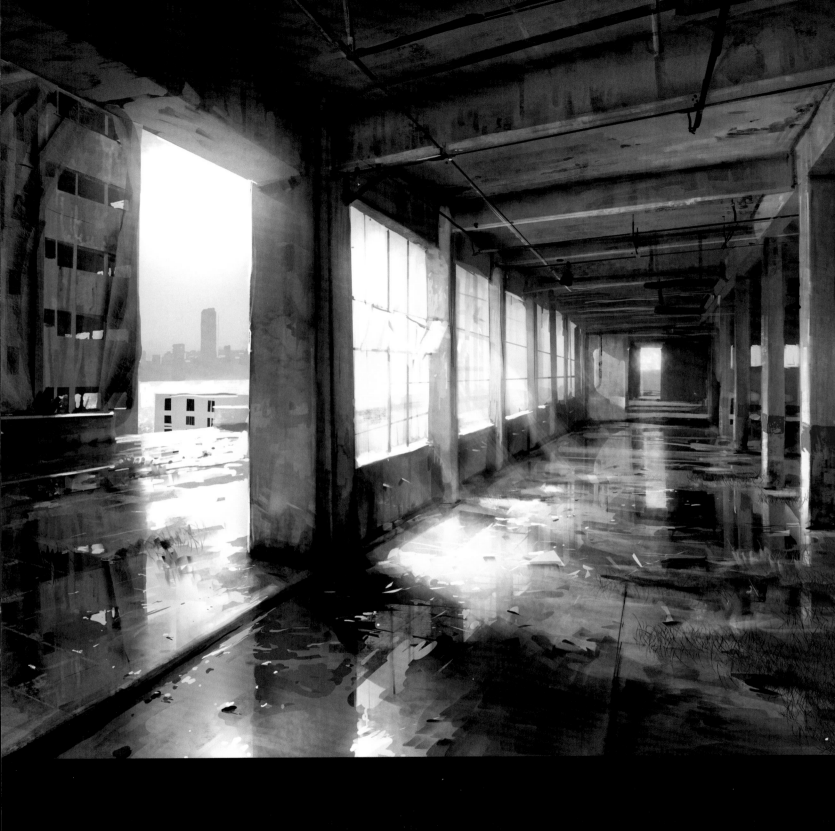

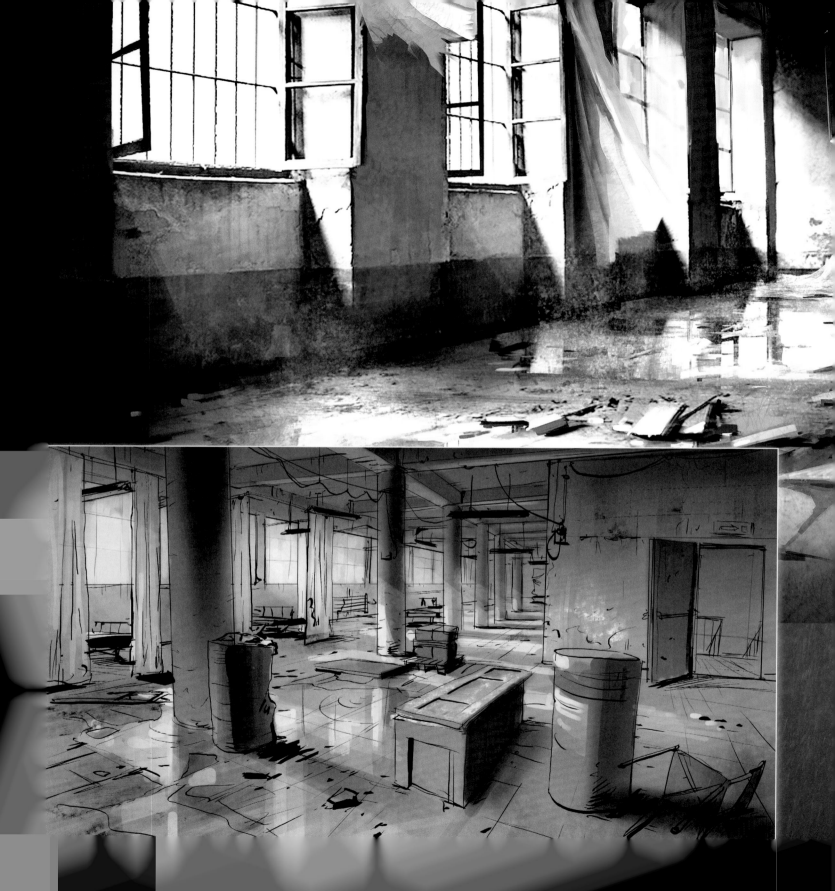

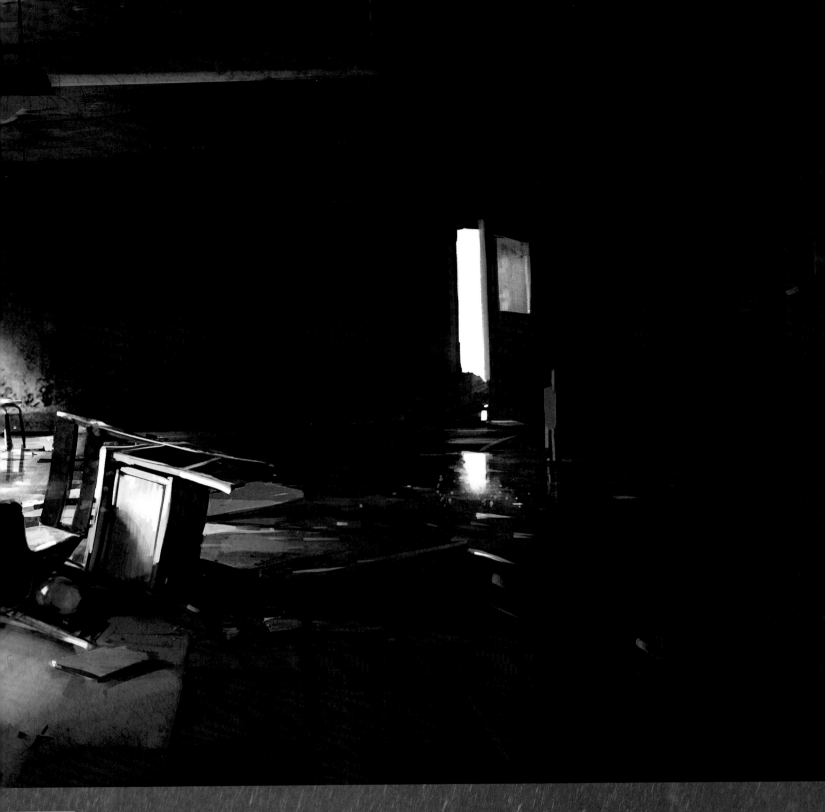

"We did a lot of research, but we also took a lot of liberties when it comes to the look of the place," Sammelin says of *Battlefield 4's* Baku. "Because this is the near future, you can take some liberties to make it spectacular. So we spun away on the big surrealist skyscraper complex they have and just imagined them building more of those around the whole area so you actually start in the old town of Baku and leave towards the construction of New Baku."

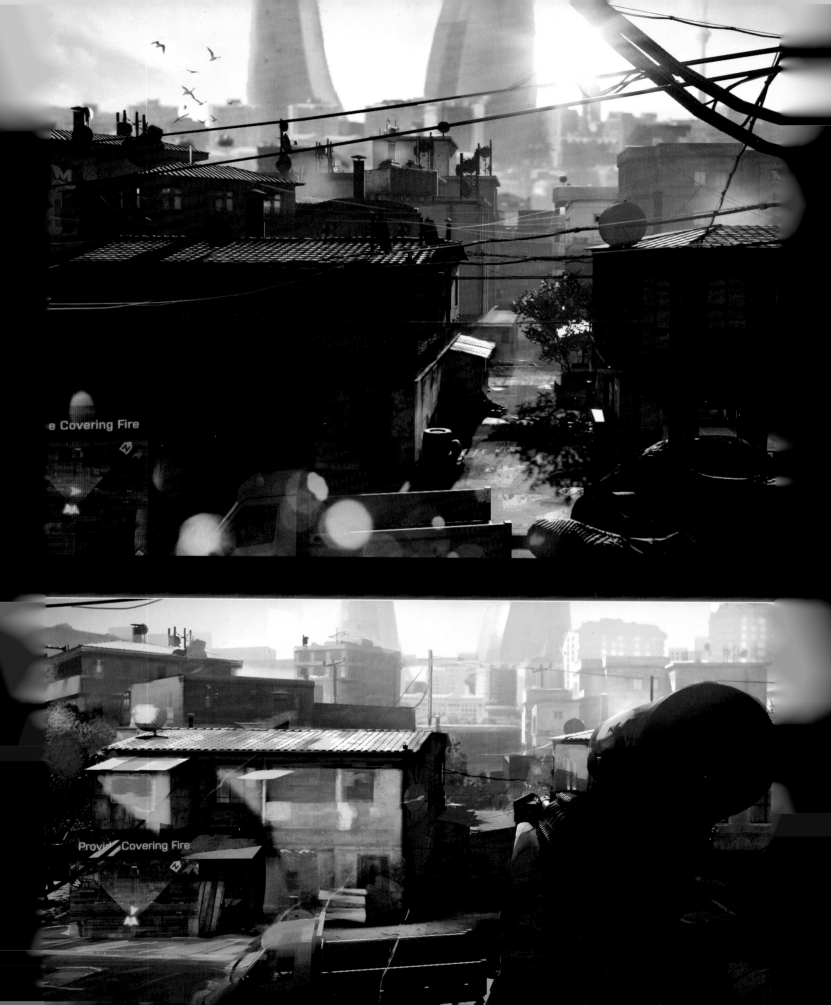

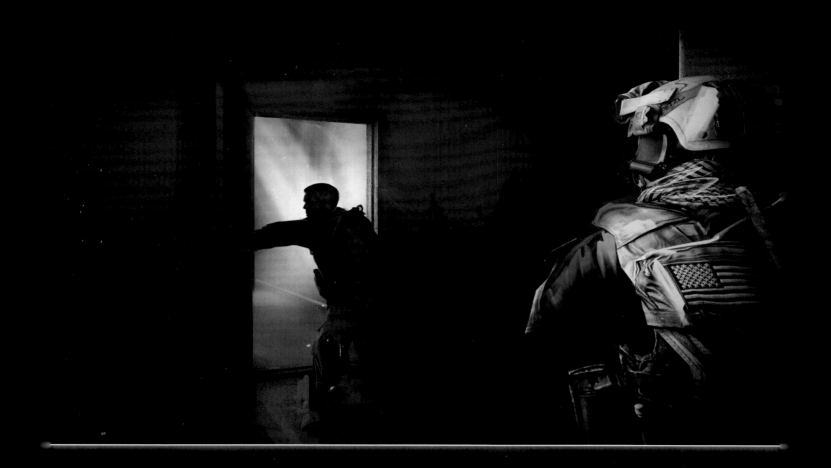

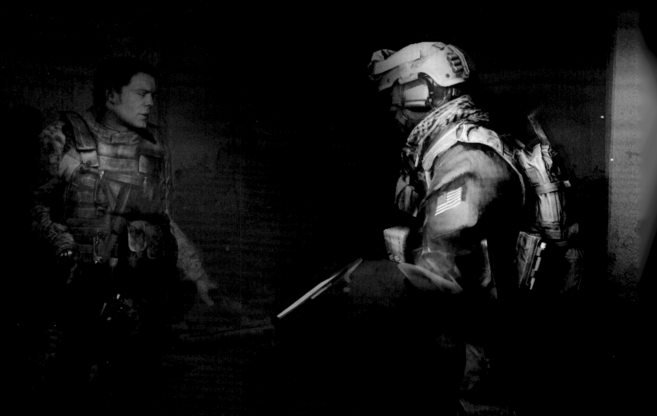

Battlefield 3 was created with effectively one concept artist. For the sequel, the team was expanded to five people - and the results are obvious. With more resources, DICE has been able to flesh out its vision with more efficiency and more vision, and the results are clear to see.

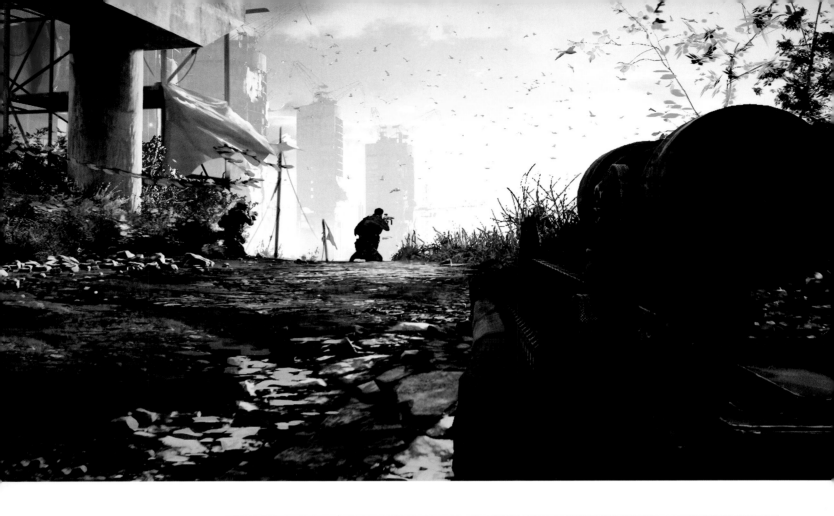

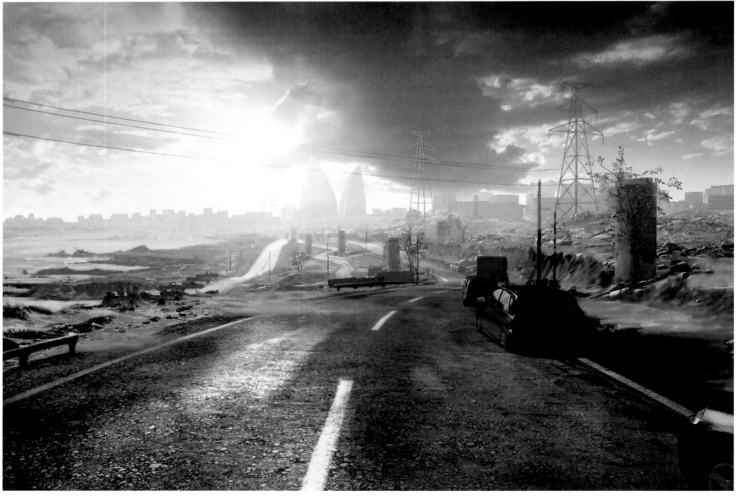

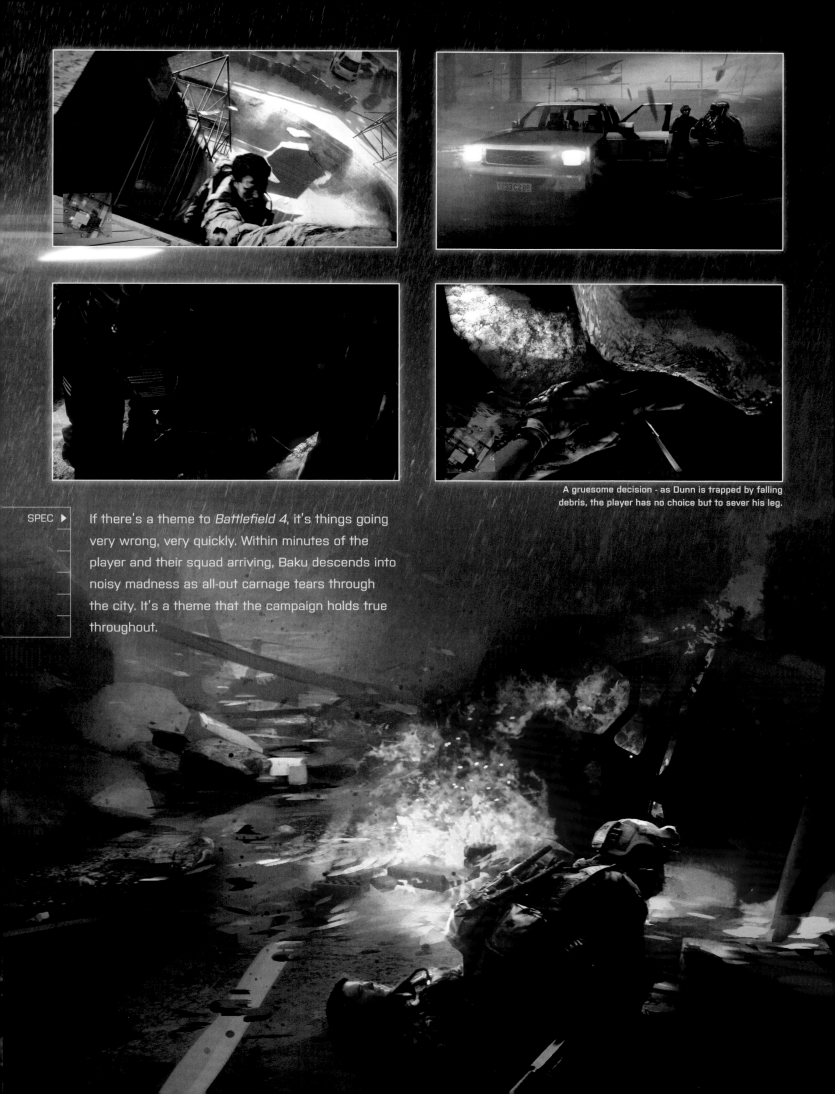

A gruesome decision - as Dunn is trapped by falling debris, the player has no choice but to sever his leg.

If there's a theme to *Battlefield 4*, it's things going very wrong, very quickly. Within minutes of the player and their squad arriving, Baku descends into noisy madness as all-out carnage tears through the city. It's a theme that the campaign holds true throughout.

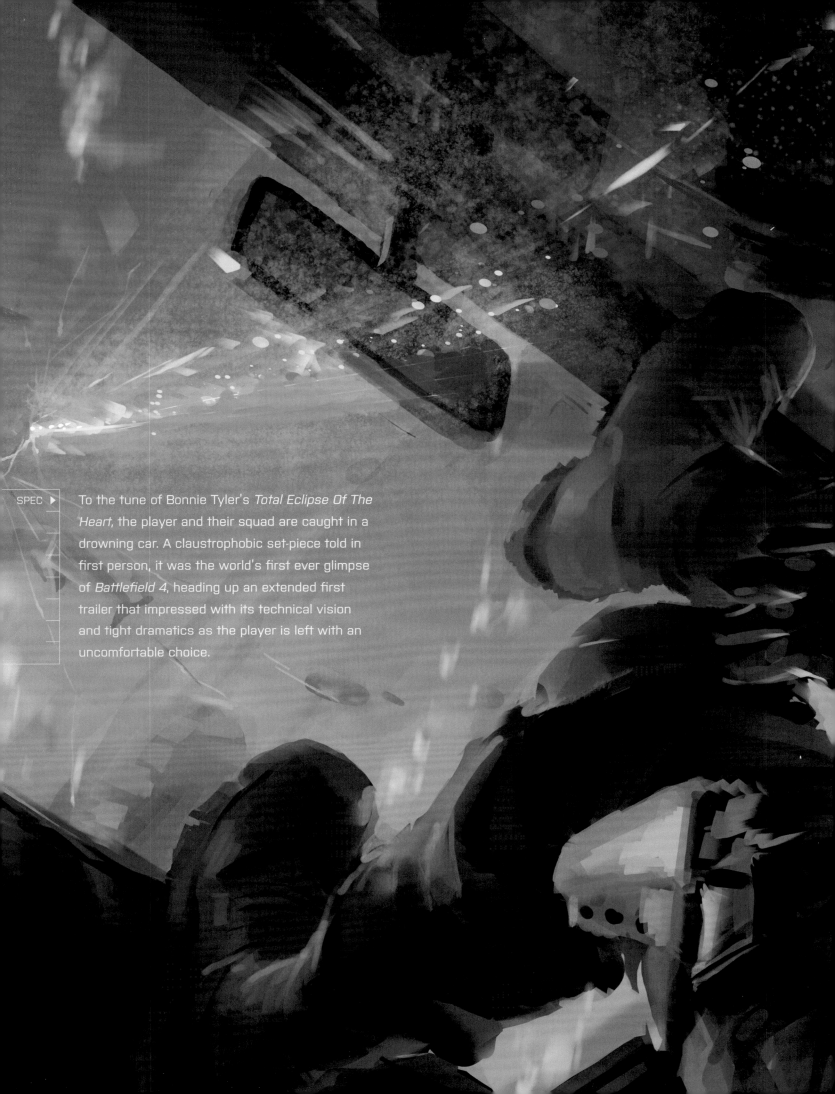

SPEC ▶ To the tune of Bonnie Tyler's *Total Eclipse Of The Heart*, the player and their squad are caught in a drowning car. A claustrophobic set-piece told in first person, it was the world's first ever glimpse of *Battlefield 4*, heading up an extended first trailer that impressed with its technical vision and tight dramatics as the player is left with an uncomfortable choice.

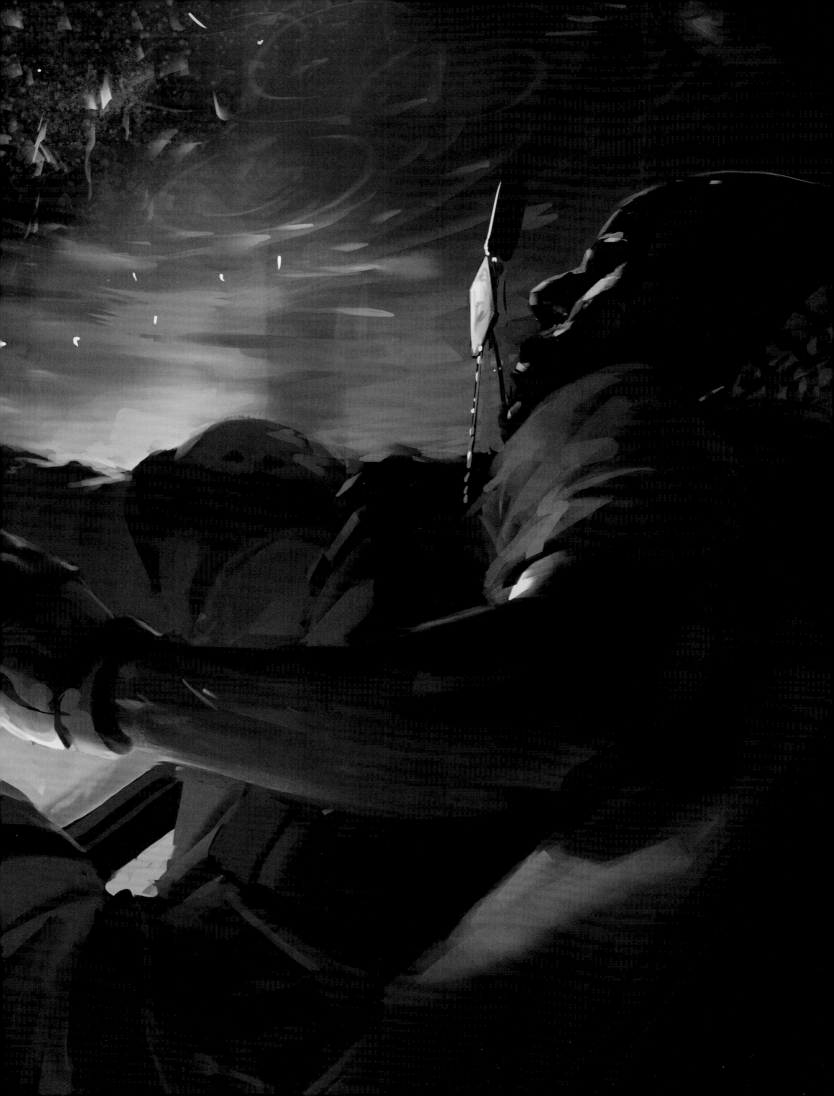

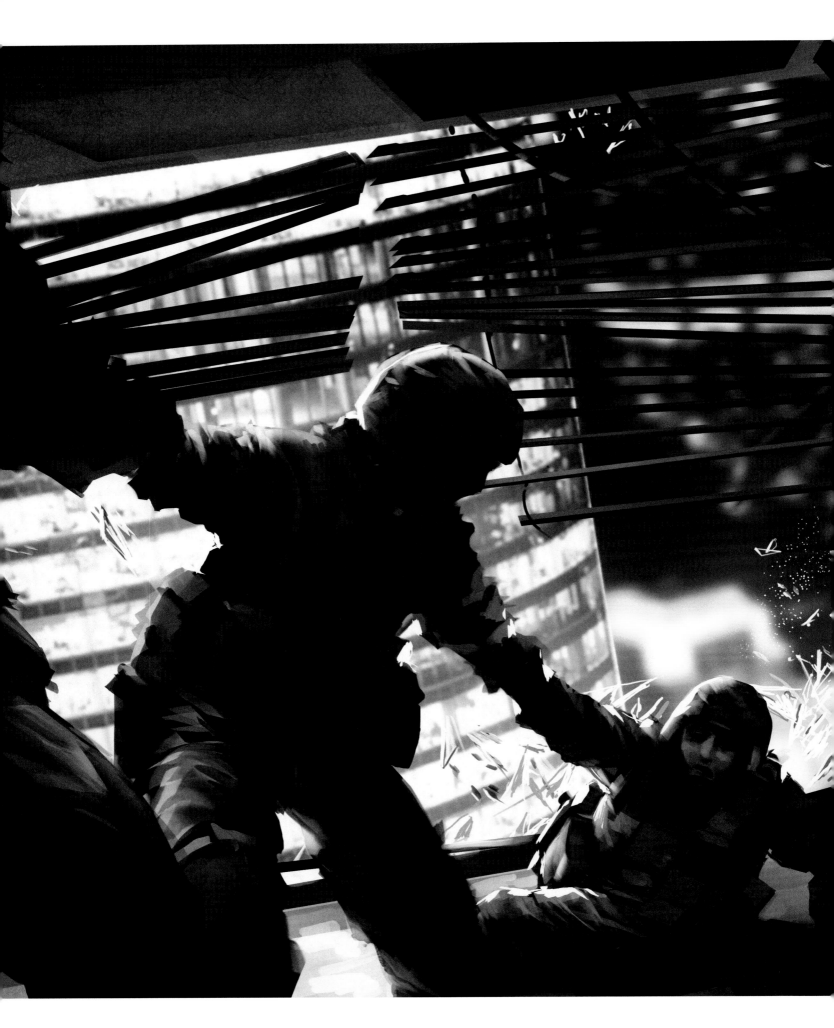

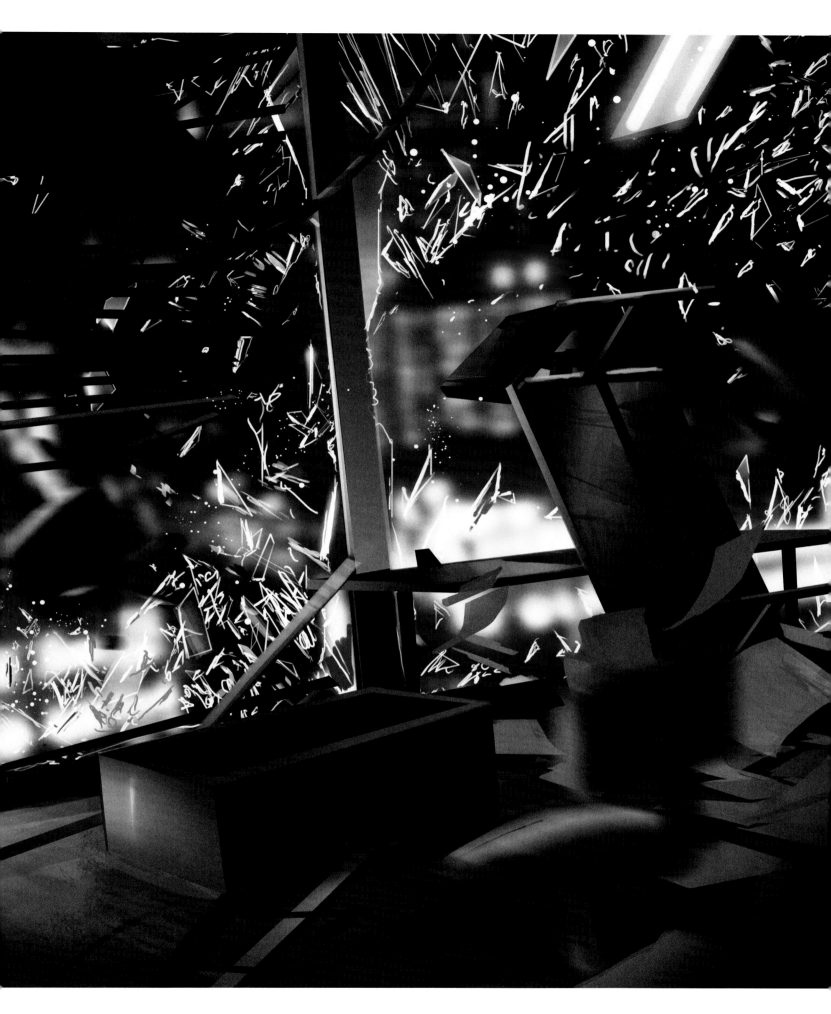

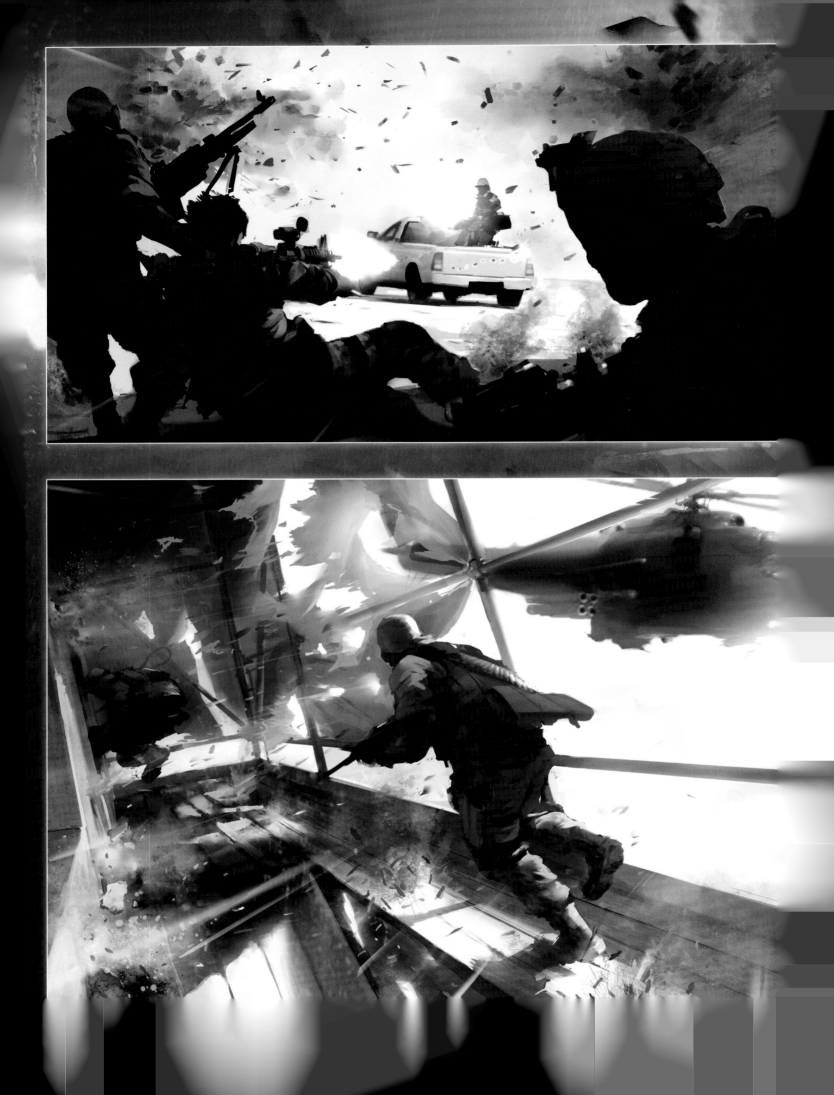

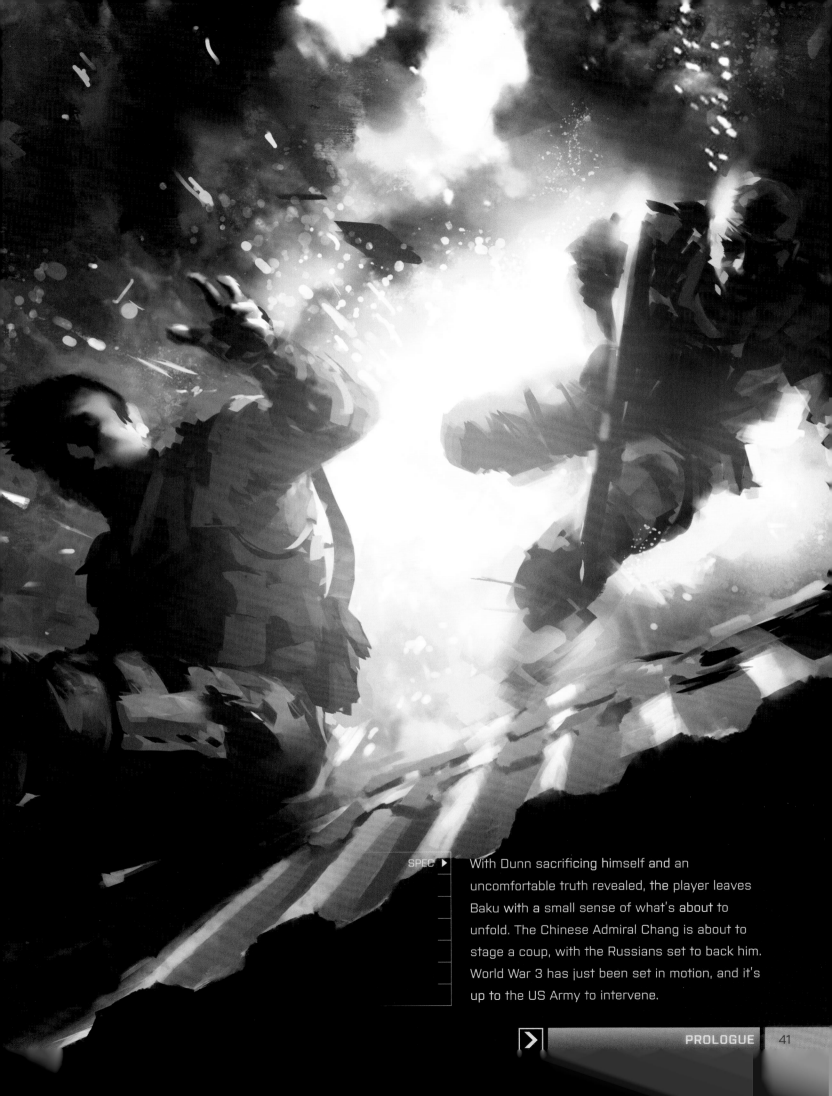

SPEC ▶ With Dunn sacrificing himself and an uncomfortable truth revealed, the player leaves Baku with a small sense of what's about to unfold. The Chinese Admiral Chang is about to stage a coup, with the Russians set to back him. World War 3 has just been set in motion, and it's up to the US Army to intervene.

SHANGHAI
//

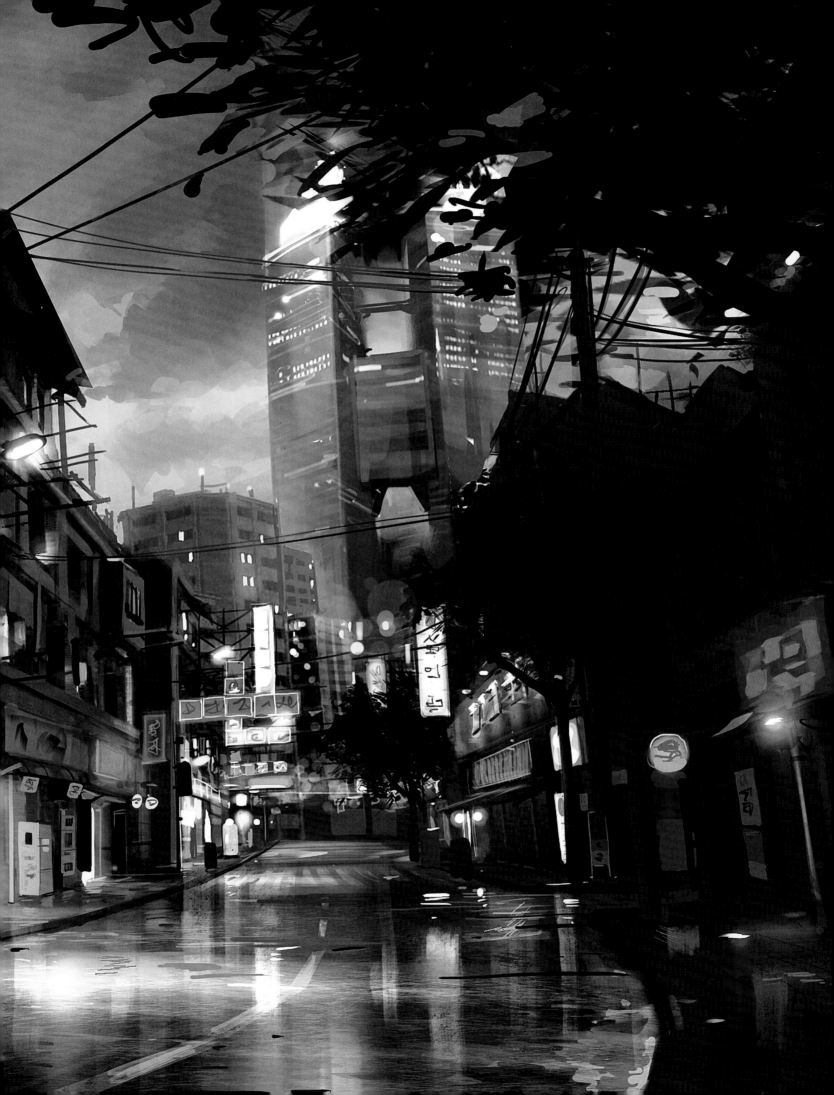

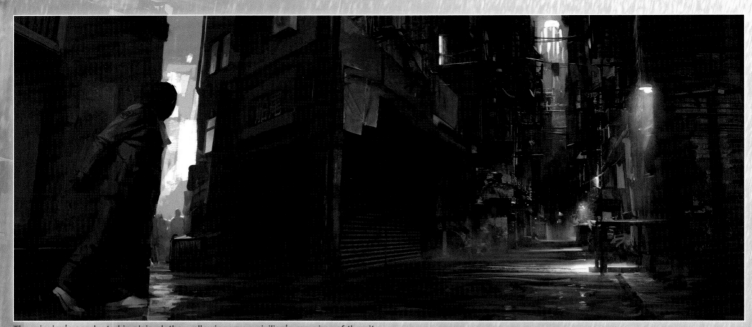

The mission's conducted in plain clothes, allowing you a civilian's eye view of the city.

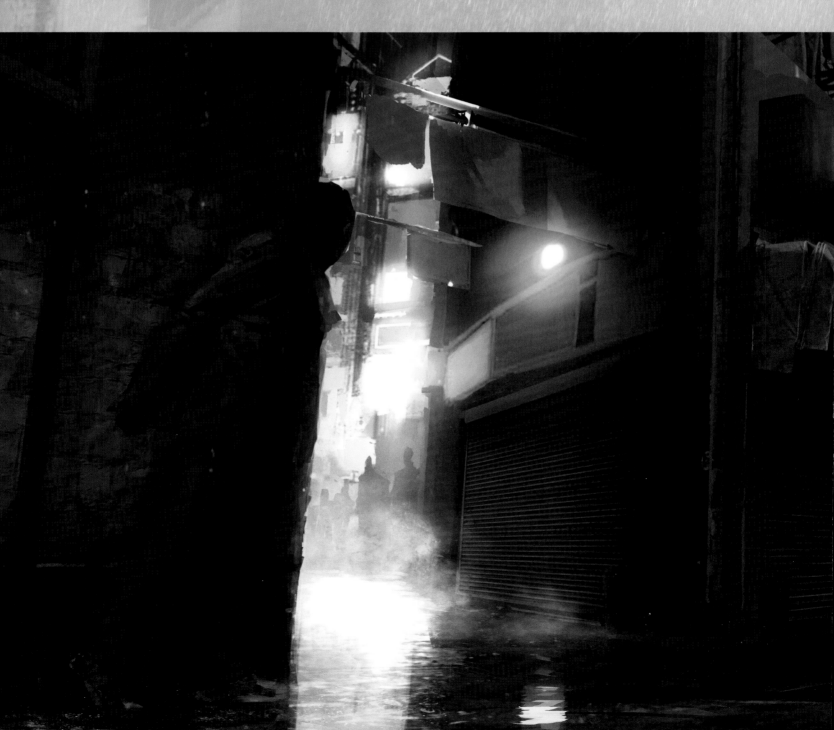

SPEC ▶

With the world teetering on the brink of war, the player, Pac and Irish are sent on a covert mission in Shanghai. Jin Jie, one of the few advocates for harmony in the region and a future leader for China, has been assassinated, and the US forces have been implicated in his killing. The city erupts in pandemonium, with skirmishes swallowing the streets.

Your mission is to recover a group of VIPs and extract them from the madness. The only problem is that the Chinese forces are engaging in a similar operation, leaving you on a collision course with the local military. After a successful extraction, you make to leave the city - only to see a flash in the sky that suggests the worst is yet to come.

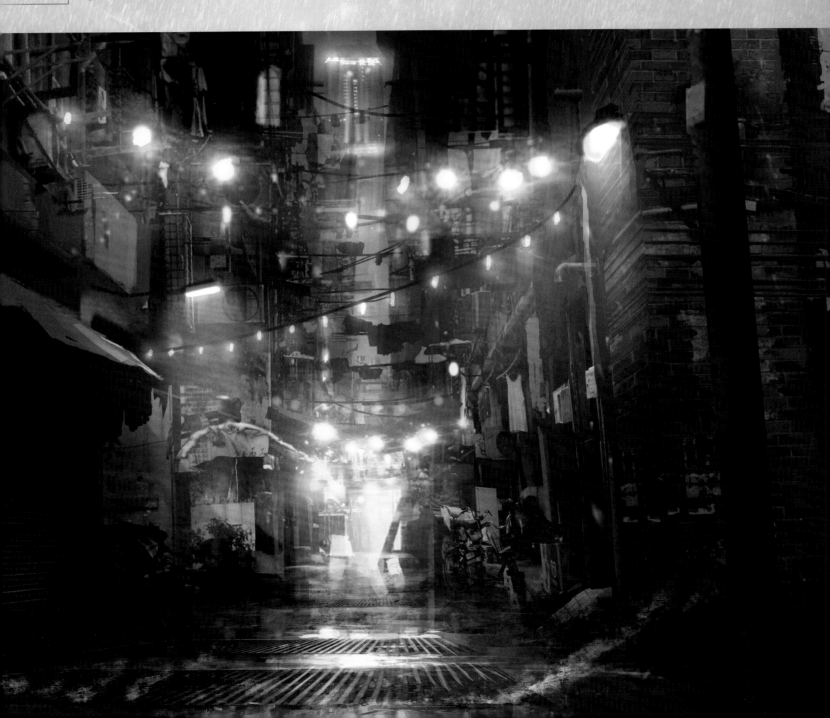

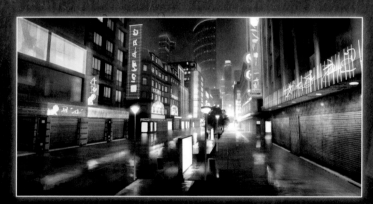

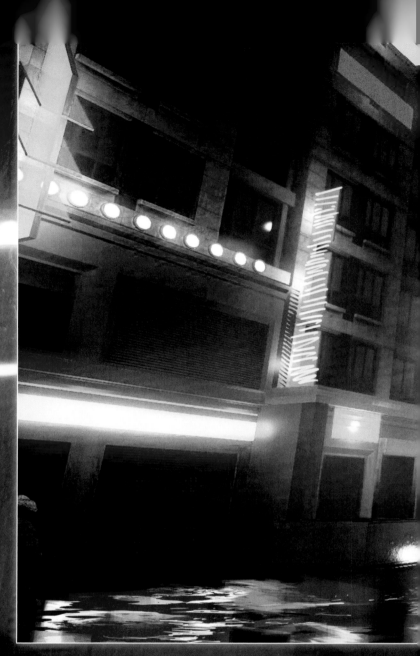

SPEC ▶

There's a lot of cinematic influence in the look of *Battlefield 4*, and it's perhaps not surprising that the Shanghai section bears the mark of one of Asia's most eminent directors, Wong Kar Wai. Sammelin remarks, "I'm a big fan of the cinematographer he uses, Christopher Doyle, I really, really like the way he shoots films."

Doyle's love of neon, and his ability to make it feel like an age-old part of the cityscape, can be seen throughout DICE's Shanghai. It's a city that's been well documented on film, too, meaning there was plenty of other pieces to take in. "Working on the specific level, we look at anything from adverts to old films," says Sammelin, "Shanghai is so rich on visual inputs so you can find just about anything, so we looked at old Chinese as well as Western cinema. You get two different versions of the city in a sense."

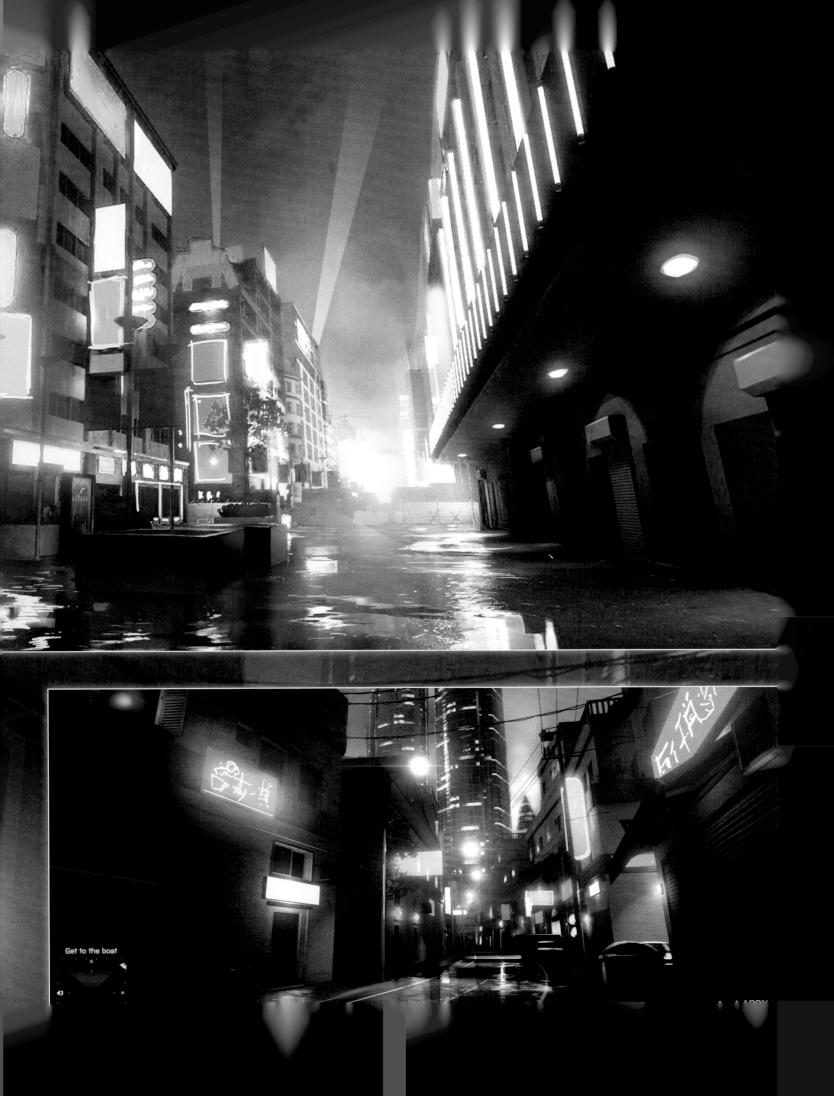

Get to the boat

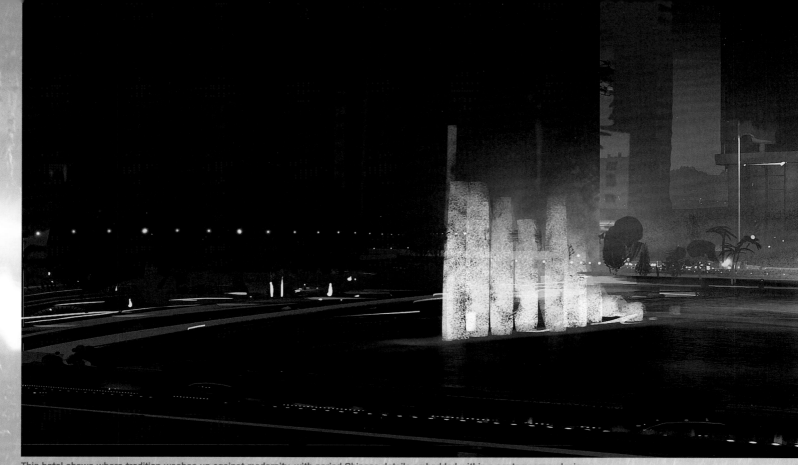

This hotel shows where tradition washes up against modernity, with period Chinese details embedded within a contemporary design.

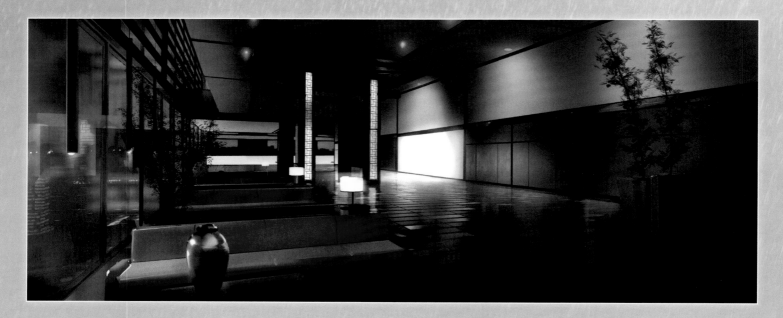

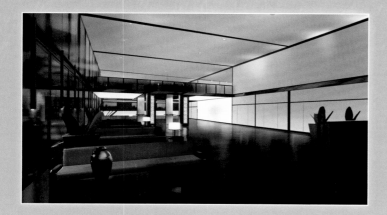

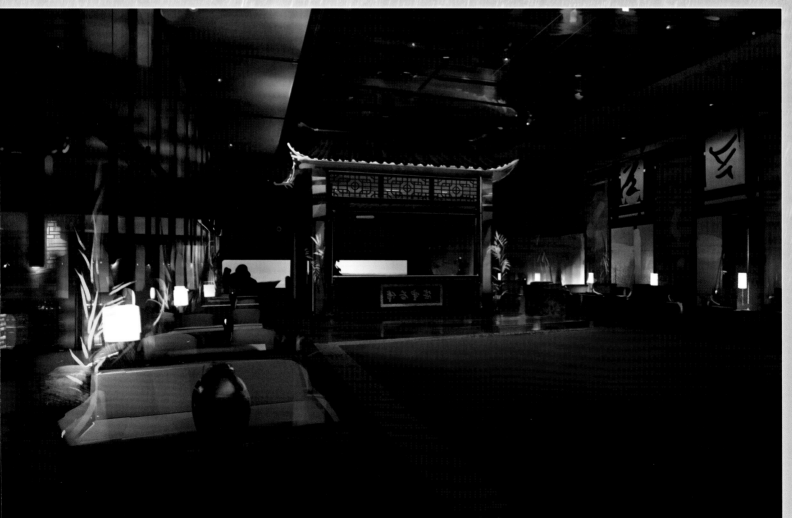

The interiors of *Battlefield 4* are conjured almost entirely from the artists' imagination. "Some building references come from modeling artists who modeled something they found interesting, other times it's us or the art director coming up with looks for buildings," says Sammelin. "Also you really can't use existing buildings, so you have to make a spin on it. Some were definitely sprung out of real world references and others were something that we made up because it looked cool."

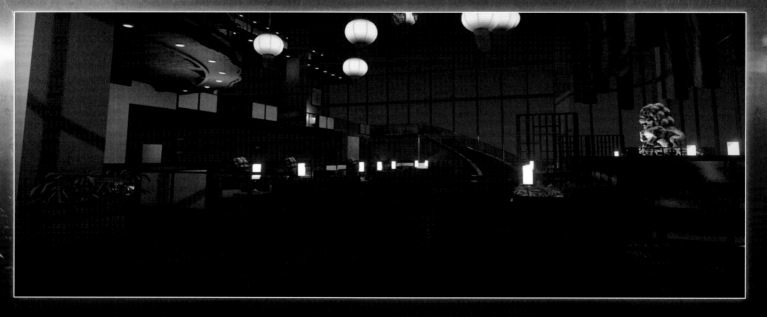

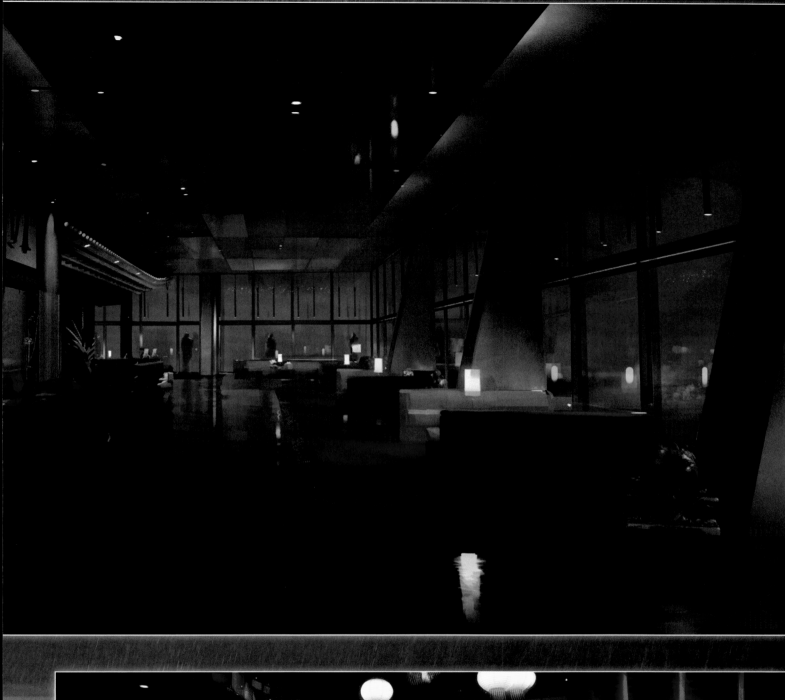
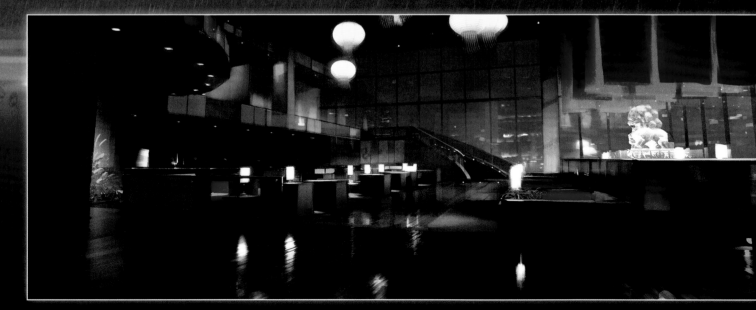

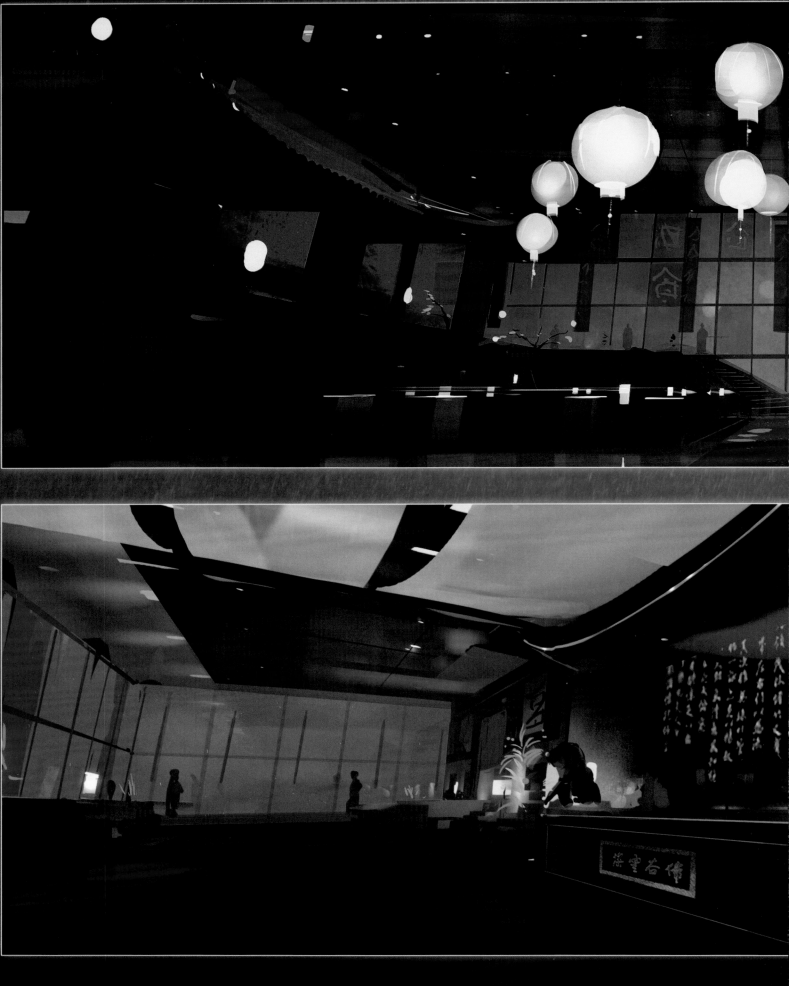

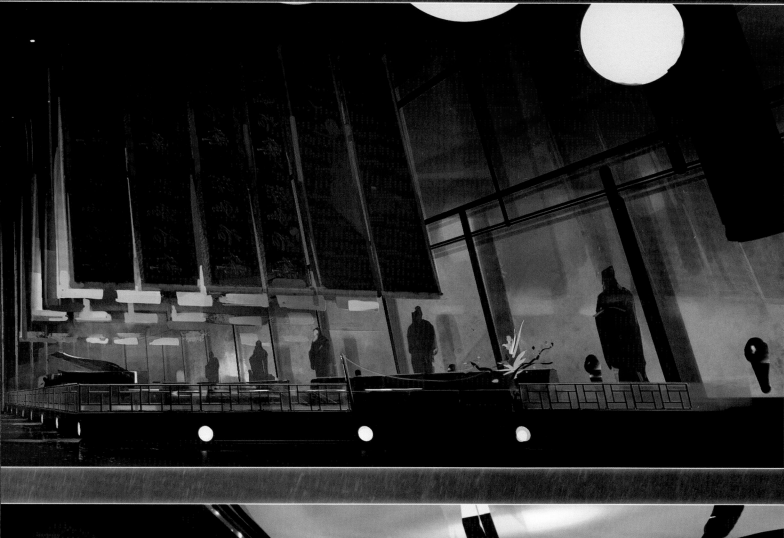

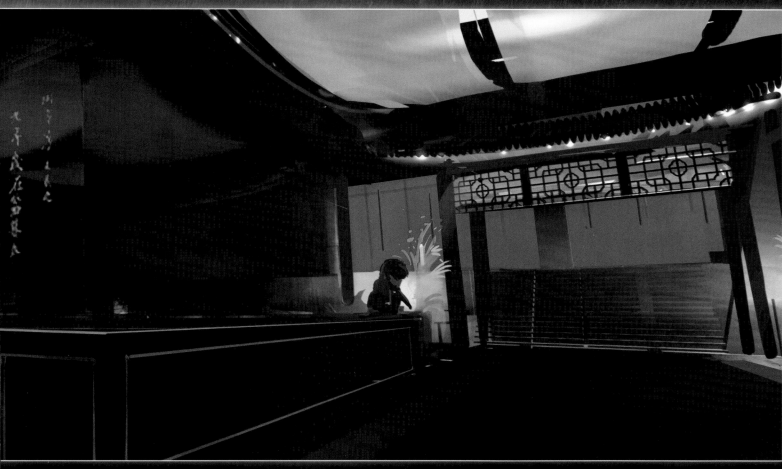

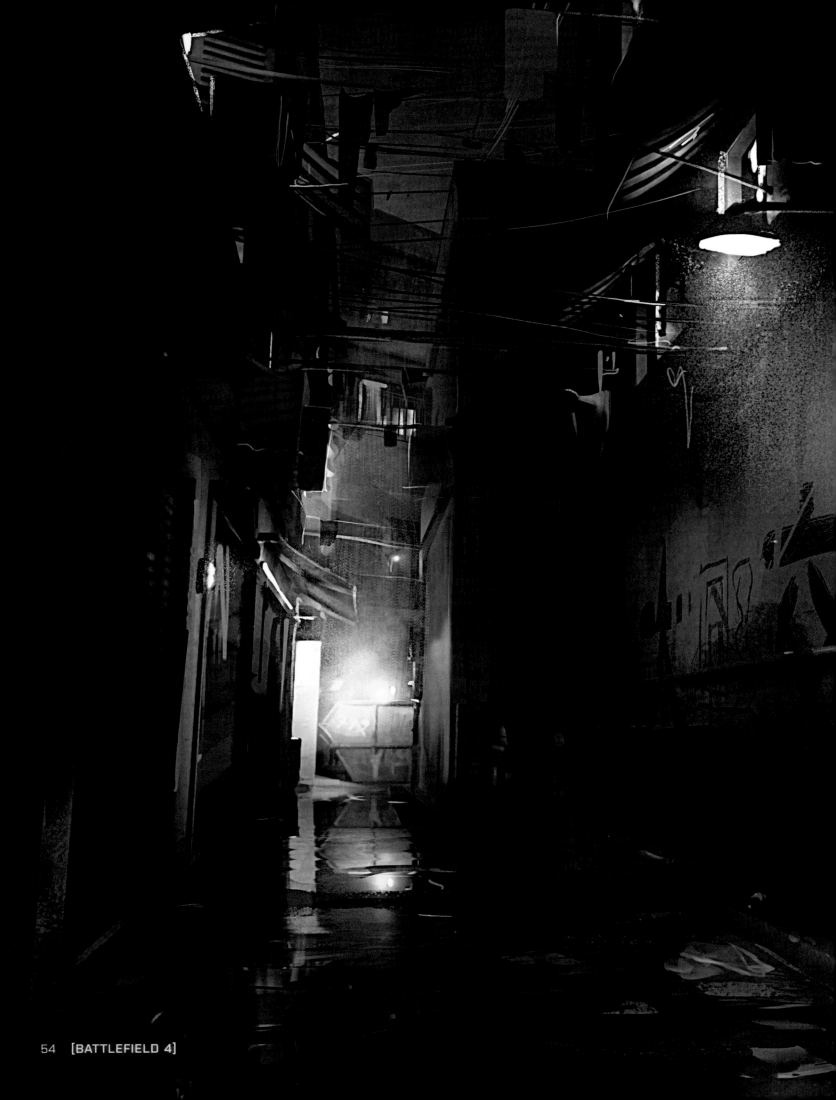

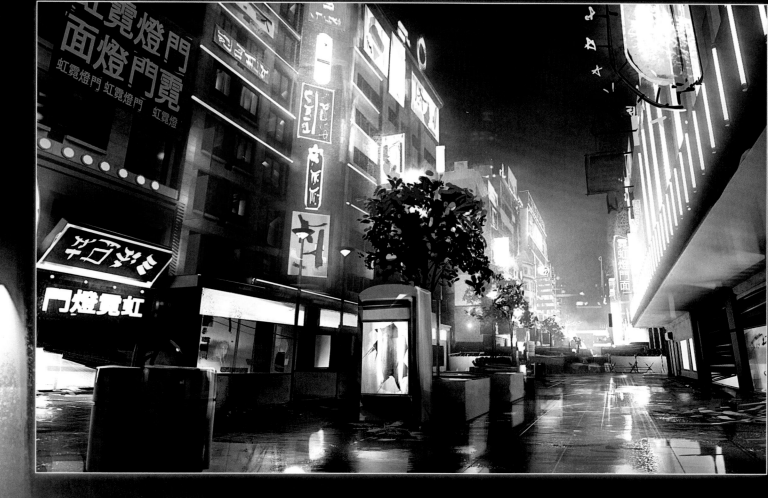

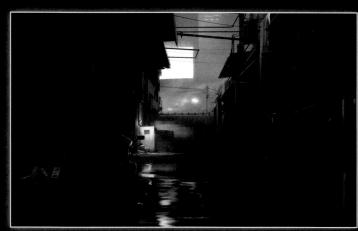

SPEC ▶

Given the strong sense of location, and the often excellent
capturing of Shanghai as a city, it may be a surprise to learn that
Battlefield 4's artists were never able to visit the city themselves.
"You can find lots by just Googling a place," says Sammelin. "Google
Maps is a wonderful tool to just walk around town and look at
different areas. You can just find a certain part of the city you find
interesting and then you use the name of that place." There was
another layer too - EA has a handful of employees in Shanghai who
authenticated the verity of DICE's vision.

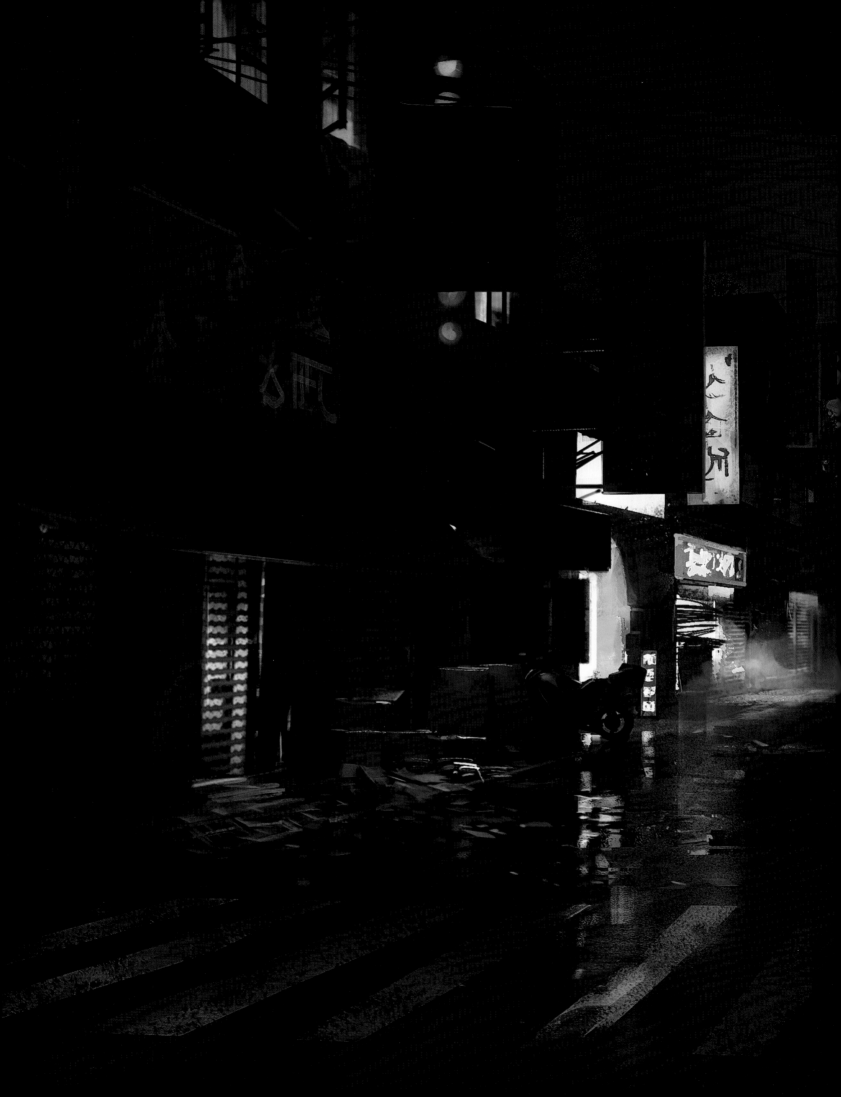

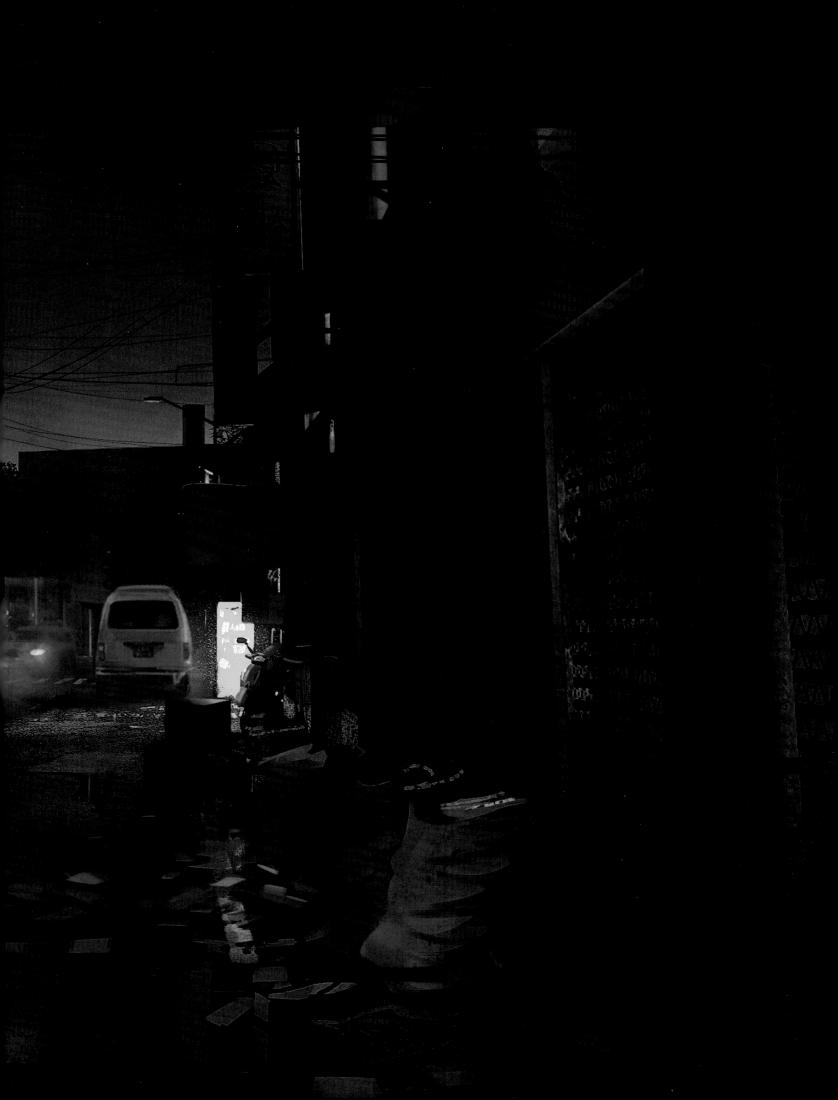

SPEC ▶ DICE's depiction of Shanghai has glamor and tradition, but it also has a lived-in quality. These are streets that, while empty, feel like they've only just been abandoned, as the population flees from the encroaching battle.

While the series takes influence from high-budget Hollywood blockbusters, it's the shadow of art-house cinema that can be really felt in these dark alleys. From Christoper Doyle's cinematography through to another inspiration for Sammelin and his team, Tarsem Singh's The Fall. The vivid use of color in Singh's film is reflected here, the city at times turning into a dreamscape.

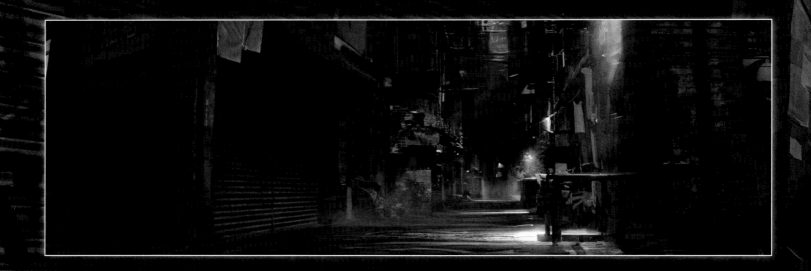

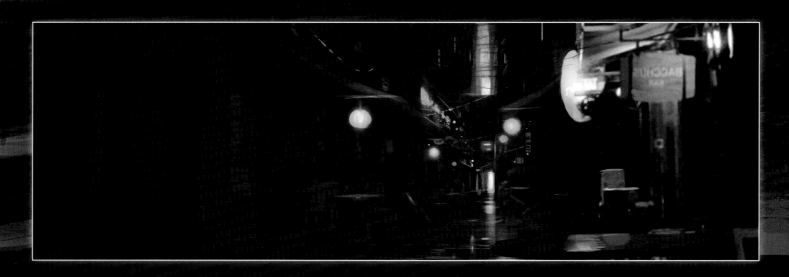

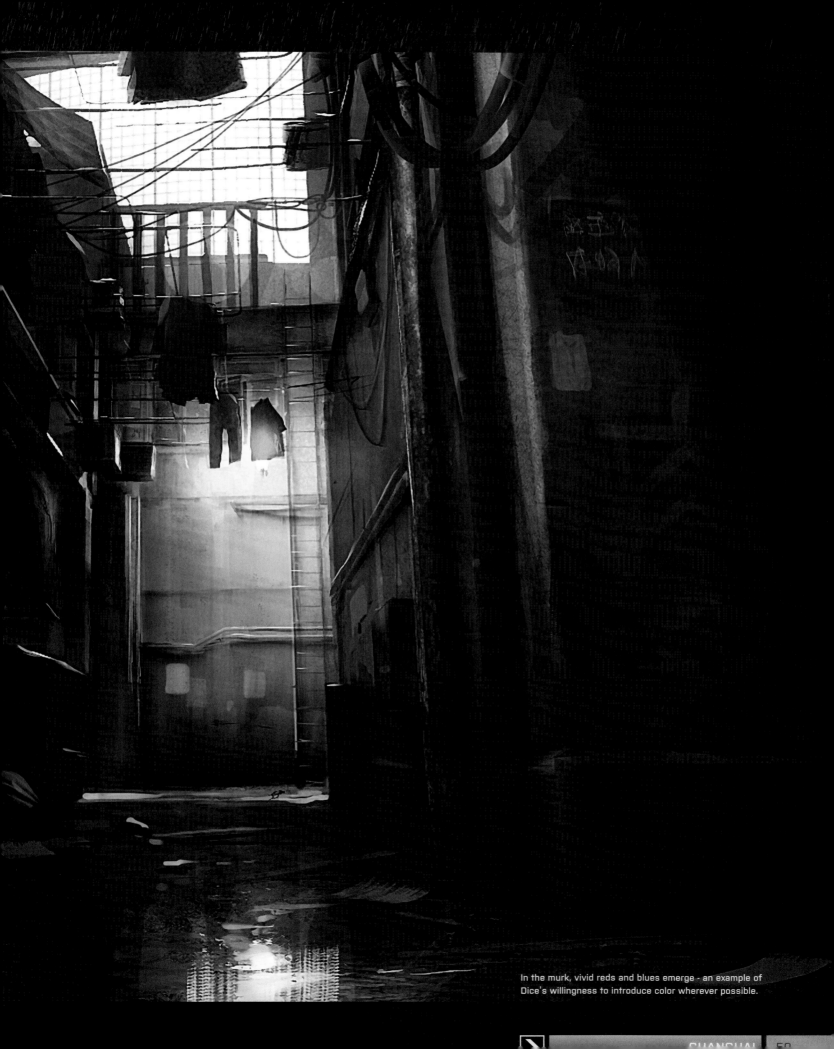

In the murk, vivid reds and blues emerge - an example of
Dice's willingness to introduce color wherever possible.

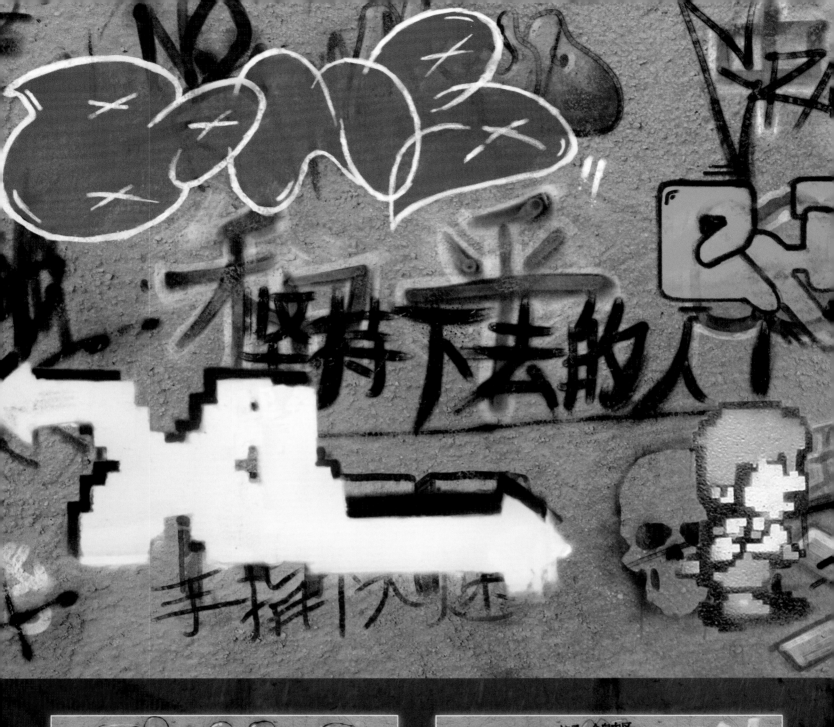

欲望

睡觉无风的

D|YLAN

forever beauty
OBOHIDÔMÉ

by
D'HAÏNE

对于现代人？

帕布罗
与朋友

周六对儿童的电视

探索
冰岛

获取线　　　　　　新的集合

淮海 时装屋

新的
竞争者

水晶香水
CRYSTAL FRAGRANCE

SPEC ▶

Robert Sammelin: "It's a lot of fun to do street art, graffiti, adverts, billboards, movie posters, and it's something that thankfully becomes a necessity because you can't really use existing art, you have to do research. For a while we were really digging deep into Chinese contemporary graffiti, which is a strange way to go about it. In the end we settled for a more simple graffiti style, so didn't go full elaborate, proper street art, which would be quite fun but wouldn't suit the style."

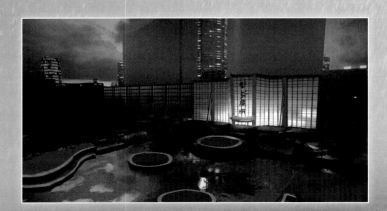

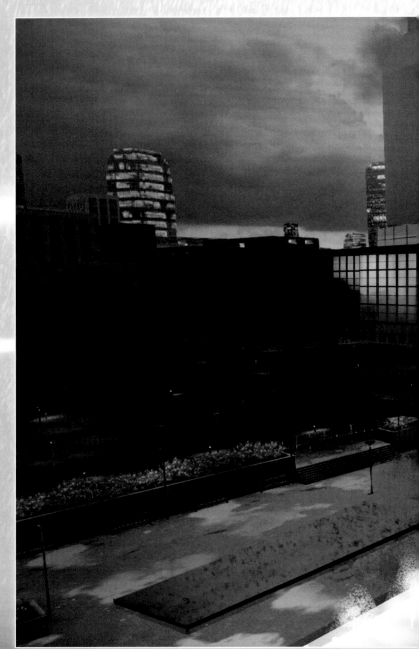

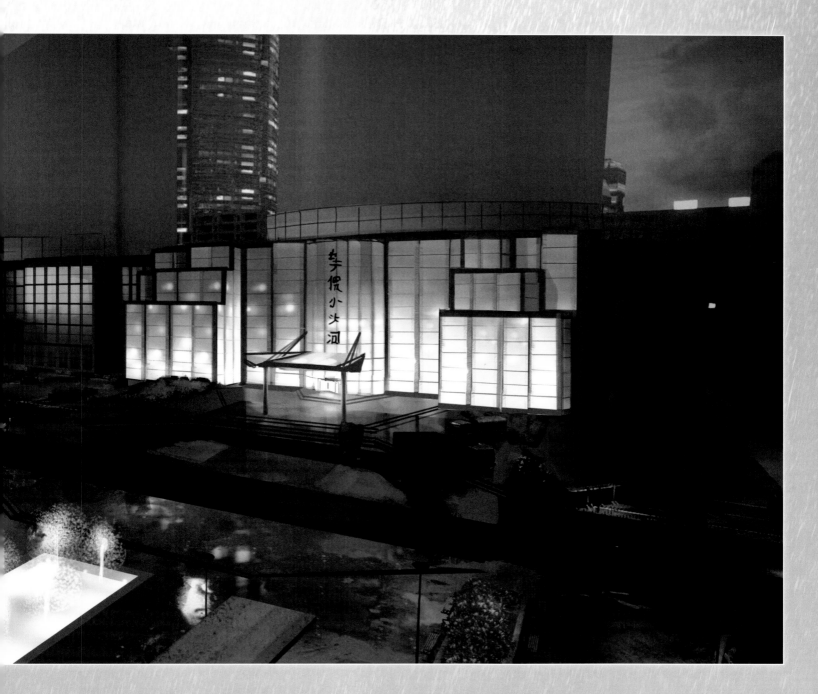

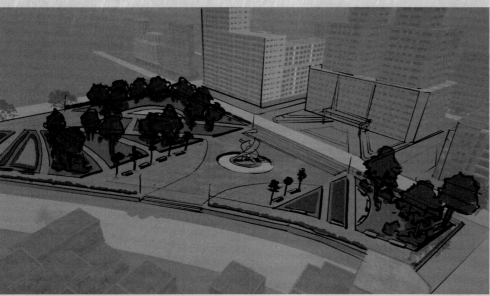

Battlefield's buildings don't emerge fully constructed. Building them can be a slow, iterative process. DICE's art team works internally, which can be a rarity in the games industry. Having them close at hand allows for a faster, more effective process.

◄ SPEC

The extraction point where Kovic, Huang 'Hanna' Shuyi and her partner are whisked away by helicopter. Recker and crew aren't so lucky, though - they'll have to stay behind to ensure the VIPs can get away safely, only to then have to work their way through thickening enemy lines to escape a Shanghai that's fast descending into madness. It's a noisy, spectacular and exciting climax to one of *Battlefield 4's* standout missions.

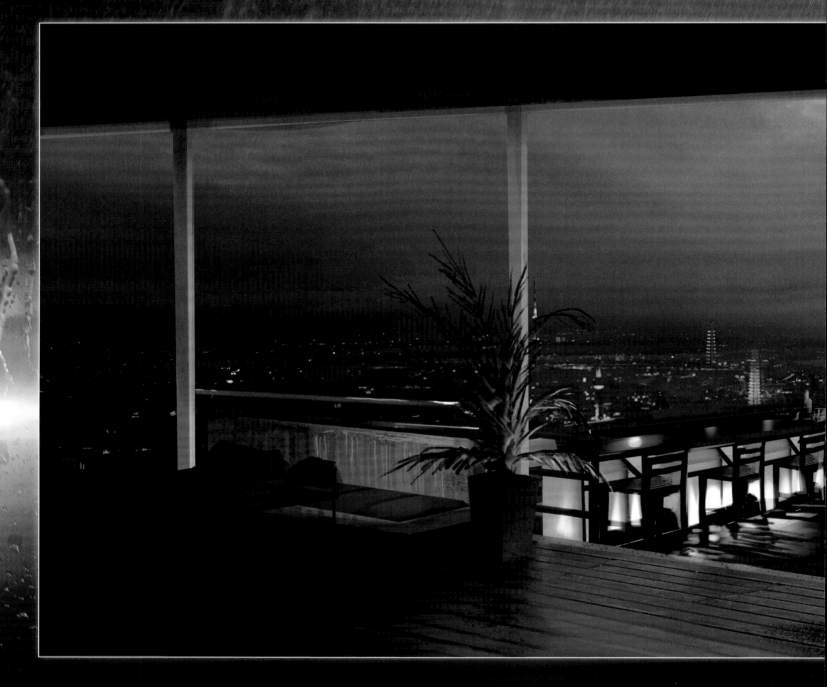

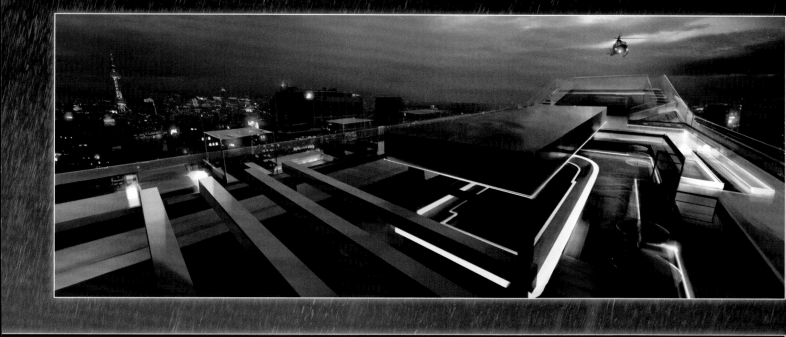

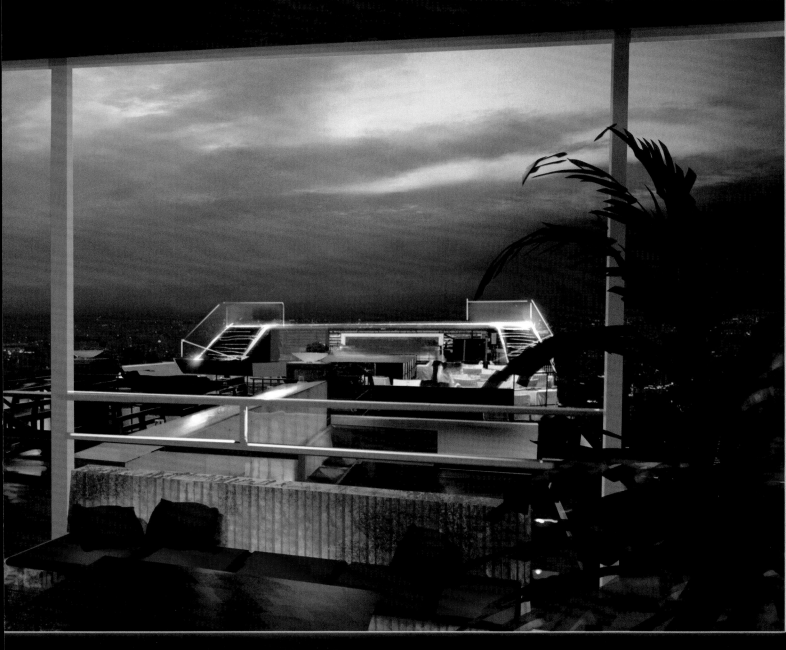

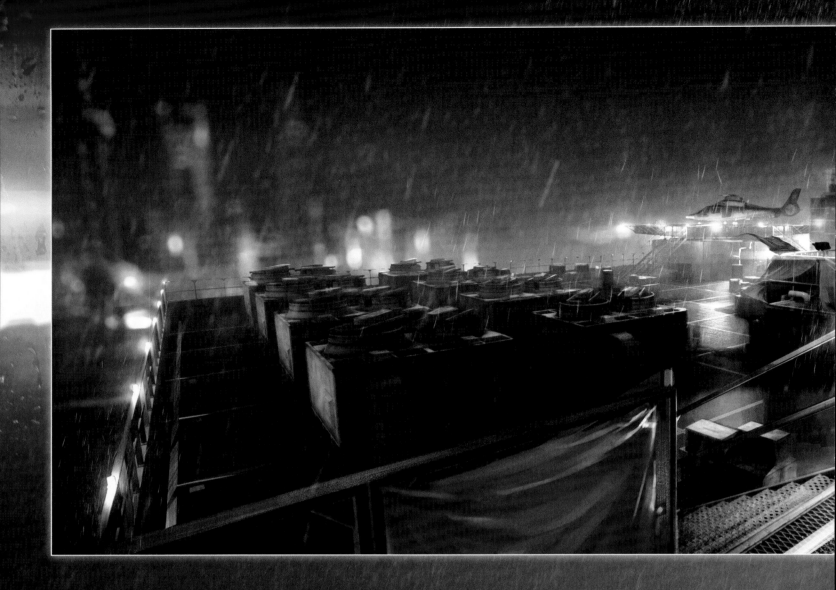

With the VIPs successfully extracted, Recker must make his own way out of the city - and it's not quite as graceful as a swift helicopter ride to safety. As the protests become more frantic in nature, and with much of Shanghai's vast population looking to escape, the streets become thick with panic. Civilian boats bob heavily with crowds of people looking for a way out, and you manage to stow away with the swarm, heading to the security of the USS Valkyrie. Or so you believe...

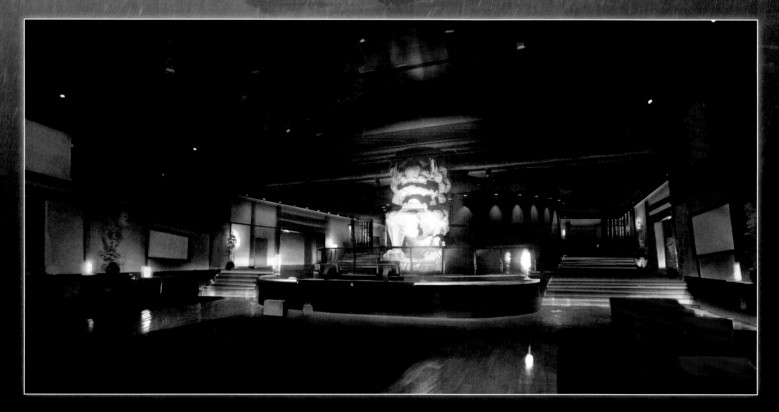

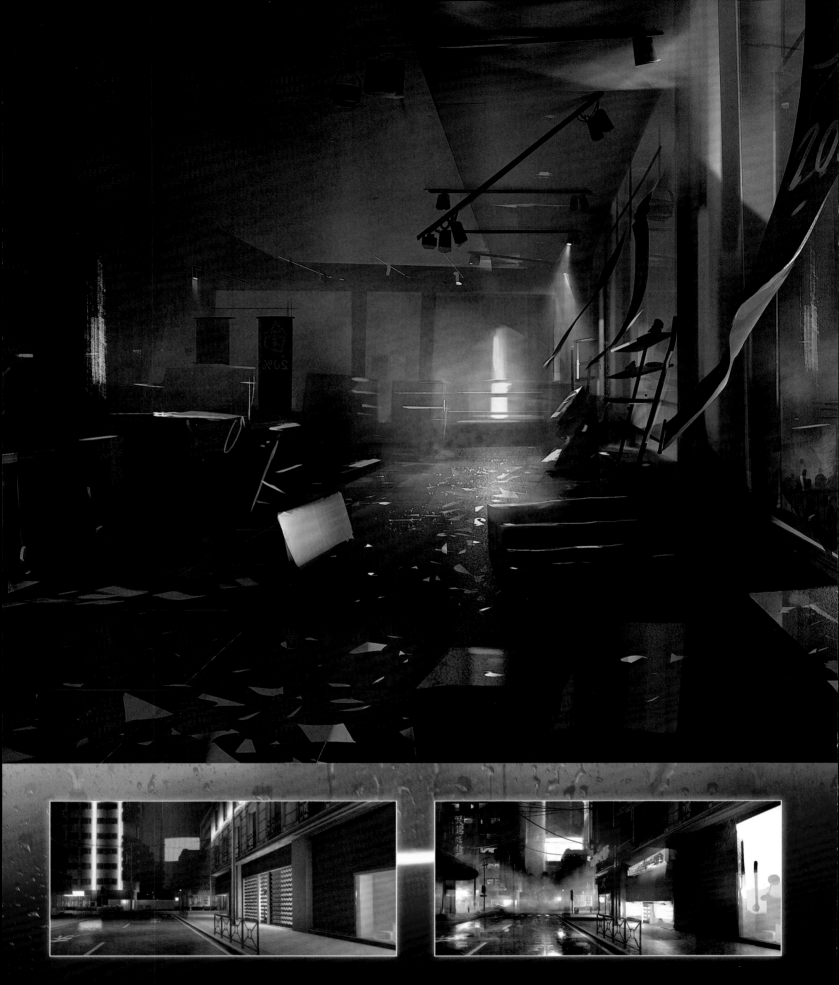

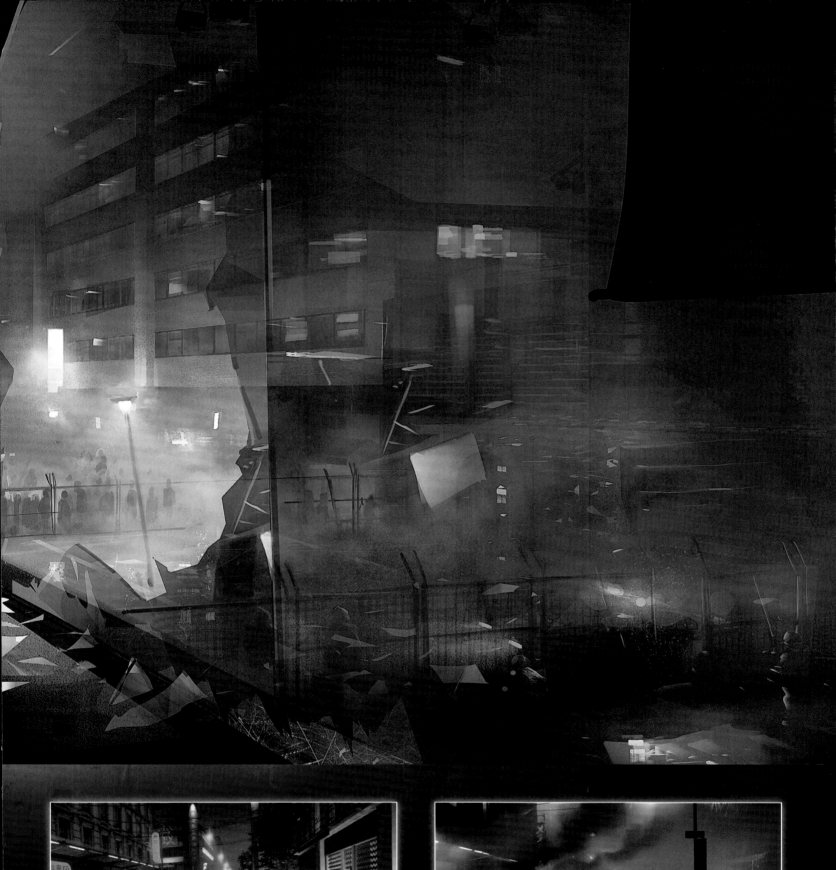

NAVAL BATTLE

SINGLE PLAYER

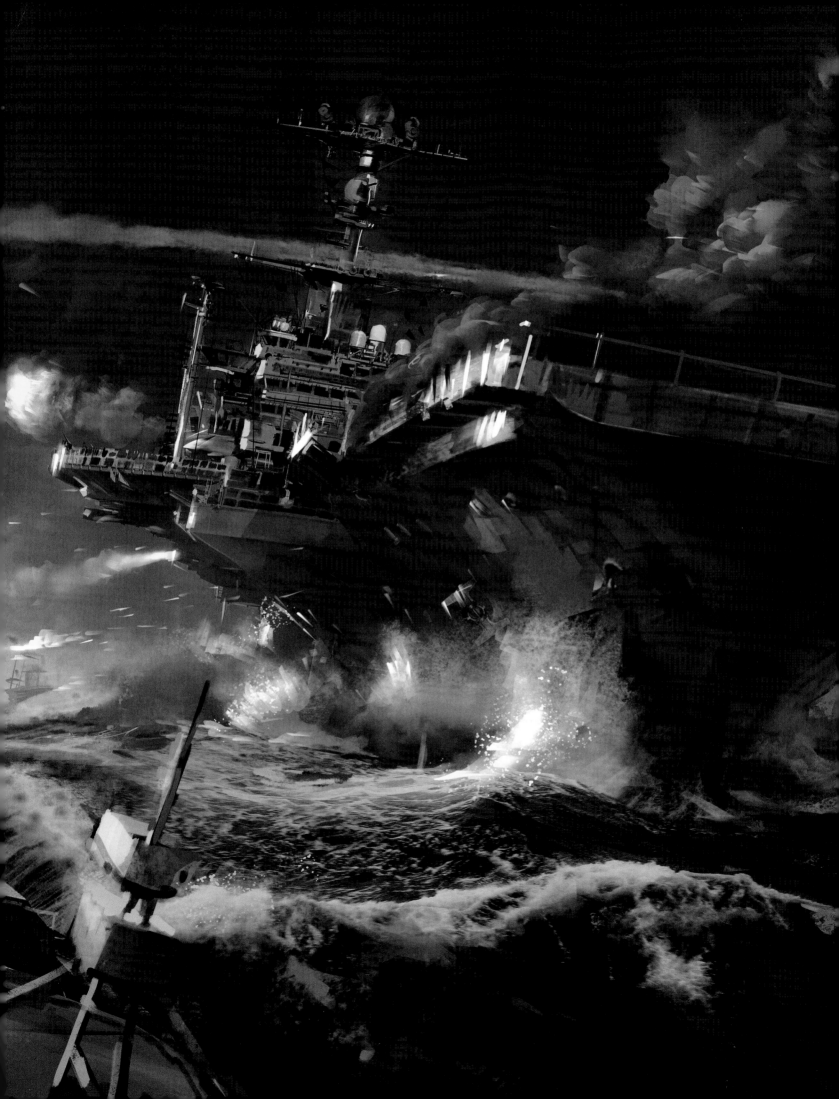

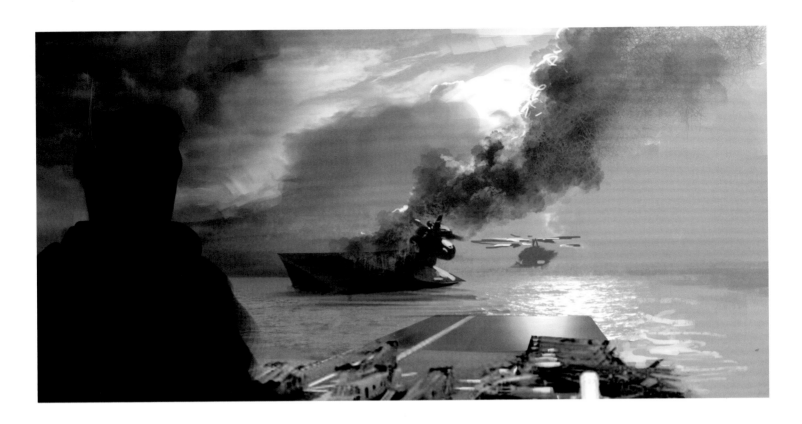

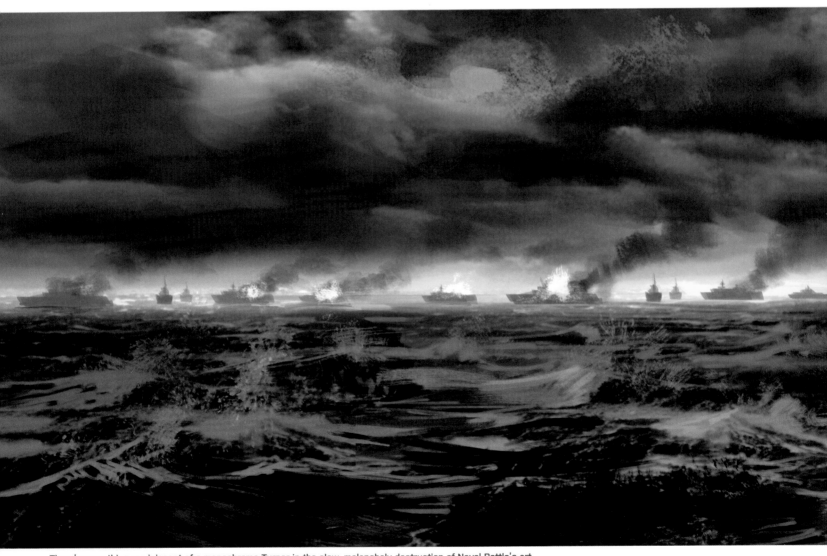

There's something reminiscent of a monochrome Turner in the slow, melancholy destruction of Naval Battle's art.

SPEC ▶

As Shanghai smolders in the distance, Recker and crew move out to liaise with the USS Titan and the 7th Carrier group in the Southwest China sea. Were it so easy: the carrier's been sunk, leaving you to pick through the wreckage to piece together its final moments, and to uncover a series of potentially catastrophic events. The Chinese sunk the ship, and are eager to do the same to the vessel that carried you here, setting up an almighty battle amidst violent waves.

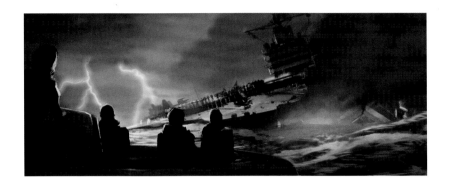

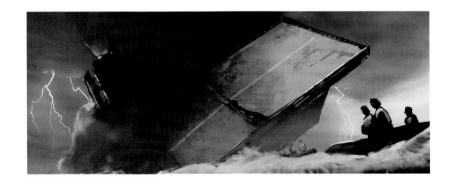

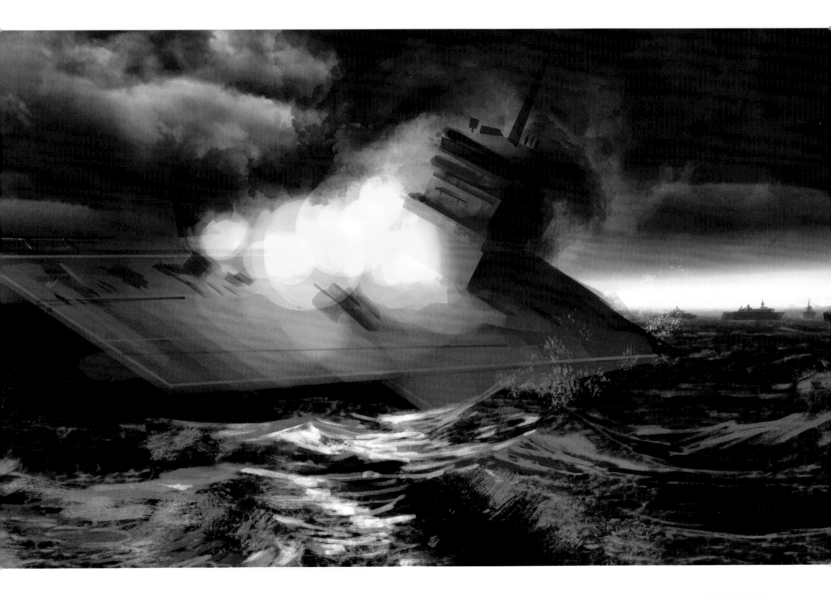

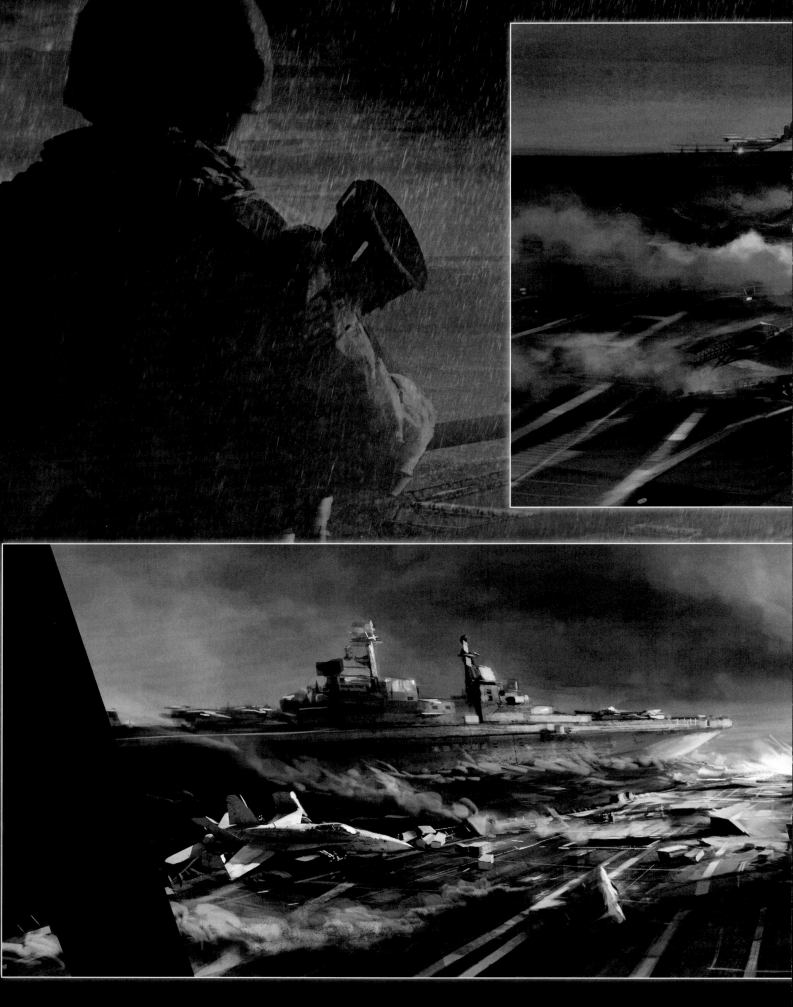

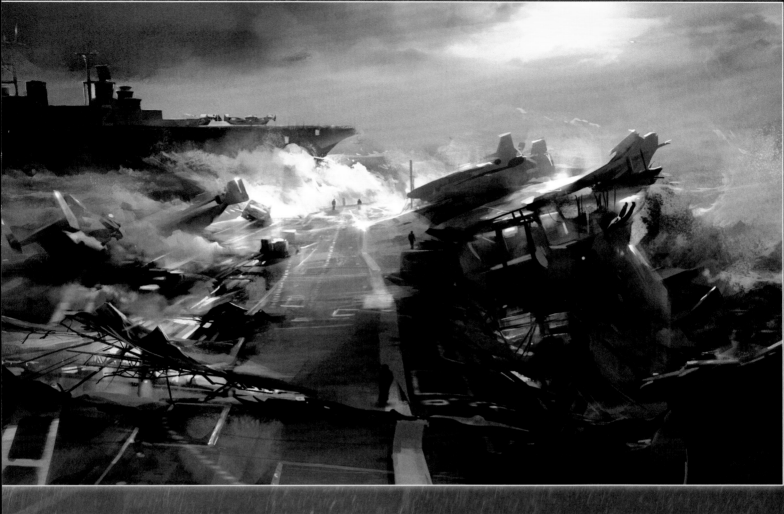

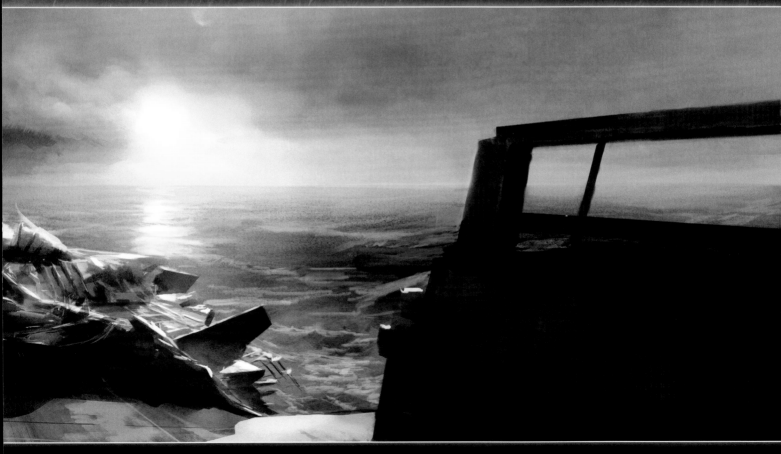

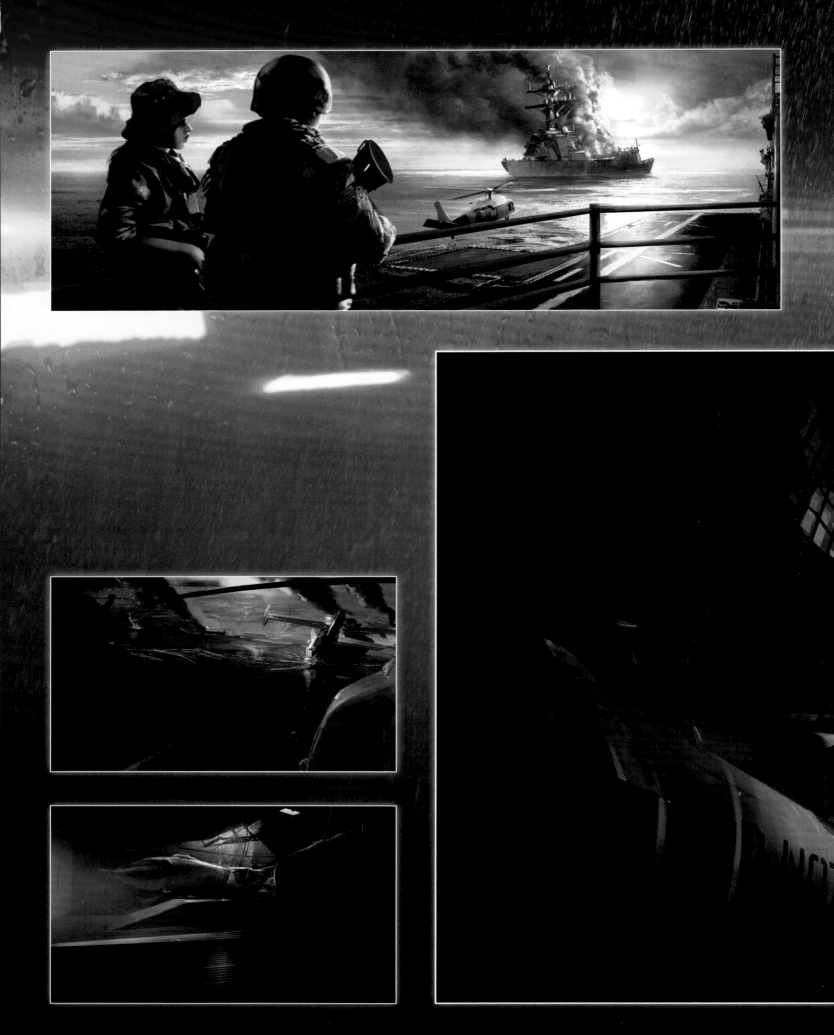

"It's pretty easy to paint a picture of awe-inspiring naval battles, but it's much harder to implement that in terms of water physics in this fully dynamic world," reveals Sammelin. "One of the early concepts we made was the storming of a naval carrier with loads of rockets flying about and it's still the goal image. I think we nailed that pretty well. It's a collaborative process between tech and art that we can riff off each other in what we can and can't do. But at this point it feels like there's nothing you really can't do - it's just finding a way to do it."

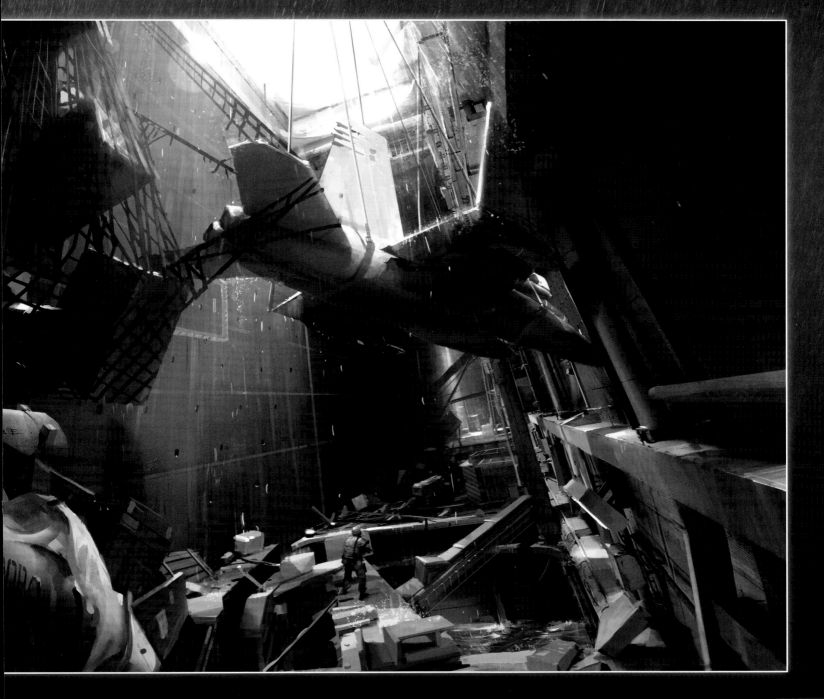

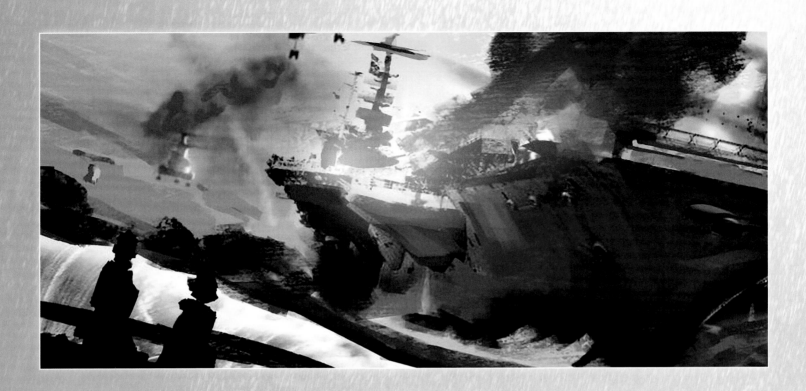

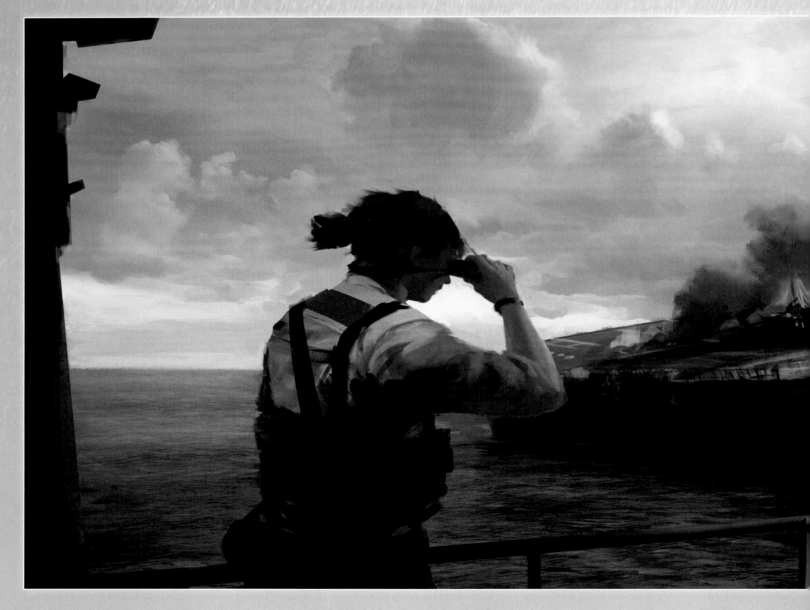

SPEC ▶ Environmental destruction has been a dream that *Battlefield's* been edging towards with each new instalment, and with Naval Battle it's fully realized. Entire walkways capsize, holes are torn in hulking hulls and the player must work their way through the ongoing evolution brought about by shellfire and warfare. It started small, with the slow chipping away of walls in the first *Bad Company*, but in *Battlefield 4* it's present on the most extreme of scales.

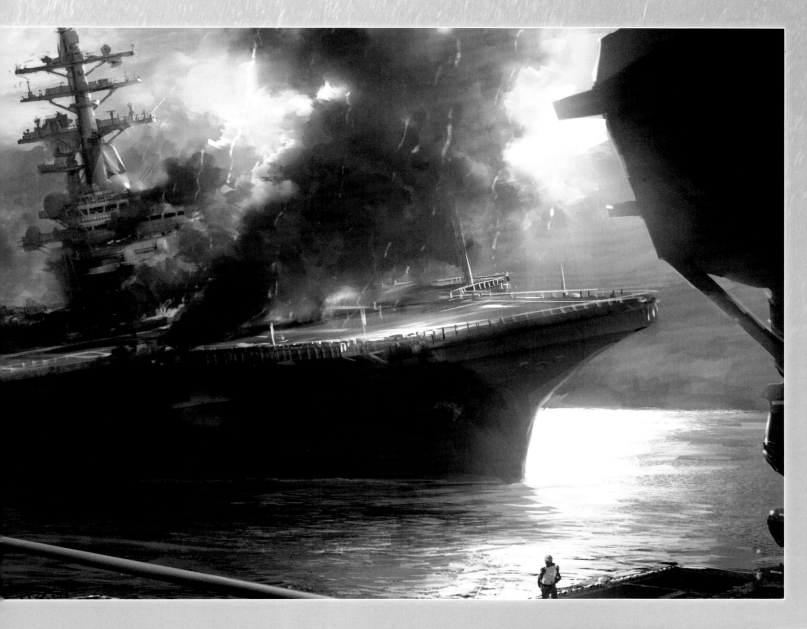

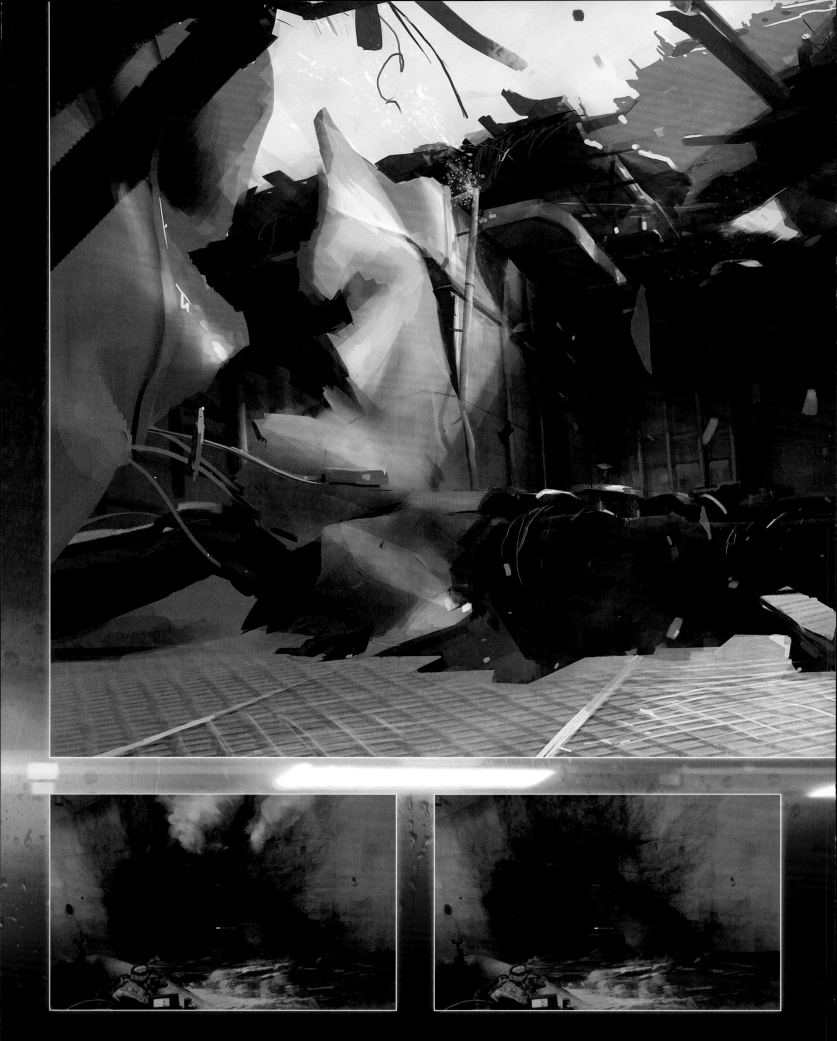

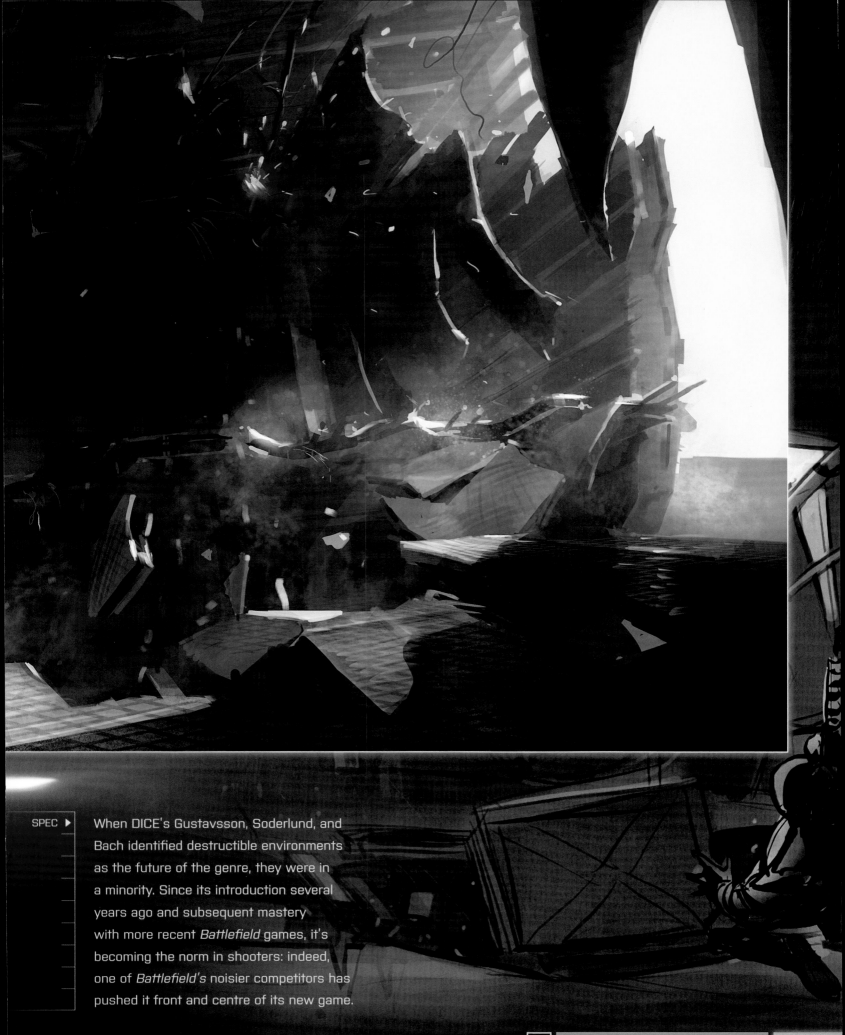

SPEC ▶ When DICE's Gustavsson, Soderlund, and Bach identified destructible environments as the future of the genre, they were in a minority. Since its introduction several years ago and subsequent mastery with more recent *Battlefield* games, it's becoming the norm in shooters: indeed, one of *Battlefield's* noisier competitors has pushed it front and centre of its new game.

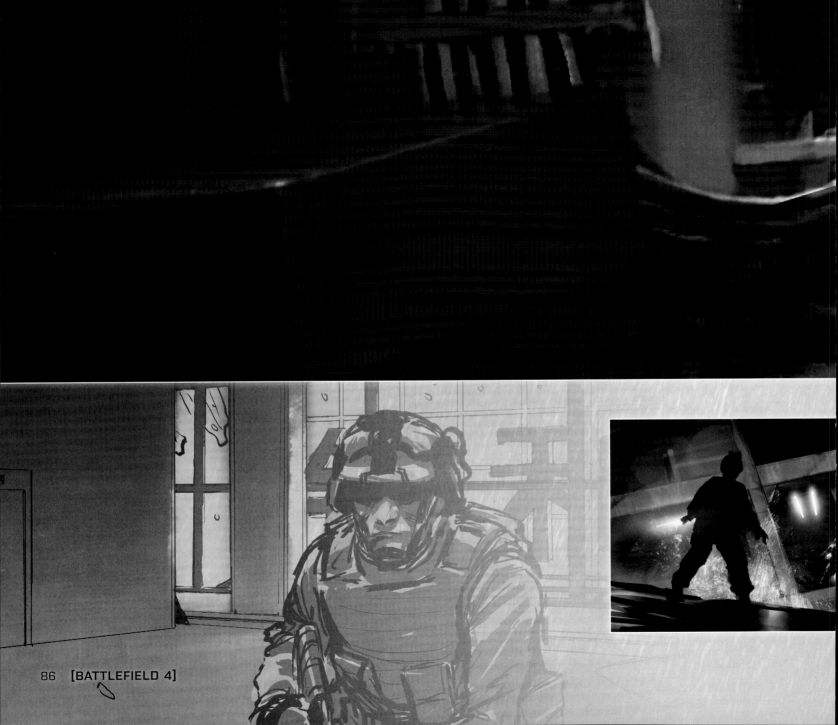

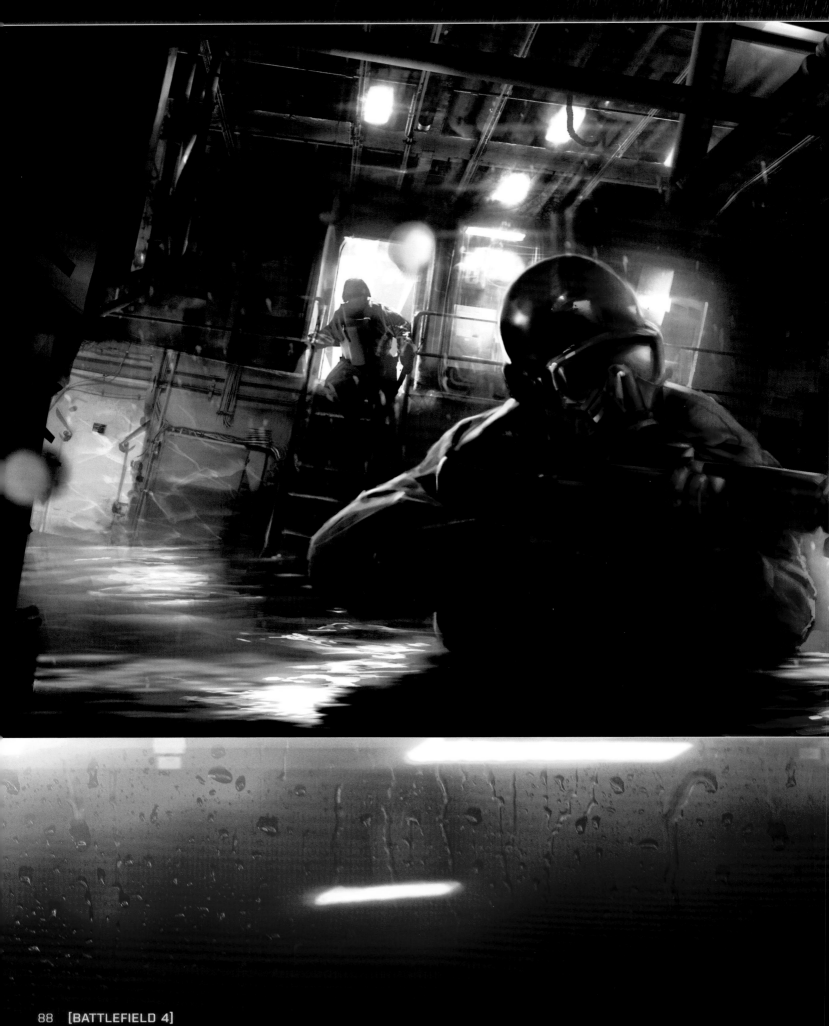

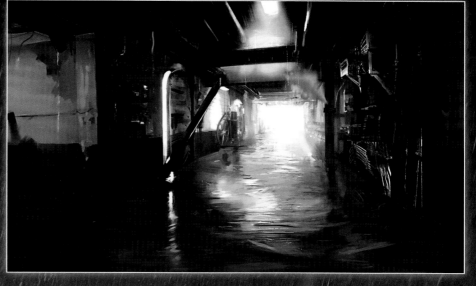

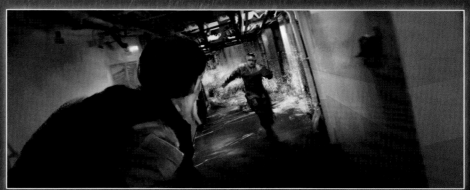

SPEC ▶

Naval Battle is one prominent example of how *Battlefield 4's* trying to up the ante from its predecessor, placing a personal story on a global stage and constantly trying to escalate the spectacle. "We've taken some bigger leaps this time around with more fantastic or awe inspiring stuff happening, whereas *Battlefield 3* was very much just a geopolitical thriller," says Sammelin. "In *Battlefield 4* it's much more of a personal story for the squad you're following around and a lot of cool stuff happens like dams exploding and whole buildings toppling over."

The carriers are shredded apart beyond recognition in Naval Battle, though in their pristine condition they're believable, well-researched places. Below decks there's a lived in quality to the quarters, and a real verity to details such as the pristine mess hall.

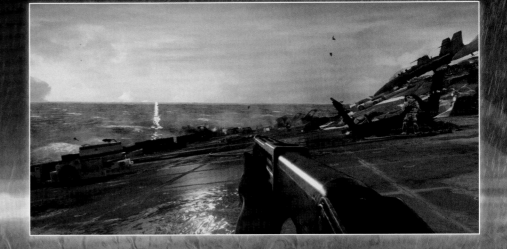

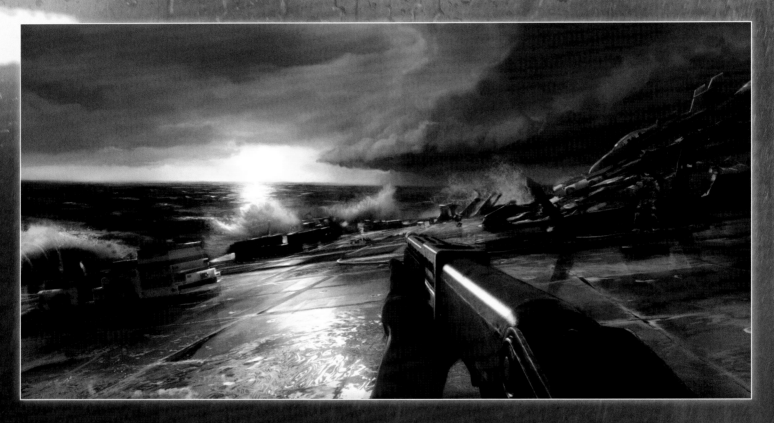

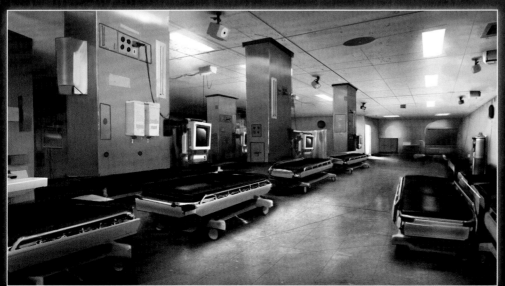

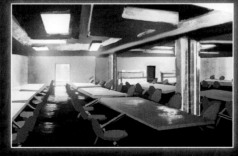

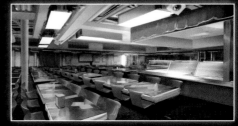

Visiting a carrier isn't the easiest thing to do in real life, so DICE's art team had to turn to the internet for inspiration. "We found a lot of references online," says Sammelin, "we couldn't really visit one - they're kind of secret in that sense - but there was some publically available ones. We had to make some stuff up, but we also had a lot of reference from movies. It's kind of a mix."

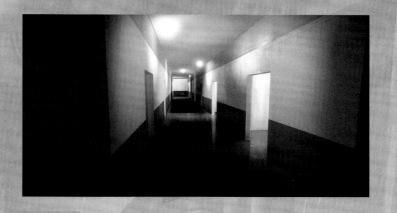

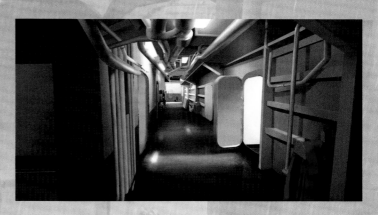

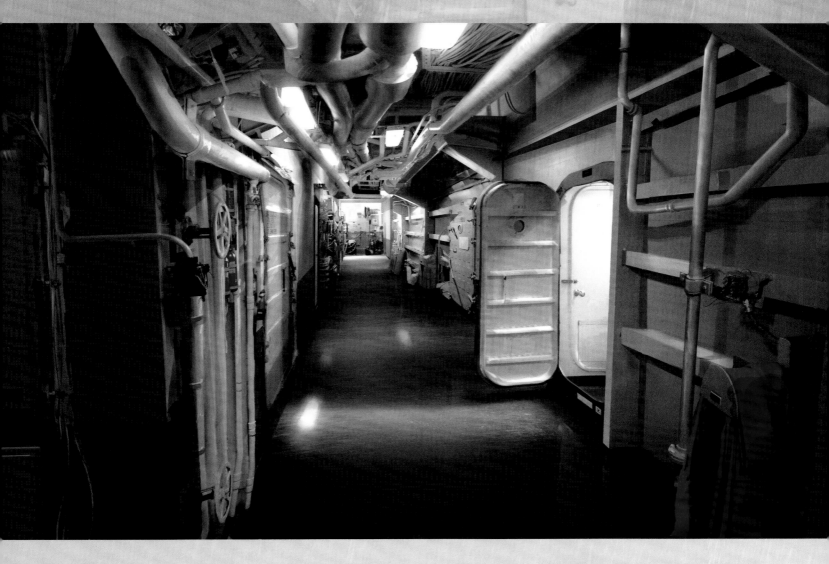

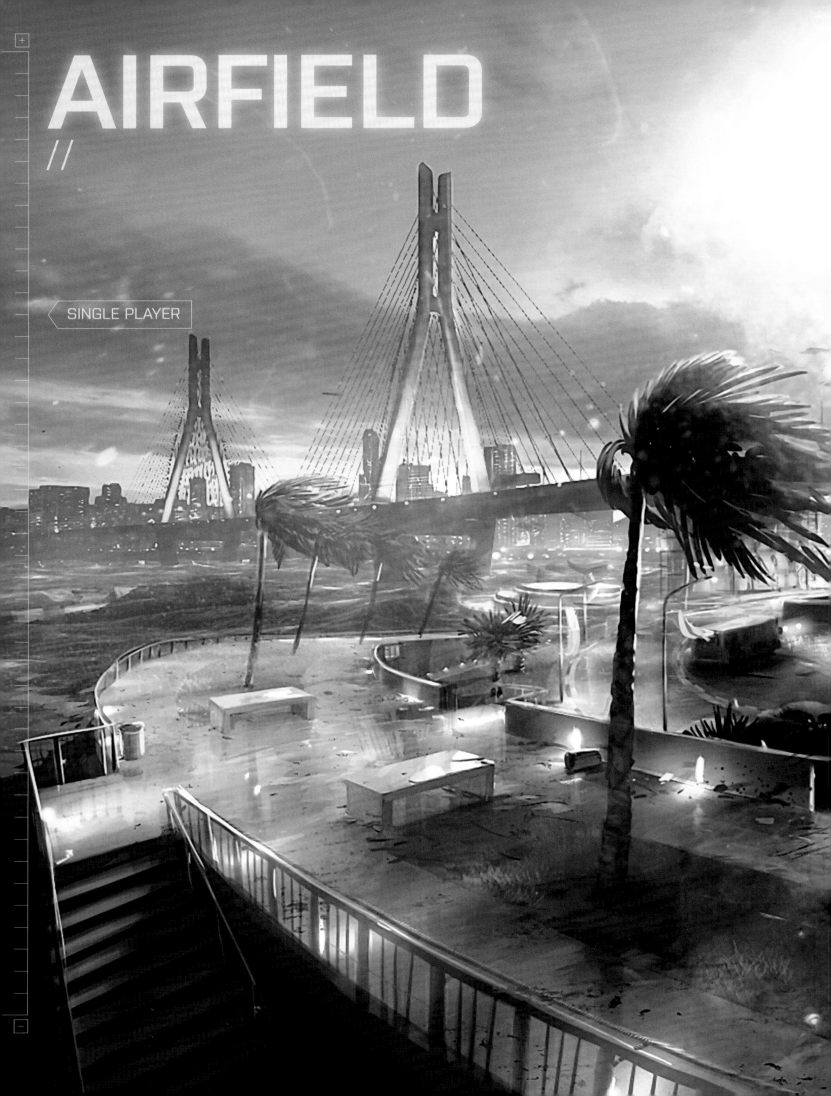

AIRFIELD

SINGLE PLAYER

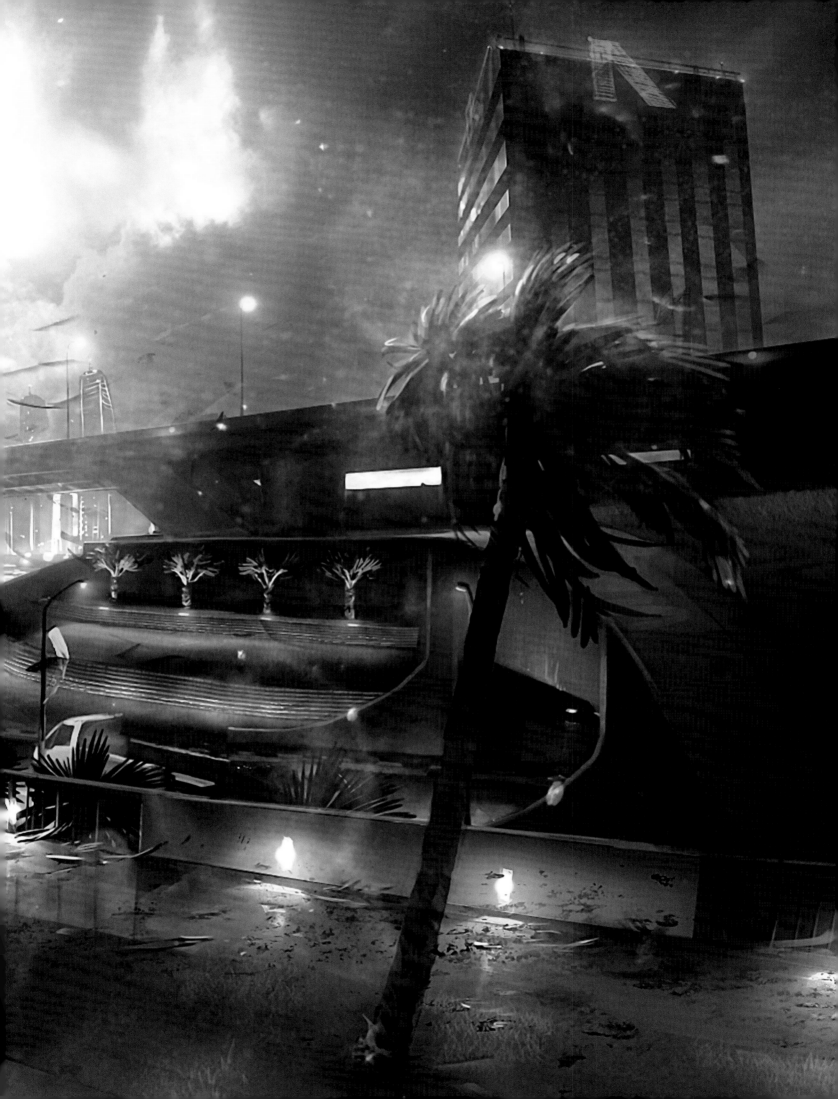

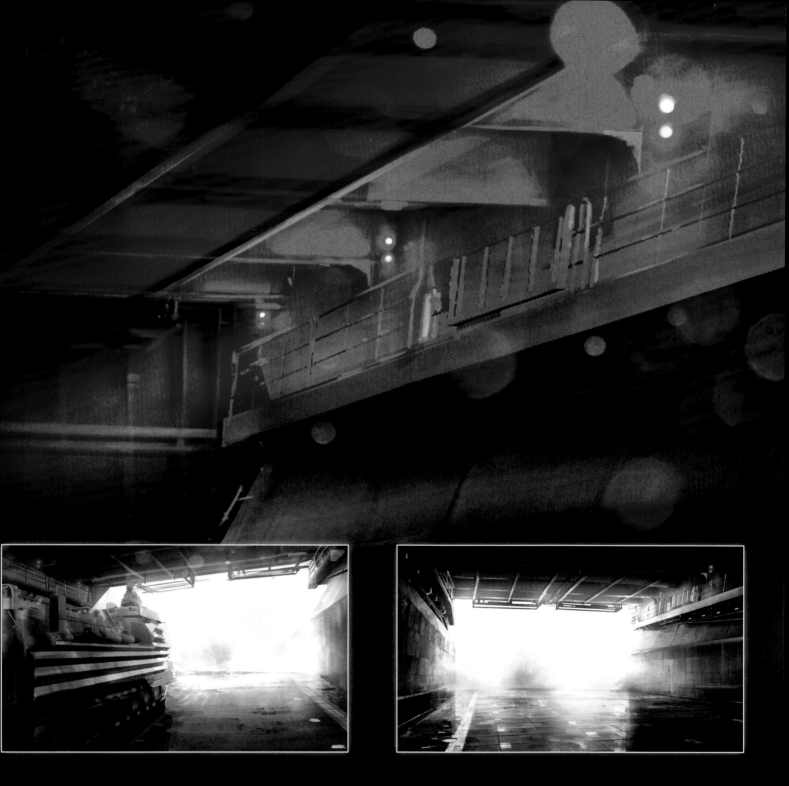

SPEC ▶

Hanna, the VIP rescued on the streets of Shanghai, joins the crew as they launch an attack on an airfield in Singapore. There's no small amount of suspicion from your squad mates as she fights by your side, though her skills come in handy throughout the series of skirmishes. But something doesn't seem quite right - were your colleagues right about her all along?

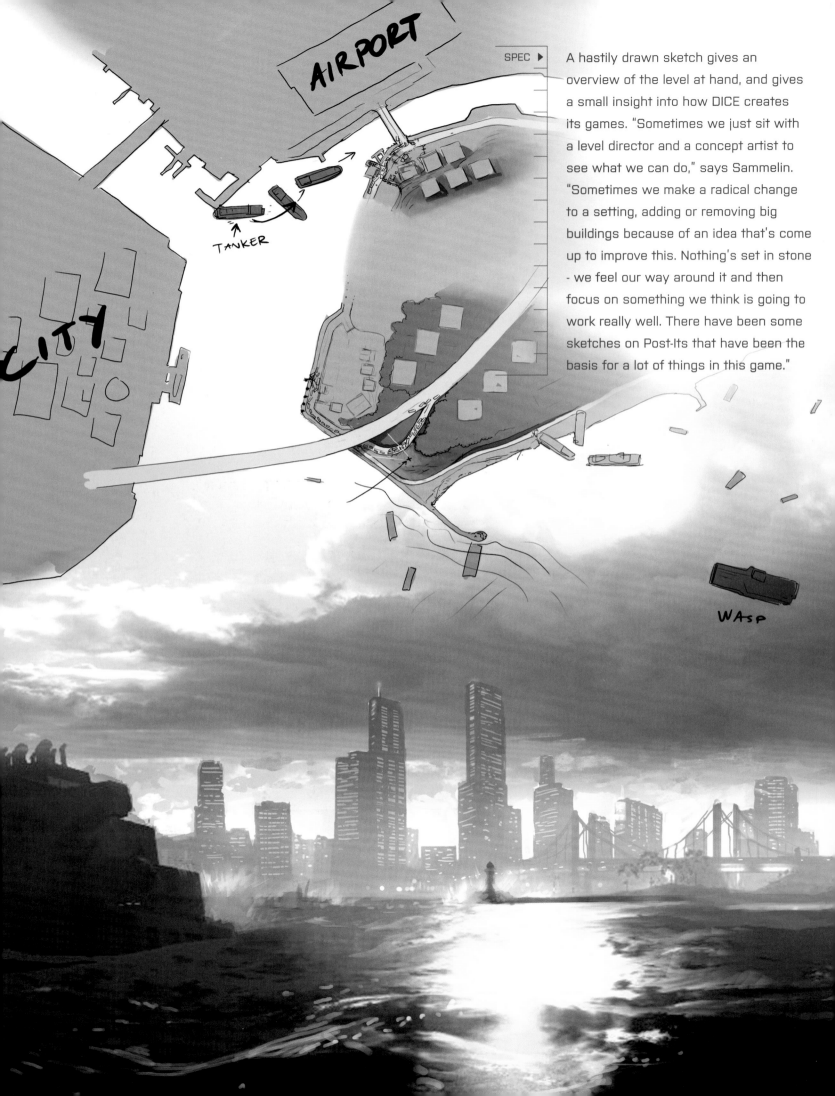

AIRPORT

TANKER

CITY

WASP

SPEC ▶

A hastily drawn sketch gives an overview of the level at hand, and gives a small insight into how DICE creates its games. "Sometimes we just sit with a level director and a concept artist to see what we can do," says Sammelin. "Sometimes we make a radical change to a setting, adding or removing big buildings because of an idea that's come up to improve this. Nothing's set in stone - we feel our way around it and then focus on something we think is going to work really well. There have been some sketches on Post-Its that have been the basis for a lot of things in this game."

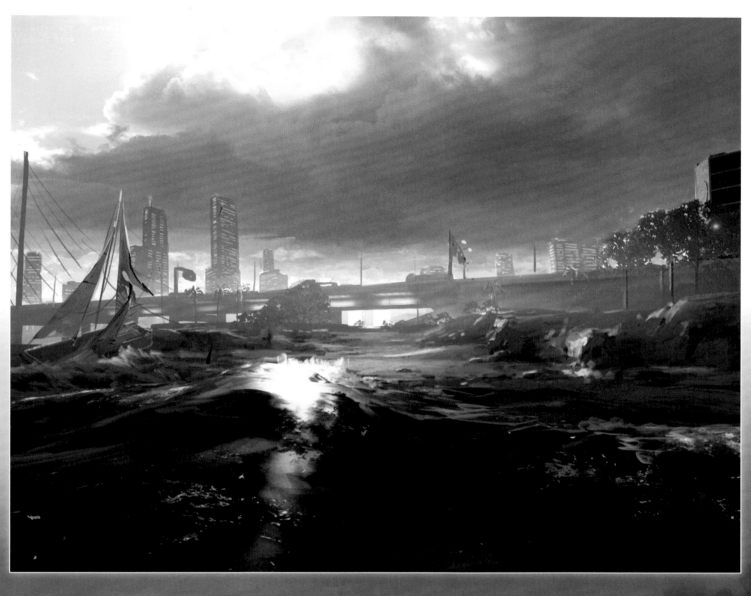
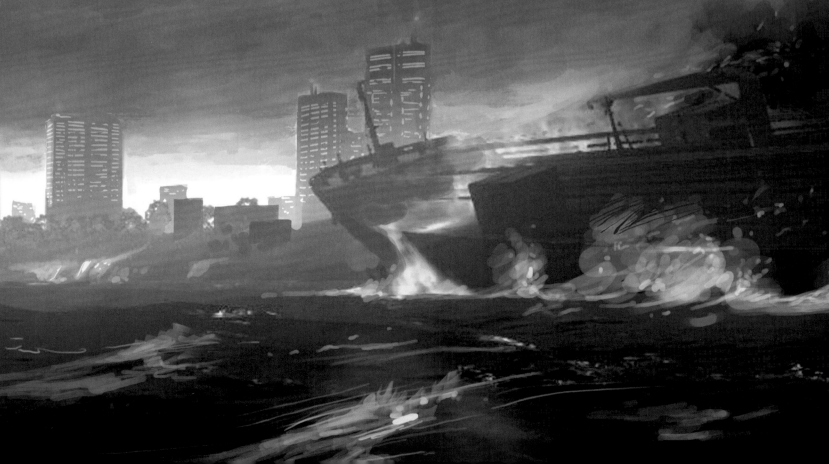

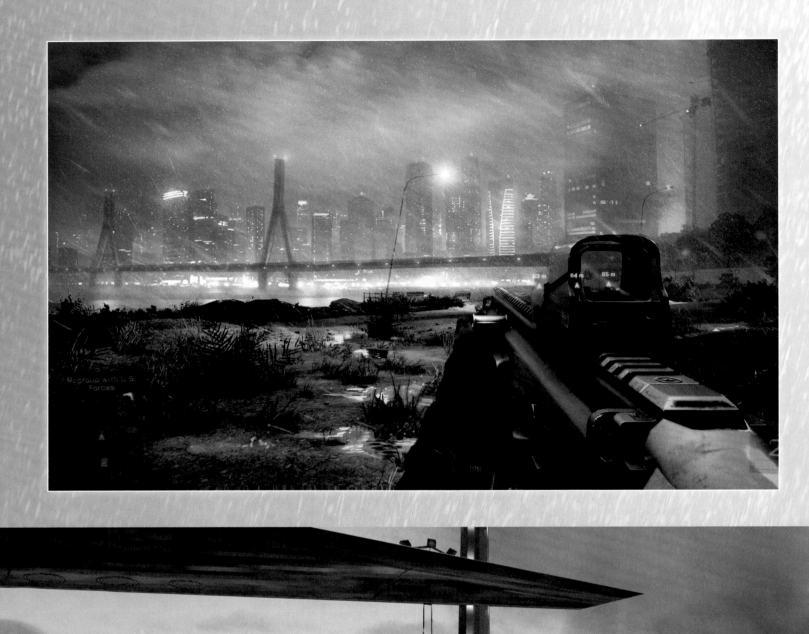

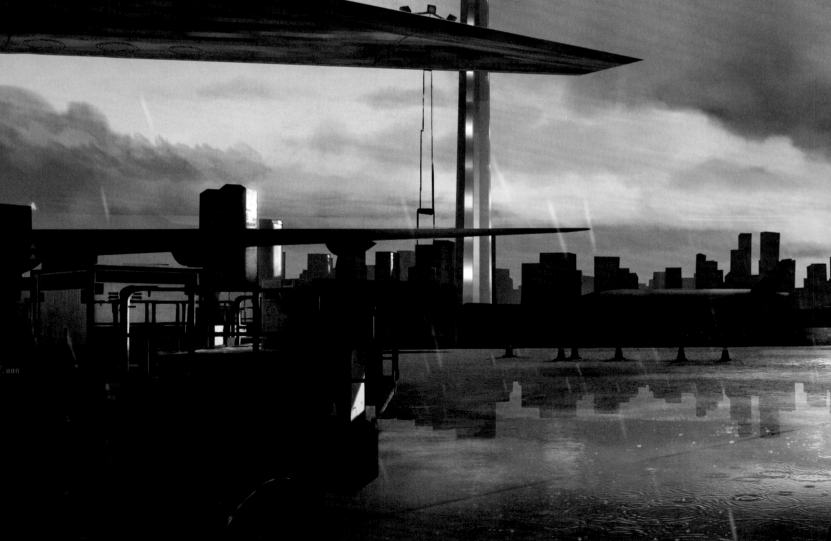

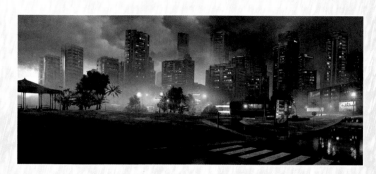
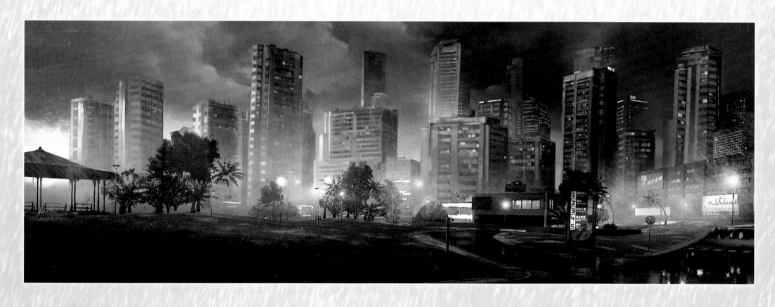
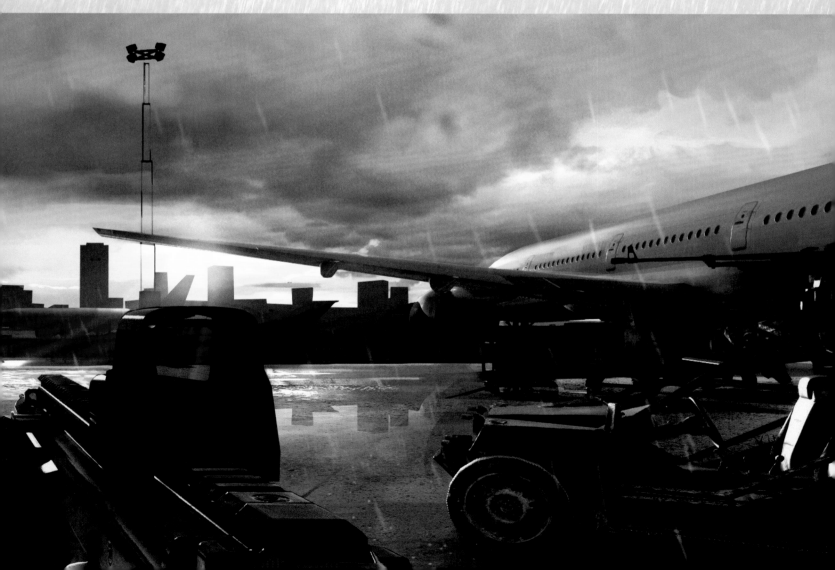

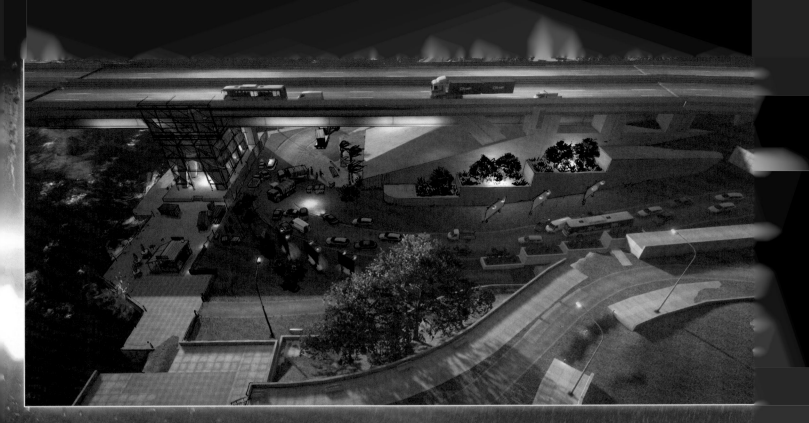

The single-player experience allows a certain amount of liberty to the developers and artists - they're not bound to any one location, and can move buildings in or out of shot at will, as well as introduce whole new elements into the landscape. An innocuous underpass can be imbued with no small amount of drama, moodily underlit while the silhouette of the cityscape hangs underneath.

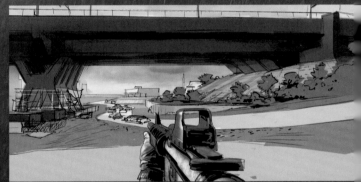

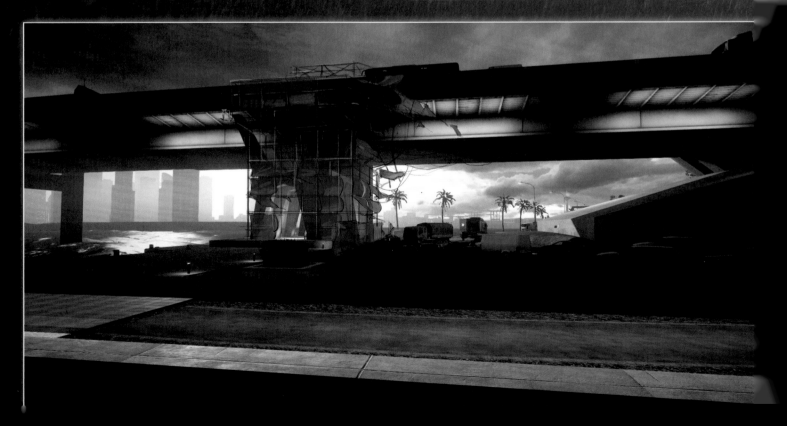

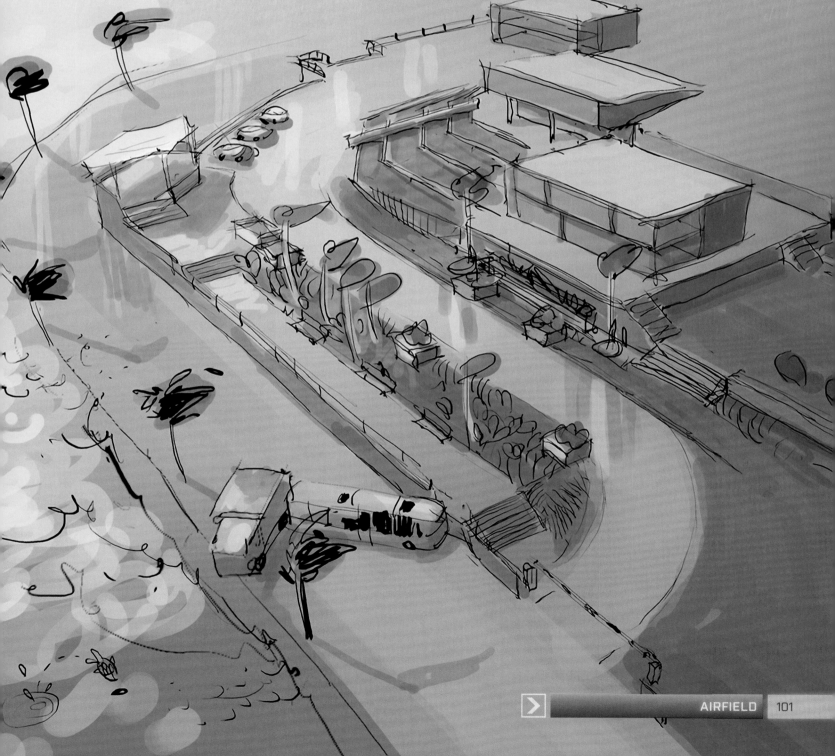

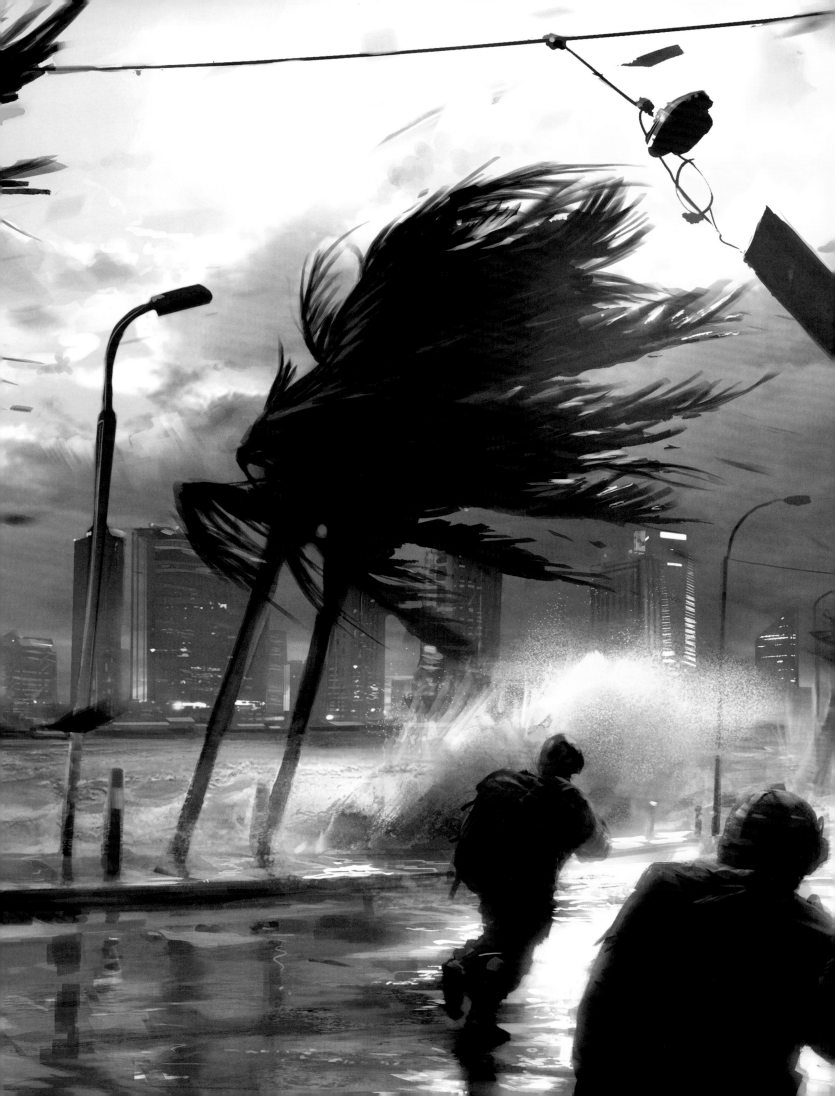

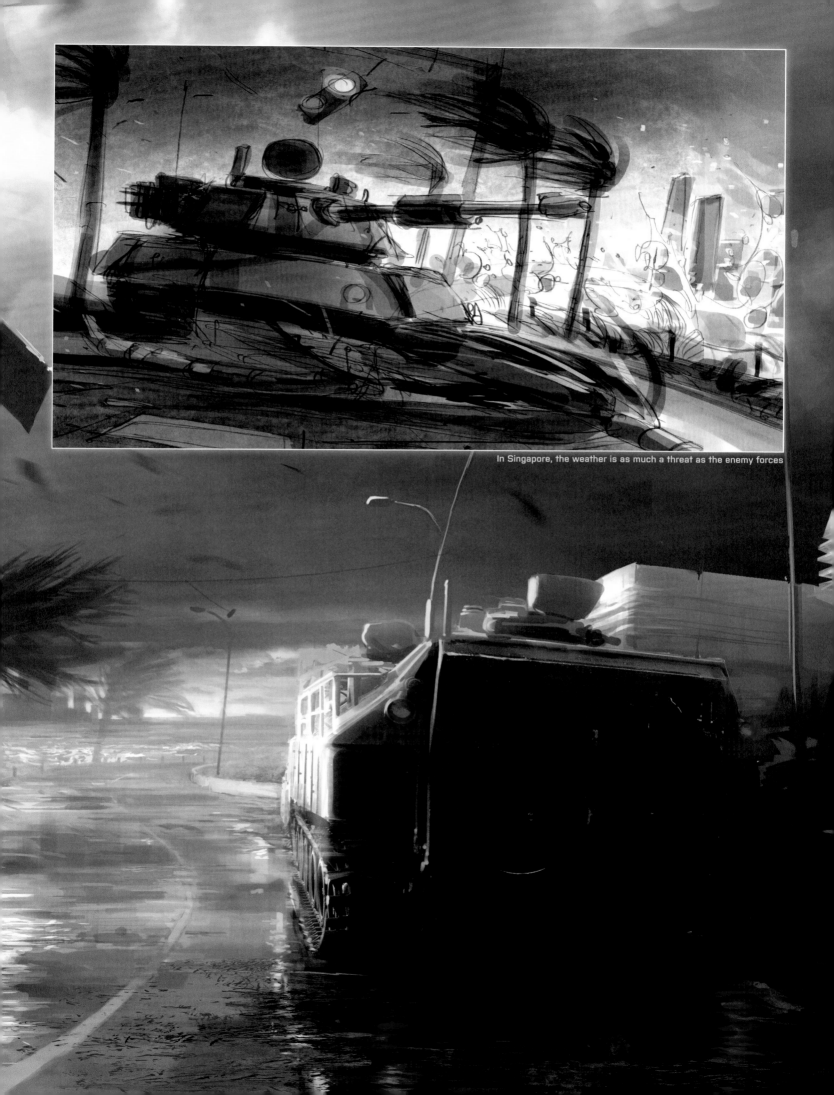

In Singapore, the weather is as much a threat as the enemy forces

"One of the central ideas of the art direction behind the game is a dramatic, almost violent world," says Sammelin. "The elements are against you which is something we've contributed to most levels. We go over and paint dramatic skies to make them match the concept. With these storms, the feeling of danger or despair is reflected in the environment, in the sky and the elements."

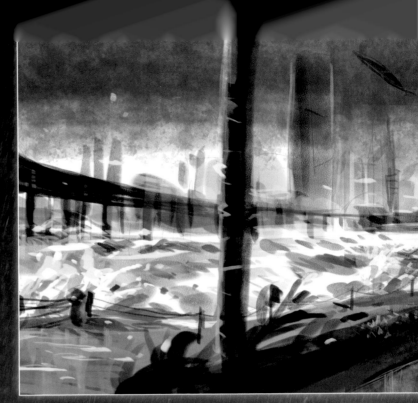

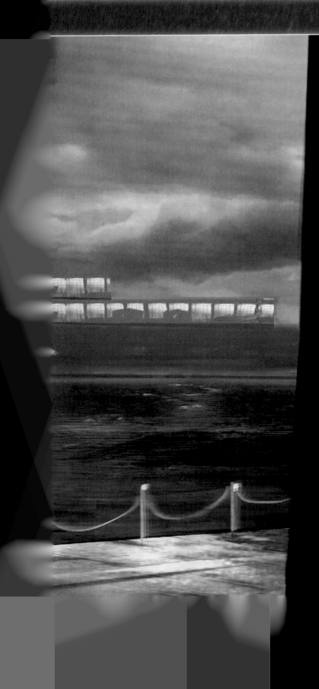

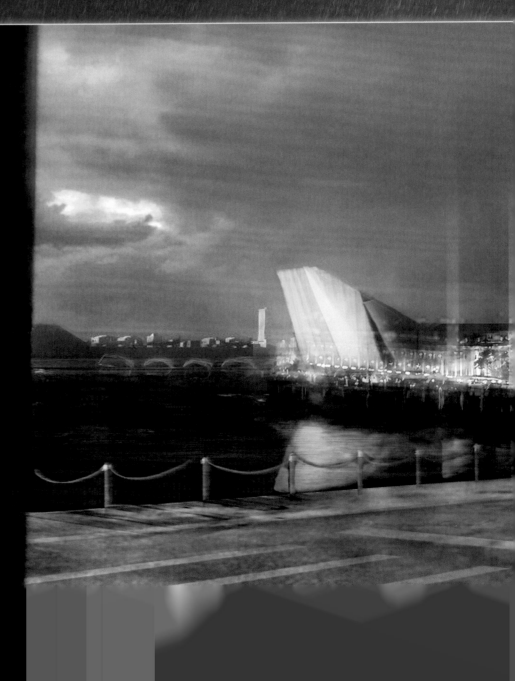

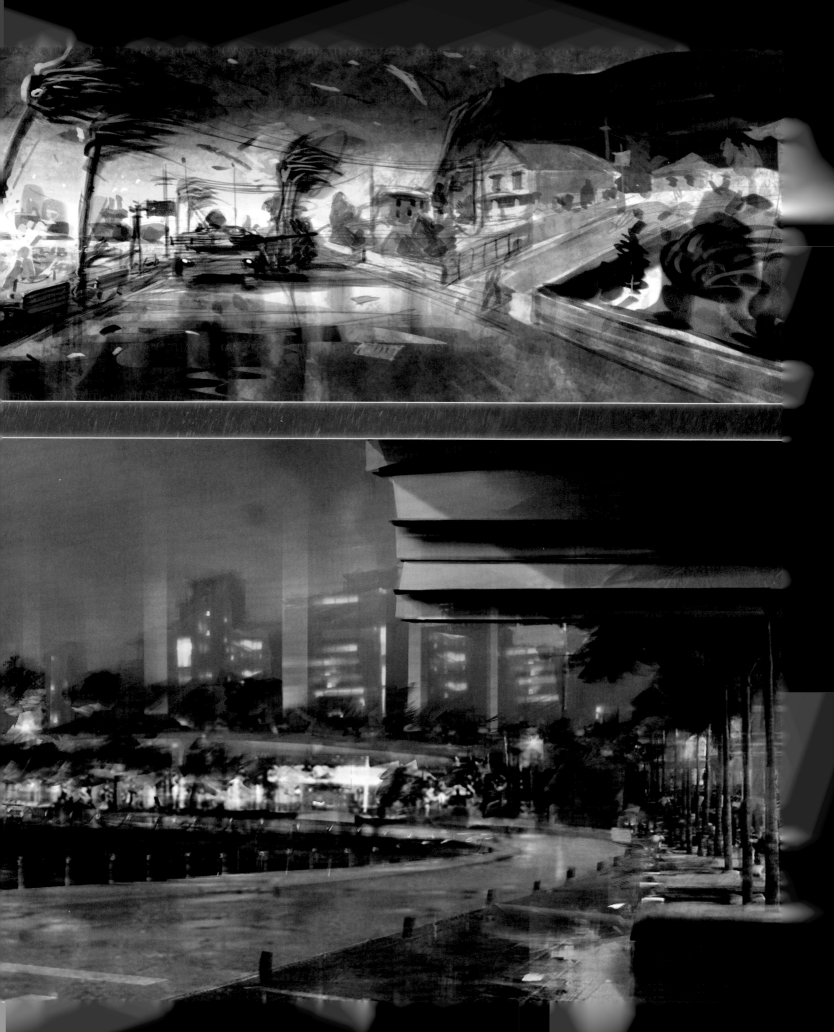

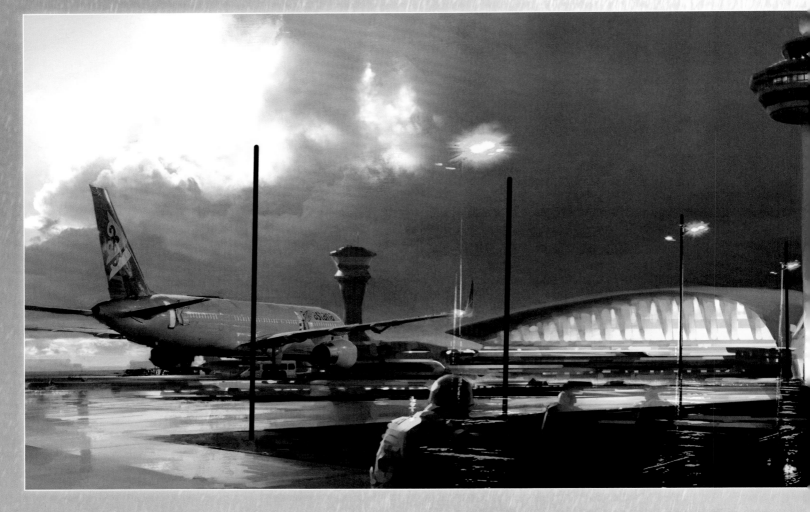

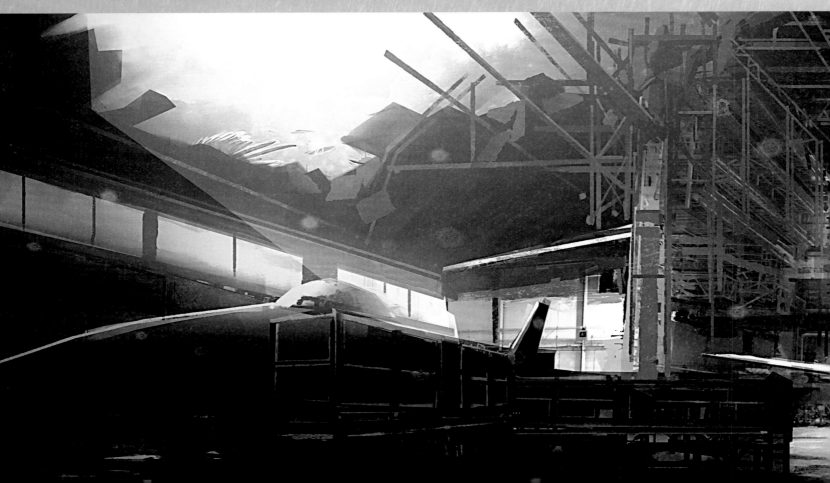

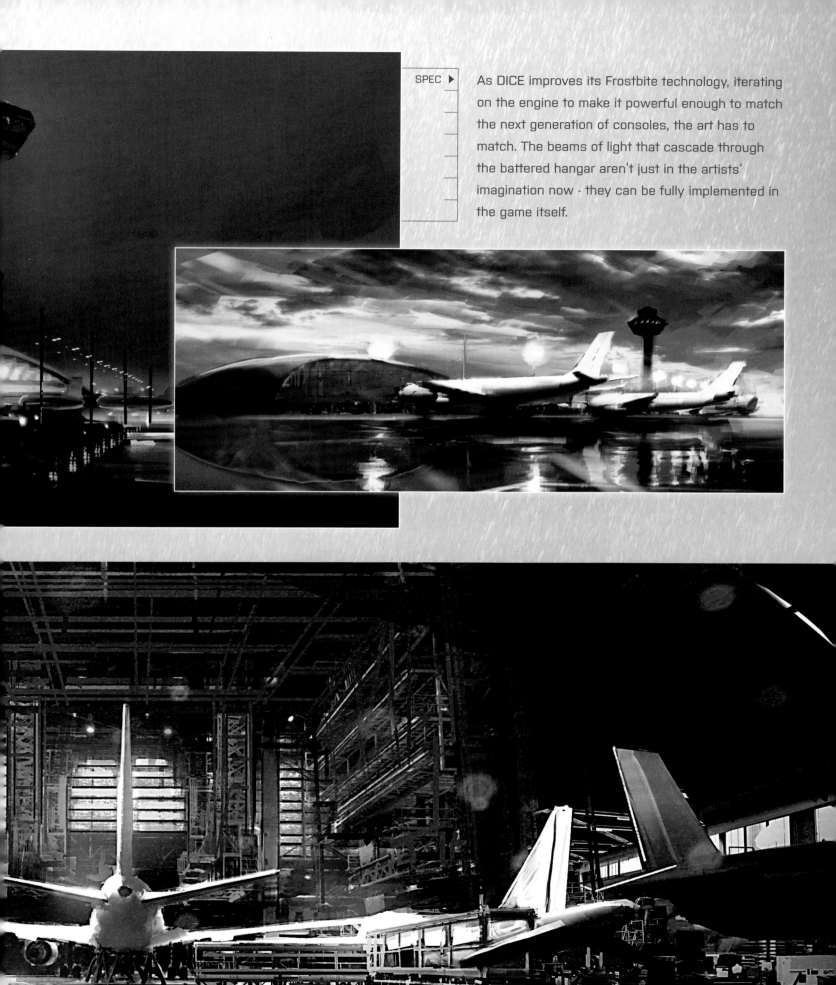

SPEC ▶

As DICE improves its Frostbite technology, iterating on the engine to make it powerful enough to match the next generation of consoles, the art has to match. The beams of light that cascade through the battered hangar aren't just in the artists' imagination now - they can be fully implemented in the game itself.

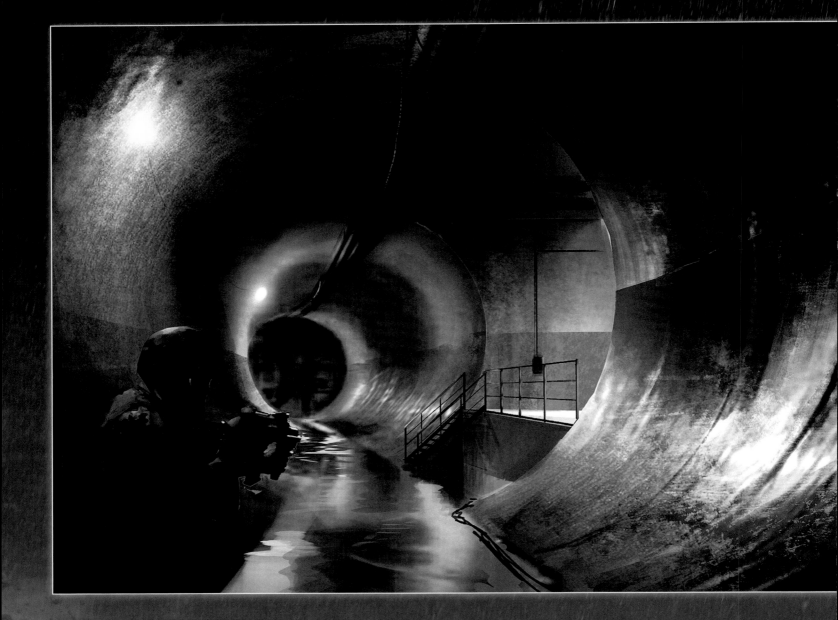

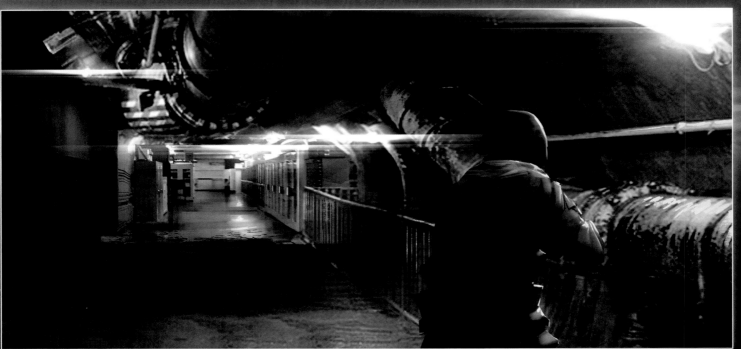

Light flickers across the camera - an effect mimicked by the game's light distortion techniques.

SPEC ▶

The climax of the Airfield section of *Battlefield 4* sees a set-piece pulled from many a Hollywood blockbuster, most notably *Die Hard 2*. It's that kind of gung ho action that informs DICE, rather than aiming for any kind of military accuracy.

"It's more interesting for the player and also personally, I think it's a wise choice to distance the game from the real world because to be honest that's not something that you'd want to play. It's a real war situation but we really want to have this movie realism to it, to have it feel really realistic and awe-inspiring. But it's far from real life and most of the locales are completely changed or subtly adjusted to fit the more appealing aspects of it," says Sammelin.

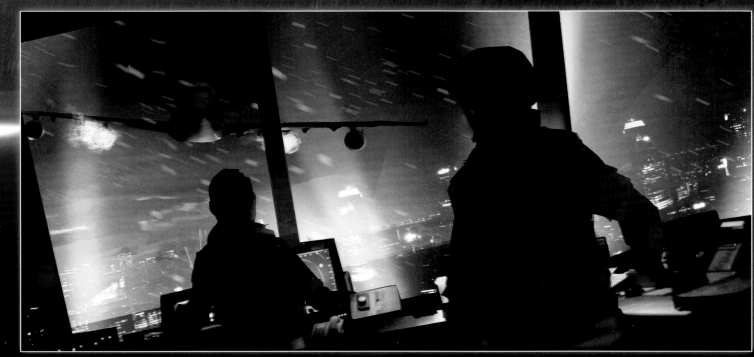

PRISON

SINGLE PLAYER

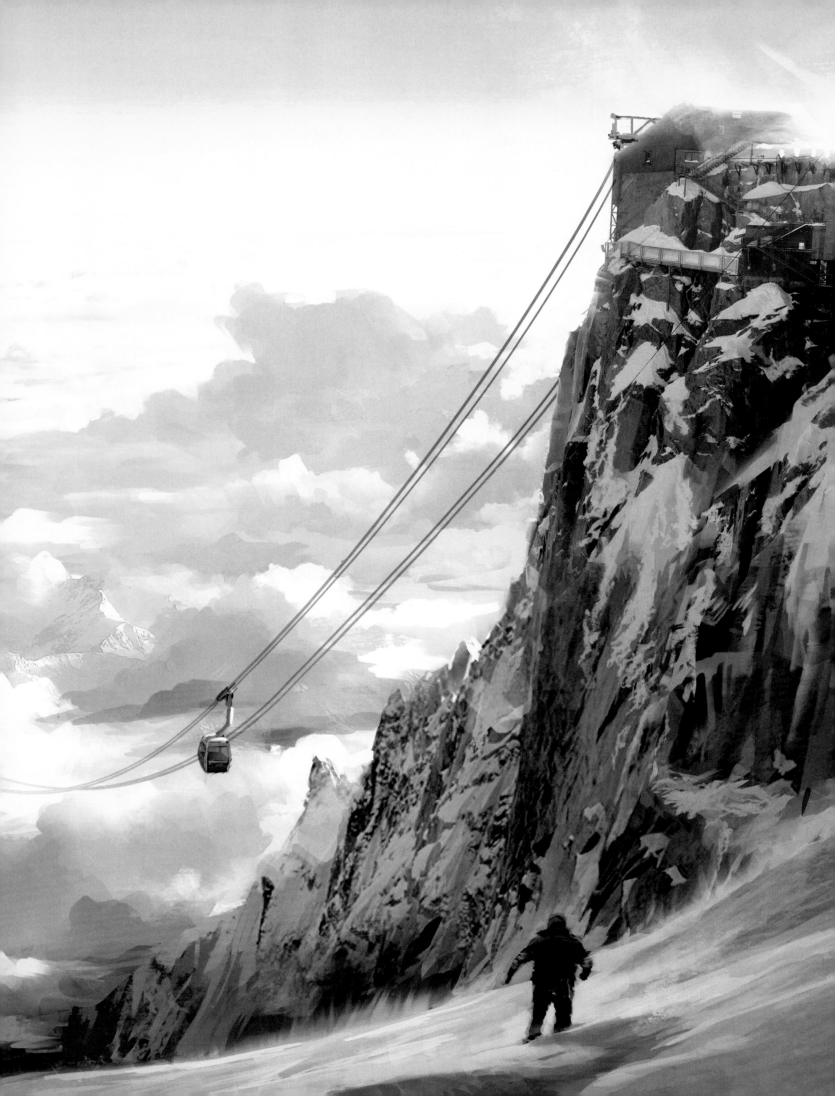

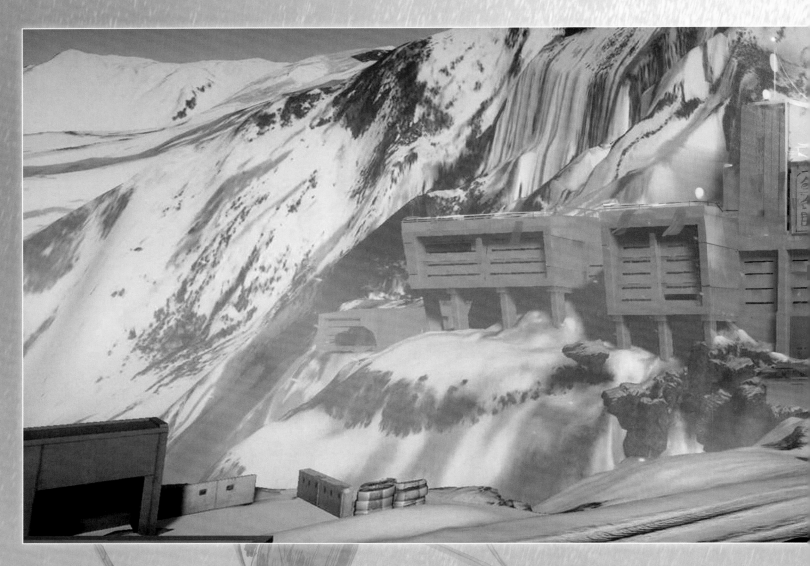

Following the urban swell of violence seen in Singapore and Shanghai, *Battlefield 4* makes a break for the hills. It's hardly a country break, though. After being betrayed, Recker finds himself in the belly of a brutal prison camp embedded in the hills of Tibet, the Russian-Chinese equivalent to Guantanamo Bay.

After the violence of previous chapters, there's a marked change in tone here

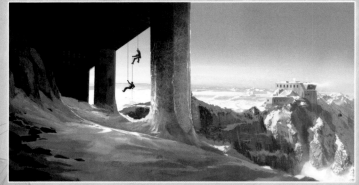

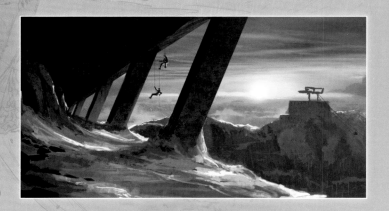

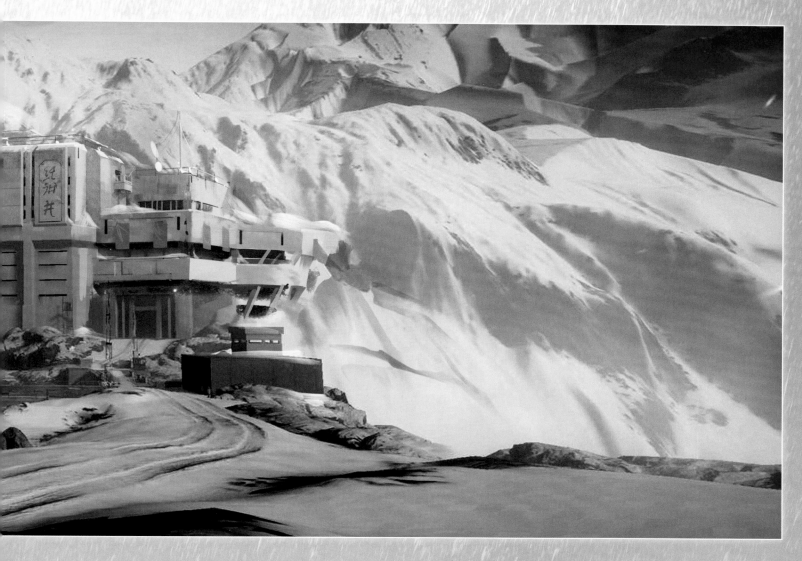

The environment itself, though, takes heavy inspiration from the real-life beauty of Tibet

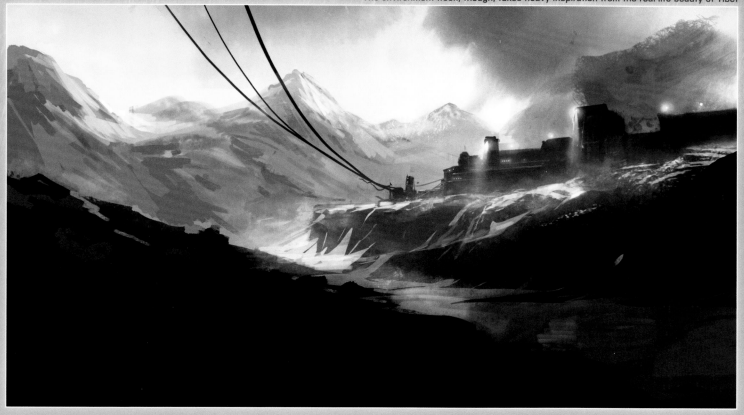

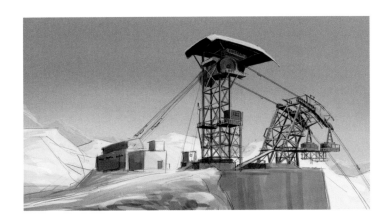

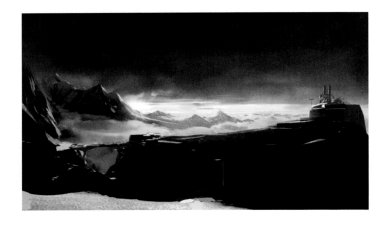

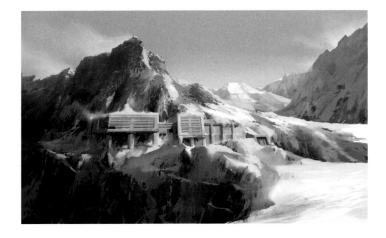

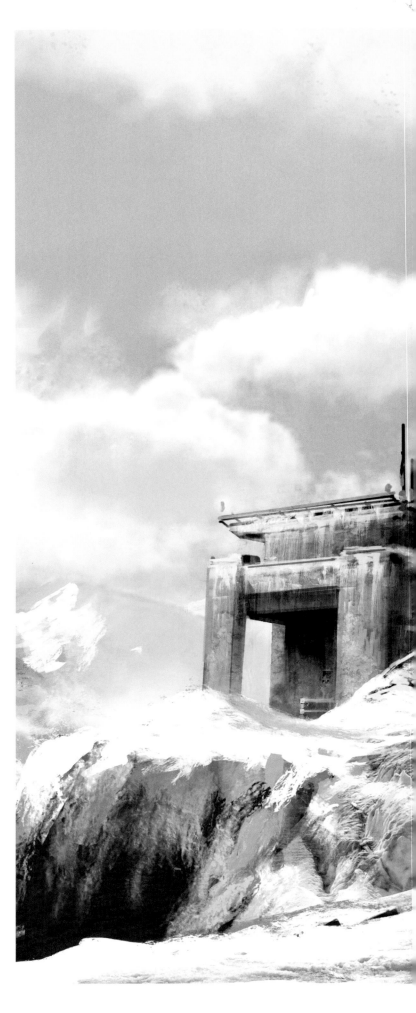

SPEC ▶ Within the prison Recker meets up with Dima Mayakovski, a Russian imprisoned since his involvement in the Paris nuclear bombing that proved pivotal in *Battlefield 3*. Old alliances are regained in the breakout, while those previously severed are patched up.

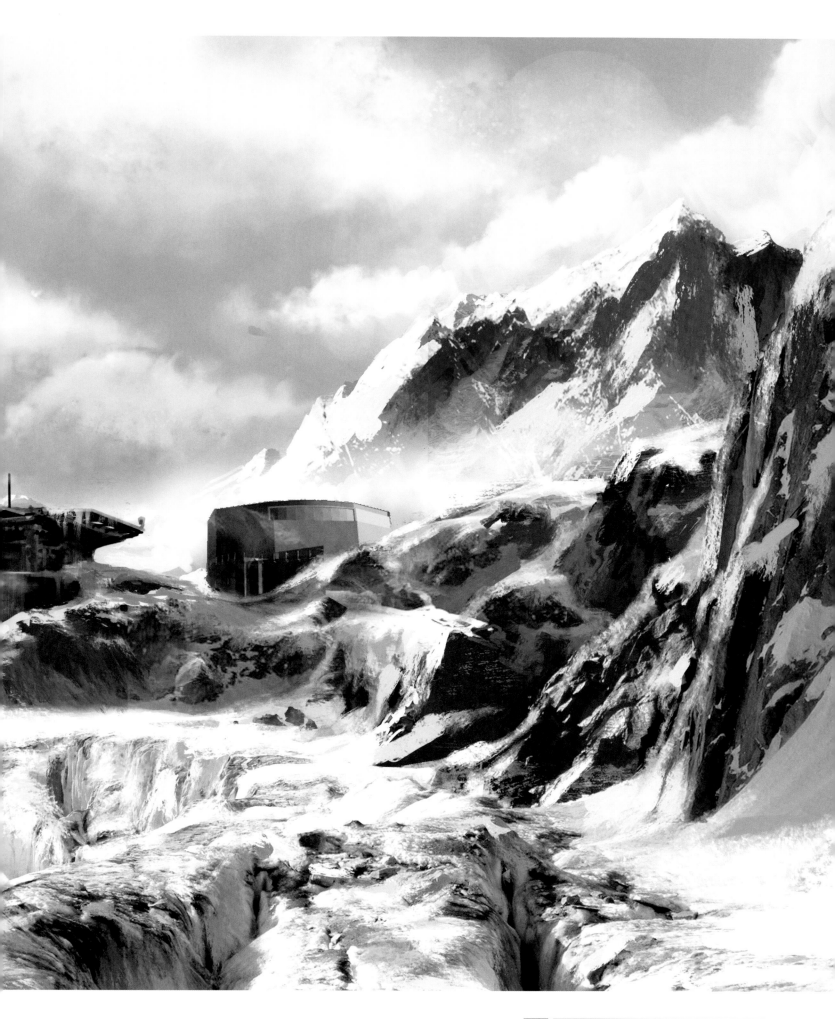

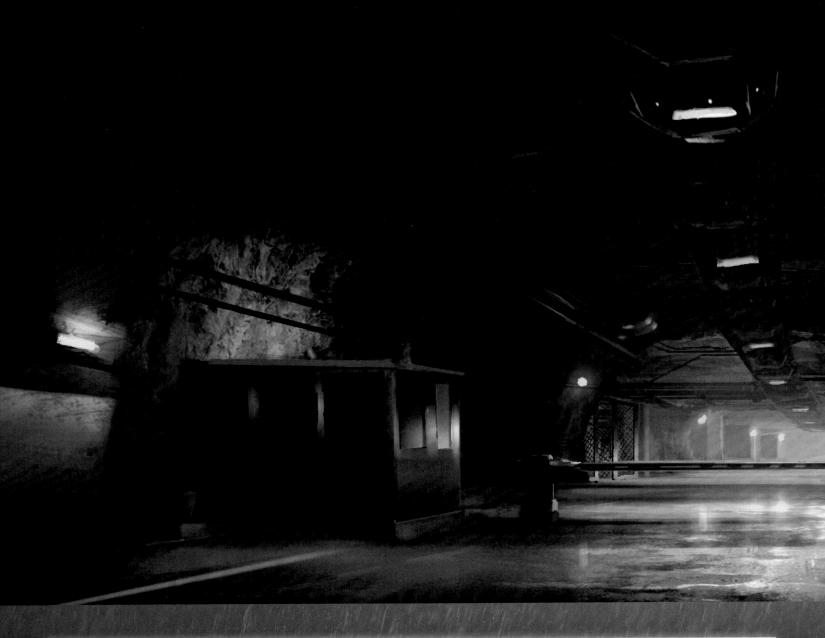

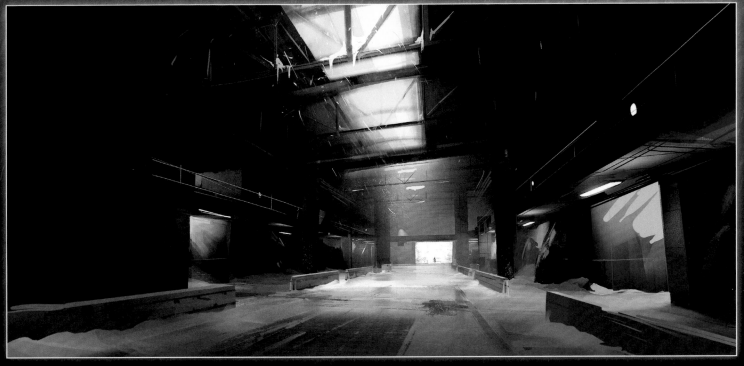

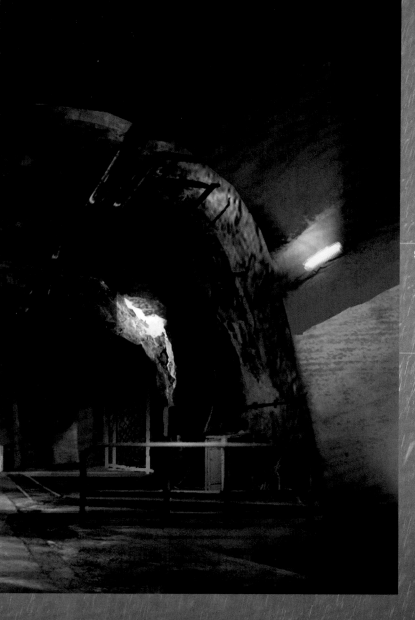

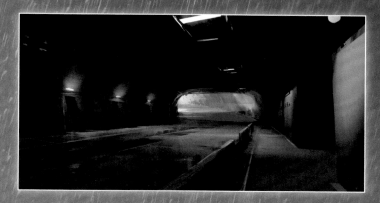

SPEC ▶ Beneath the serene foothills of Tibet, the prison complex itself is a brutal, cold construct where Recker is viciously interrogated. It's a deliberate contrast, and one of many that courses through *Battlefield 4's* art design.

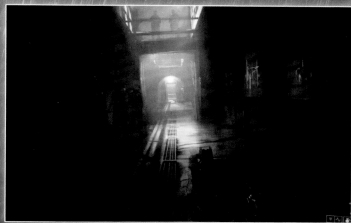

The tunnels are a first-person staple, lent life by some creative art direction

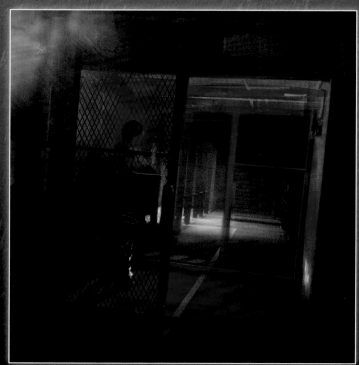

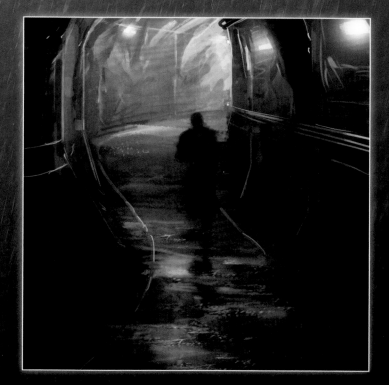

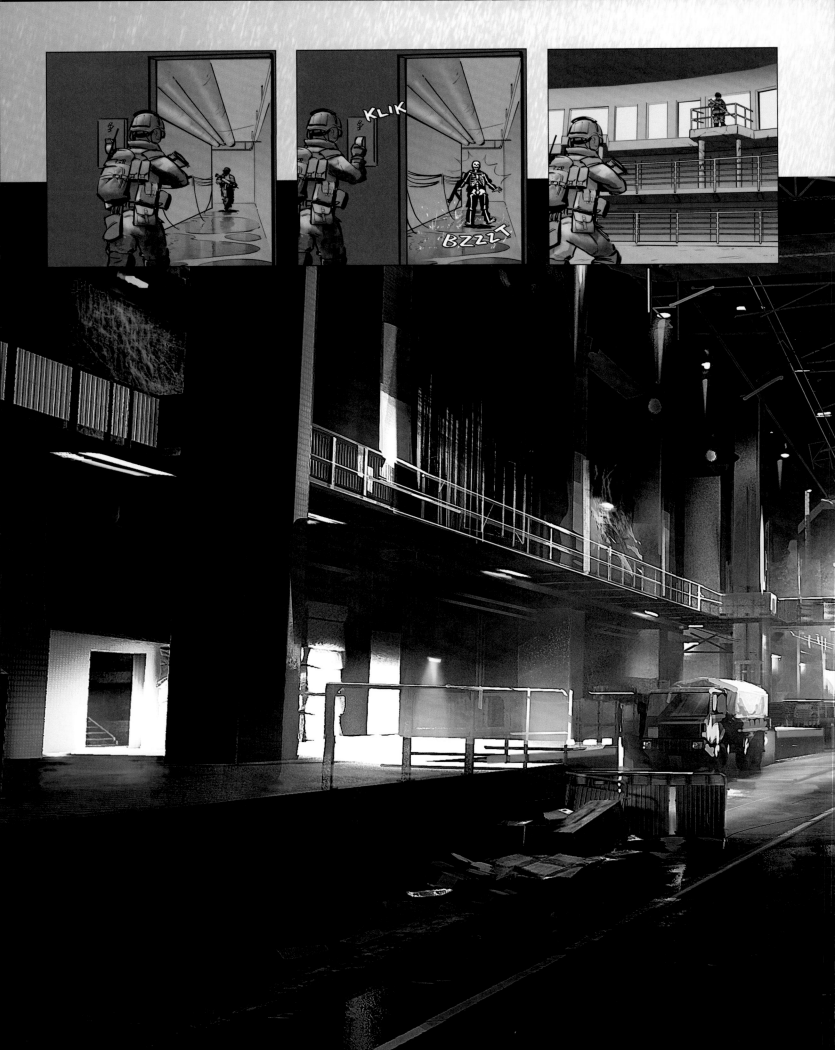

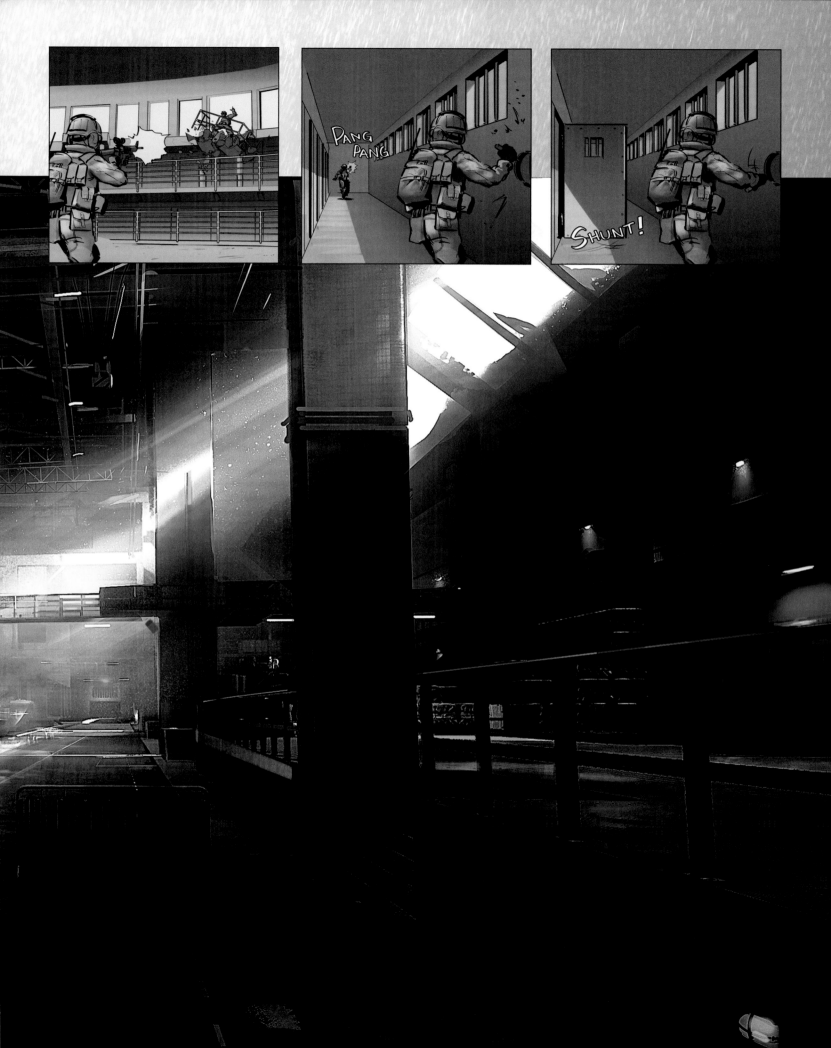

SPEC ▶

"We really wanted to push the contrast, to have some really violent situations like a totalitarian prison within really beautiful surroundings, and to have this beautiful storm in a city under siege," says Sammelin of the shifts in tone. "It's always this contrast of the beautiful with the ruined, or the downright gruesome at some points." The serenity of the prison's surrounds is soon shattered as Recker and Mayakovski make their escape, tearing through the compound with frightening force.

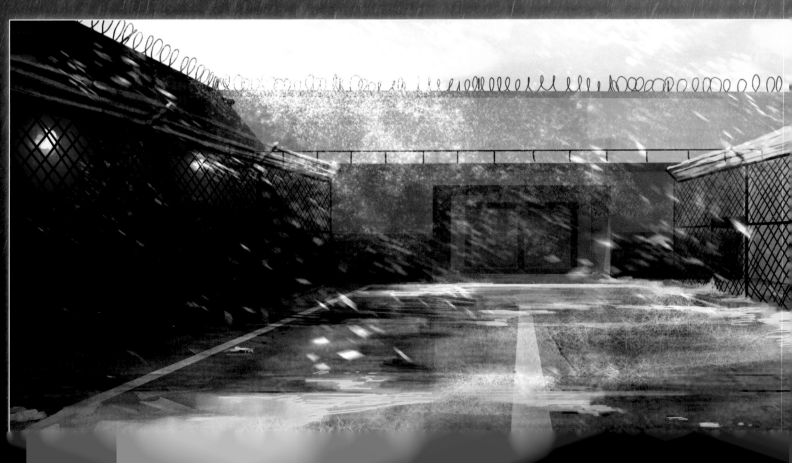

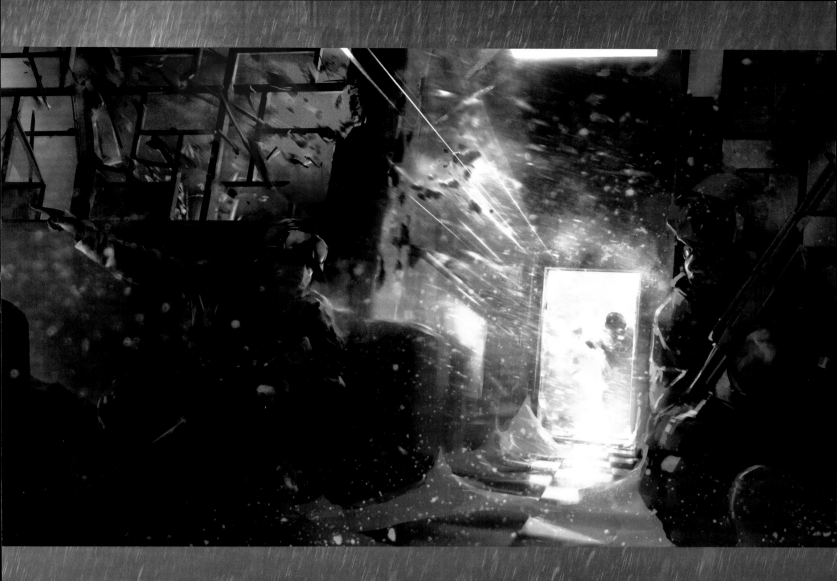

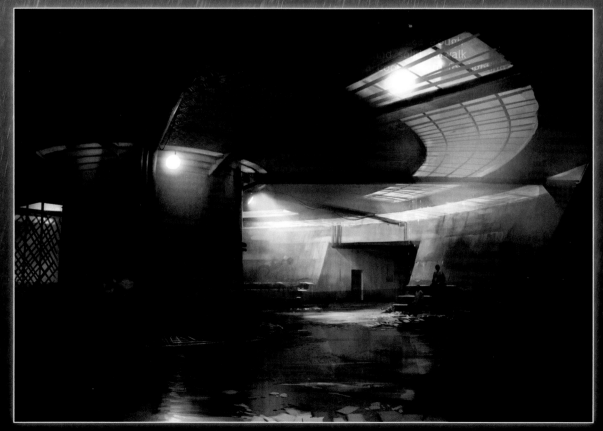

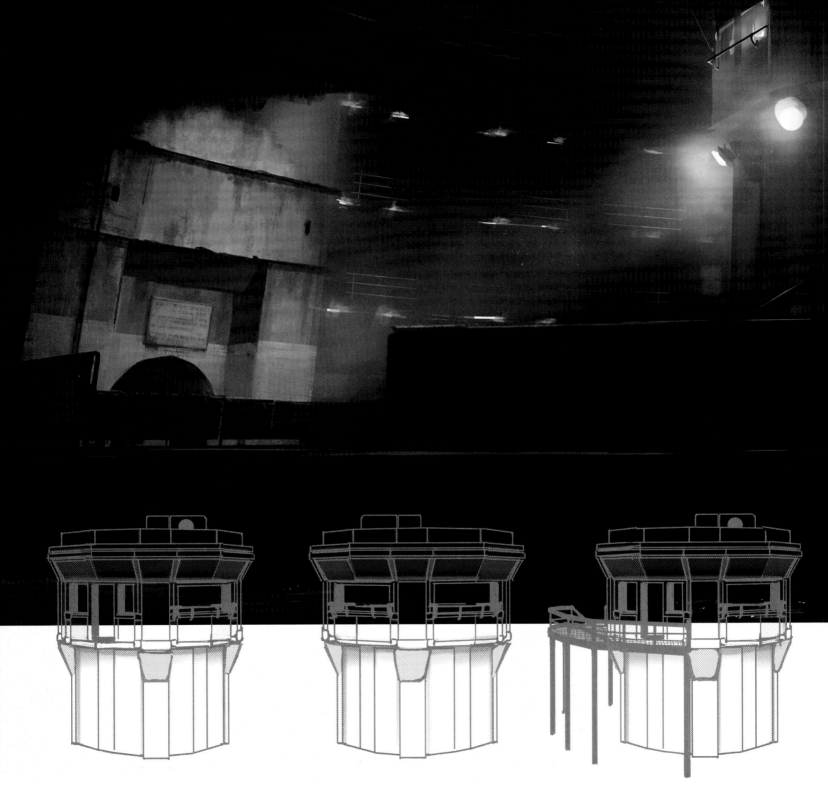

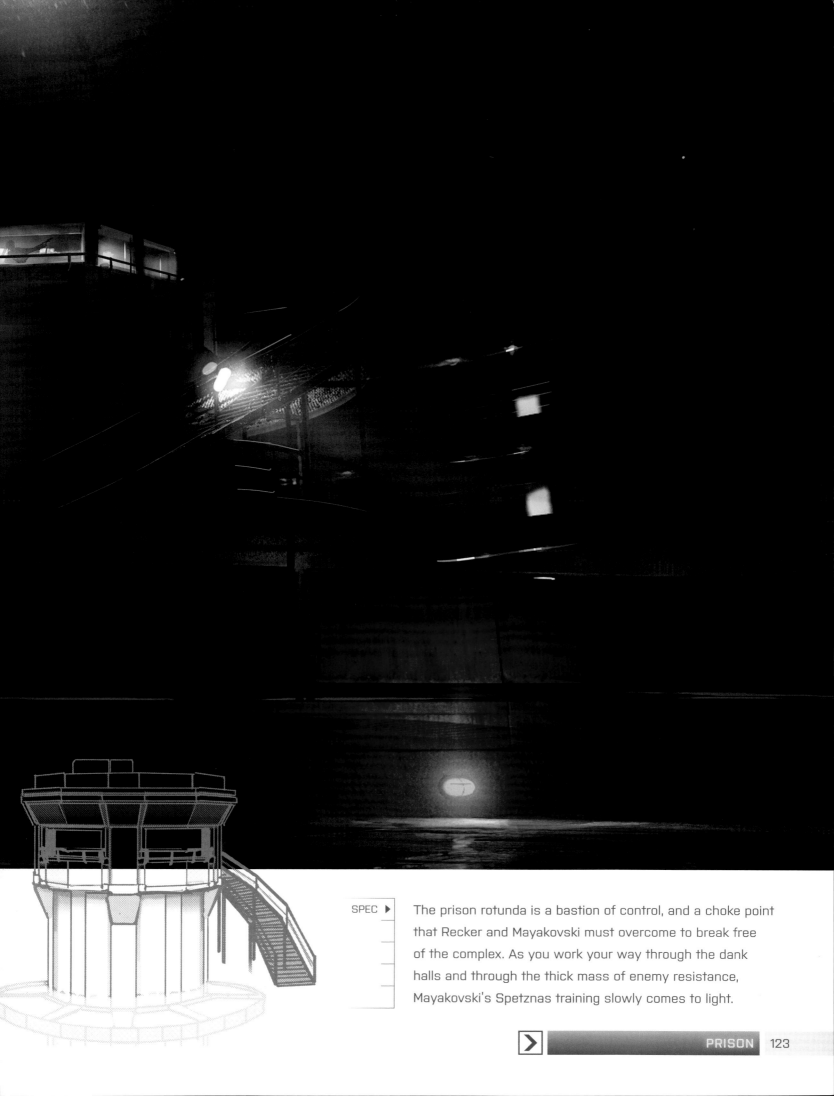

SPEC ▶

The prison rotunda is a bastion of control, and a choke point that Recker and Mayakovski must overcome to break free of the complex. As you work your way through the dank halls and through the thick mass of enemy resistance, Mayakovski's Spetznas training slowly comes to light.

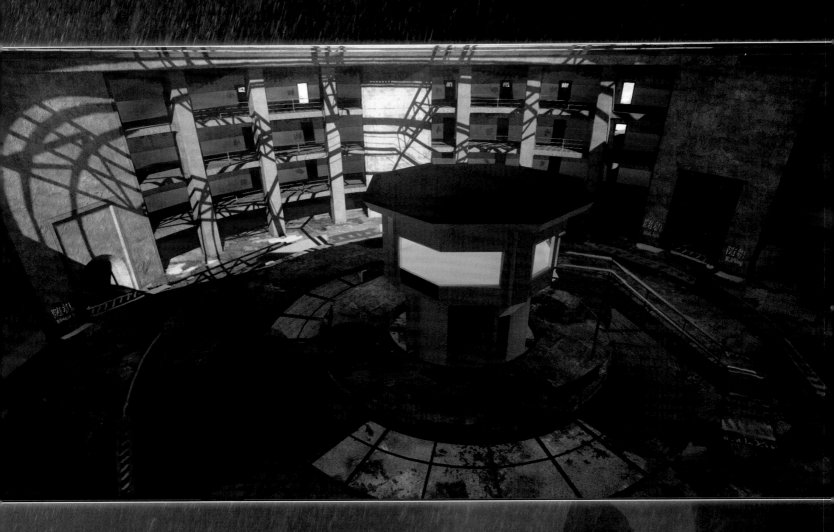

A lot of the artwork is informed by the power of
Frostbite - although as Robert Sammelin points out,
it simply ensures his team has complete creative
freedom. "When I started in the industry I heard
a lot of 'we can't really do that now' but with the
current Frostbite engine it's almost the other way
around. We're talking about having light pollution
and how light reflects and how color bounces off
different surfaces. The engine is almost too good
in that sense. We sometimes have to imitate in
concepts what you can do in the engine."

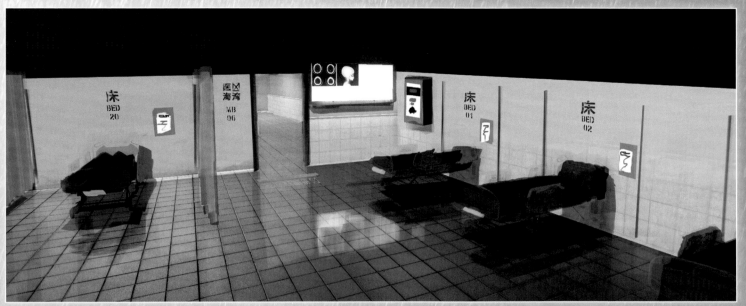

The cells have a modern, almost futuristic quality

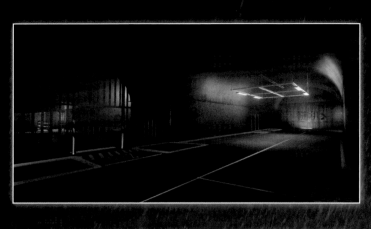

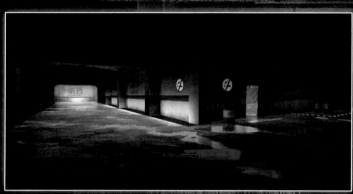

Lower levels were designed to be almost suffocating in their appearance

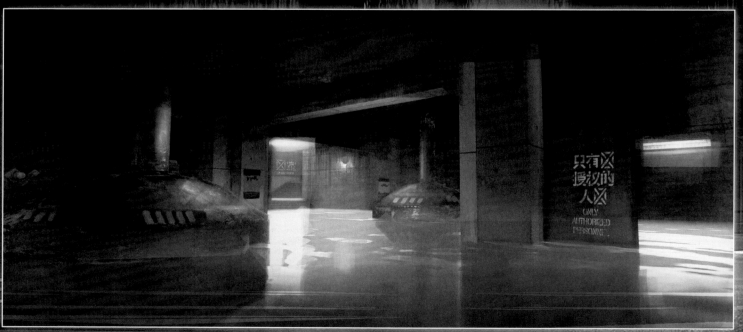

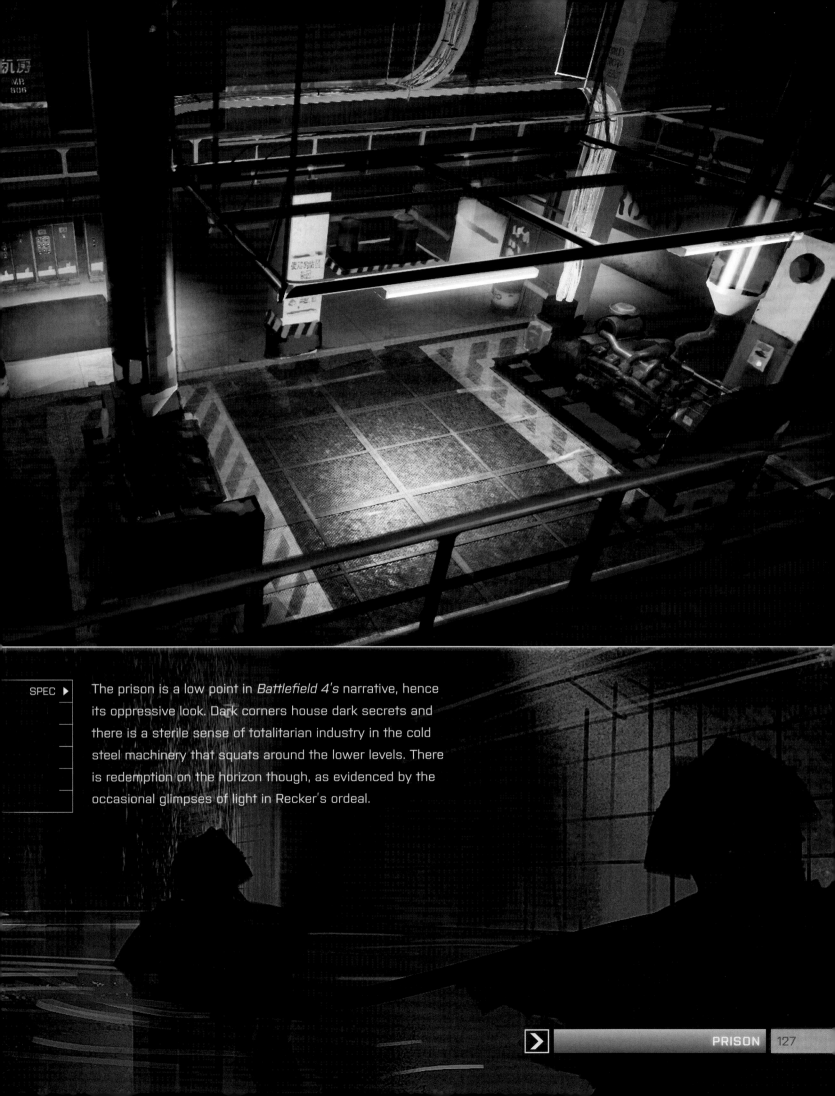

SPEC ▶

The prison is a low point in *Battlefield 4*'s narrative, hence its oppressive look. Dark corners house dark secrets and there is a sterile sense of totalitarian industry in the cold steel machinery that squats around the lower levels. There is redemption on the horizon though, as evidenced by the occasional glimpses of light in Recker's ordeal.

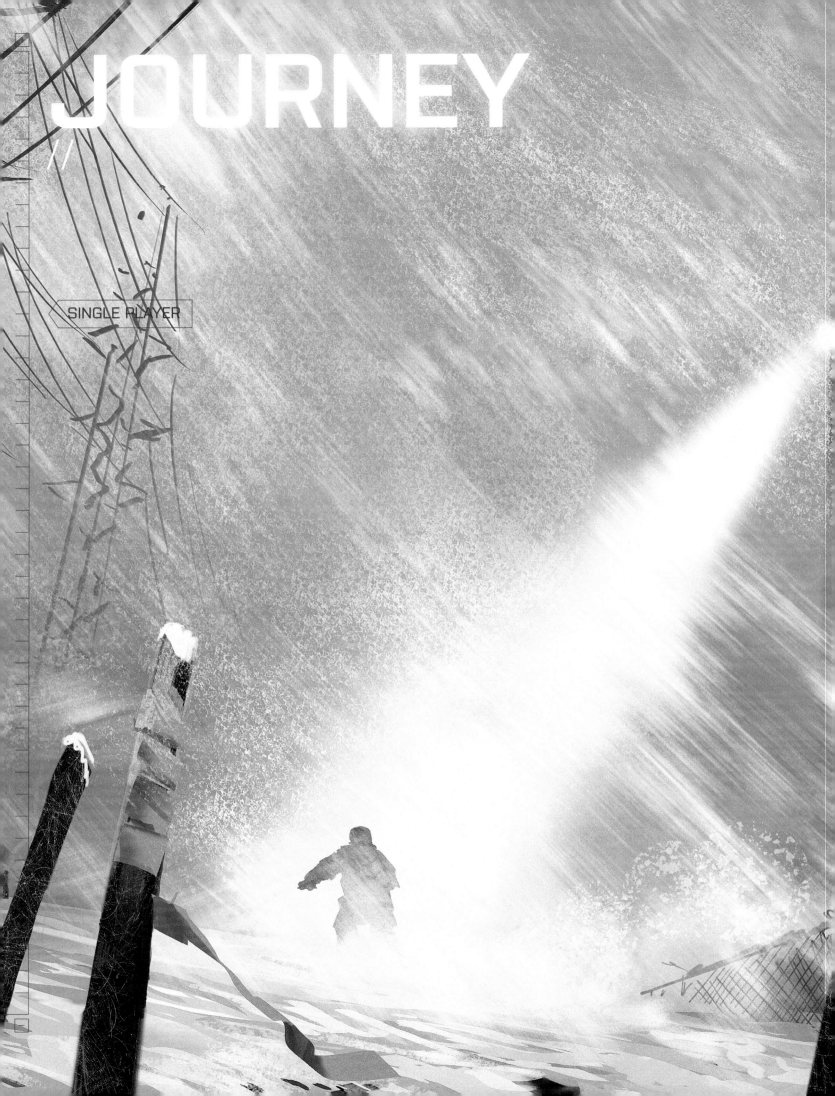

JOURNEY

//

SINGLE PLAYER

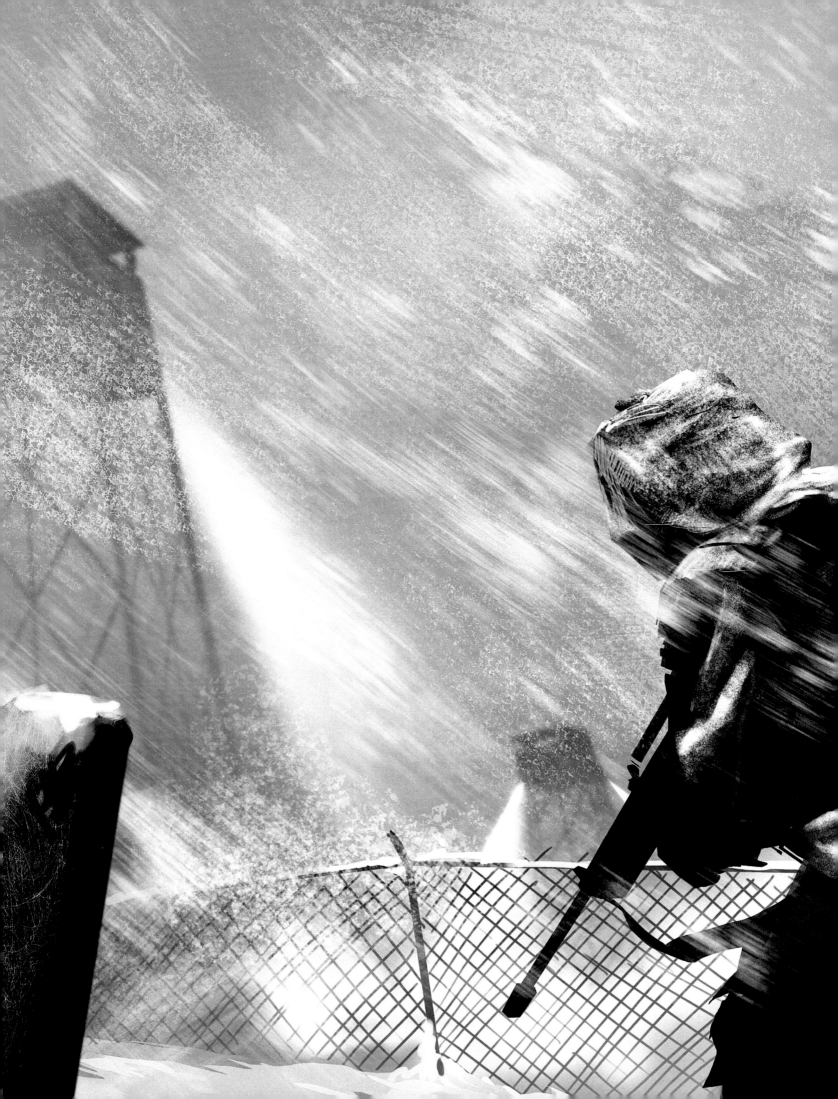

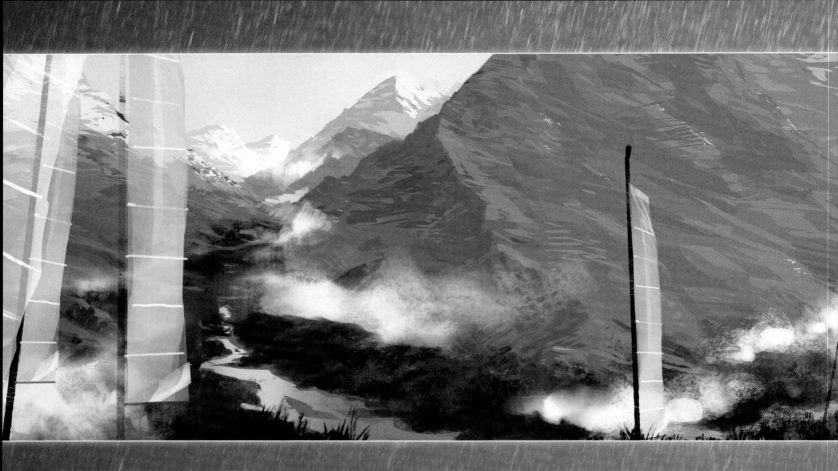

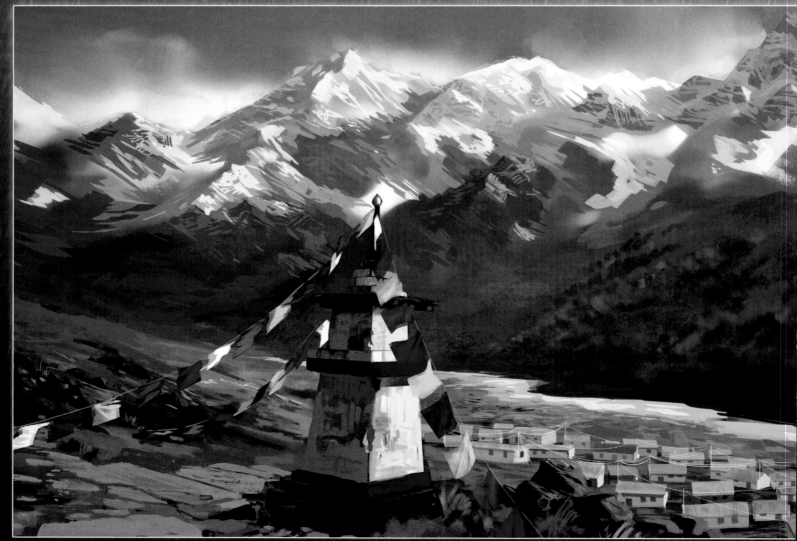

This Tibetan scene is a masterful example of changing the pace of the game.

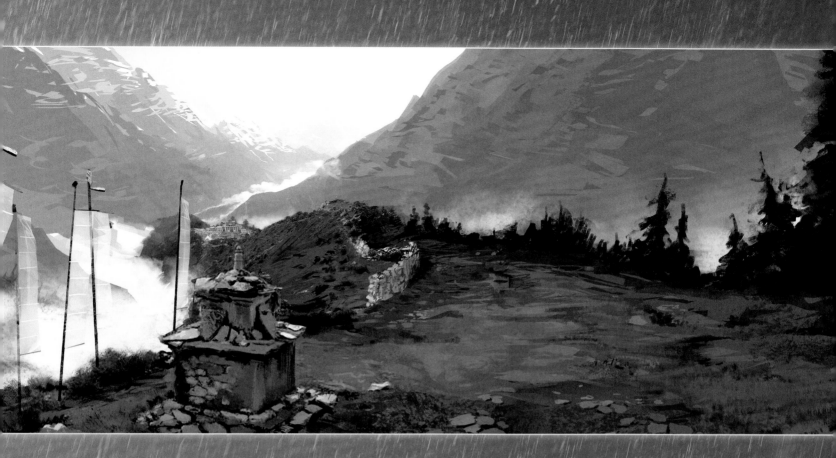

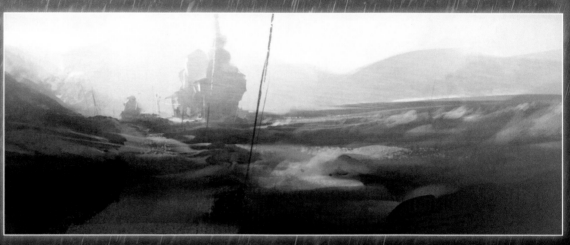

SPEC ▶ After the suffocating sprawl of the prison complex, Recker and crew finally come up for a breath of crisp mountain air in the Tibetan heights. Your new, slightly tattered mob of allies sets about tracking down Jin Jie, the Chinese dove who was thought to be assassinated by American forces. The journey is long and the environment hostile - and it will go on to reveal who you can trust in the throes of war.

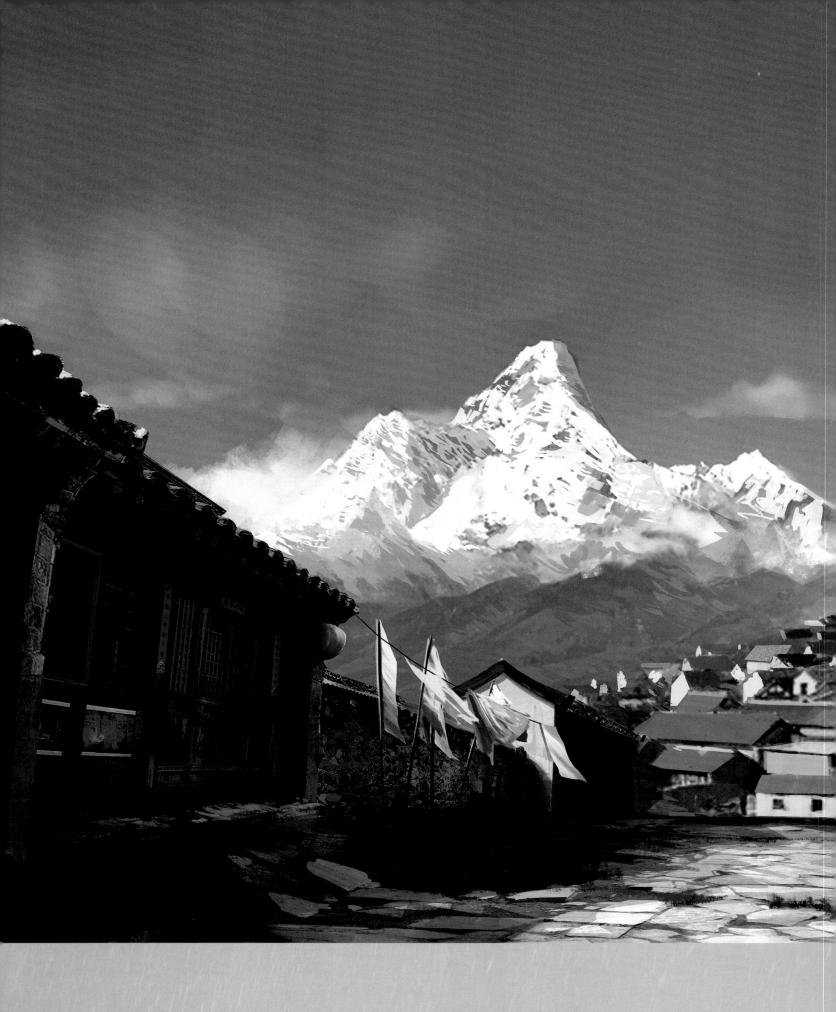

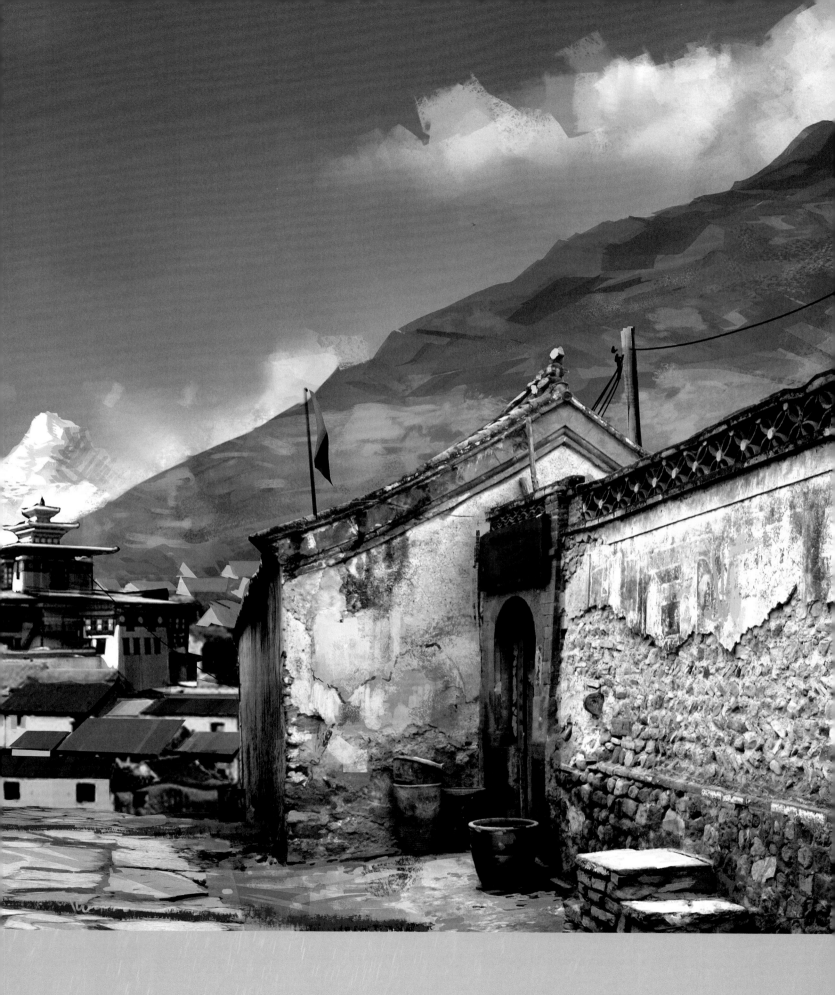

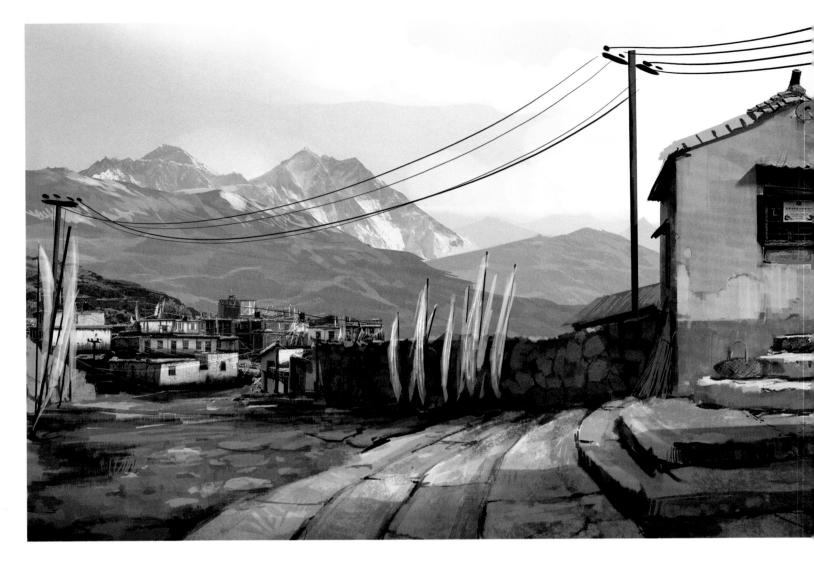

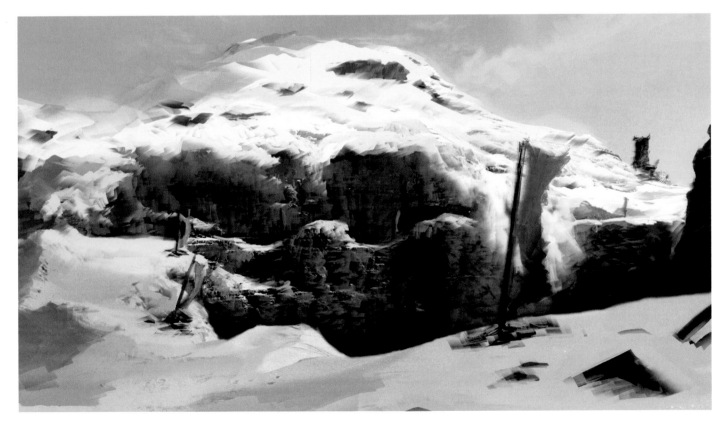

SPEC ▶

First-person shooters often get stick for being drab experiences, but it's hardly an accusation you could level at *Battlefield 4*. "I am probably one of the first to agree with the criticism of modern shooters because they are kind of dull," says Sammelin. "I think we have a really strong art direction in the *Battlefield* franchise, using these themes and the importance of having contrasting and complementing color. That's something we work through almost every concept we make to reflect, build upon and enforce the art direction."

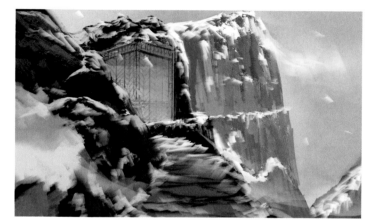

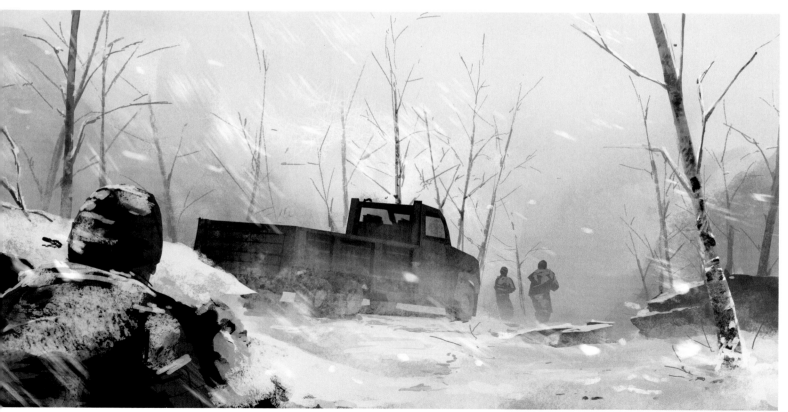

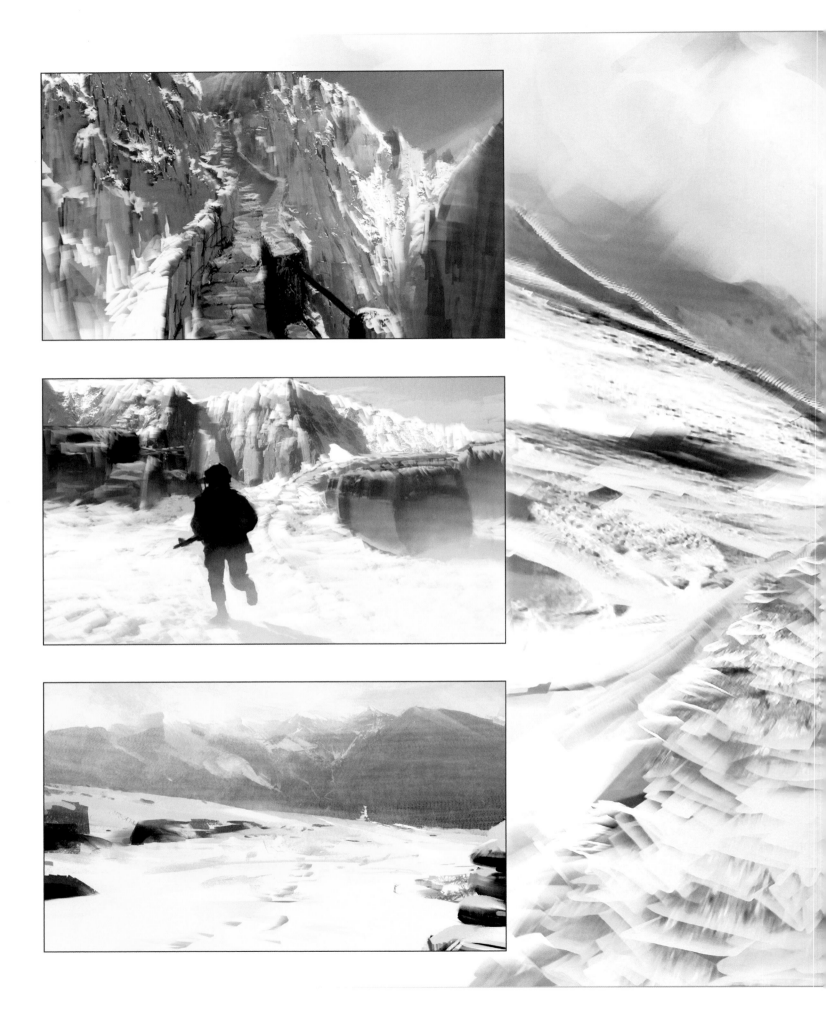

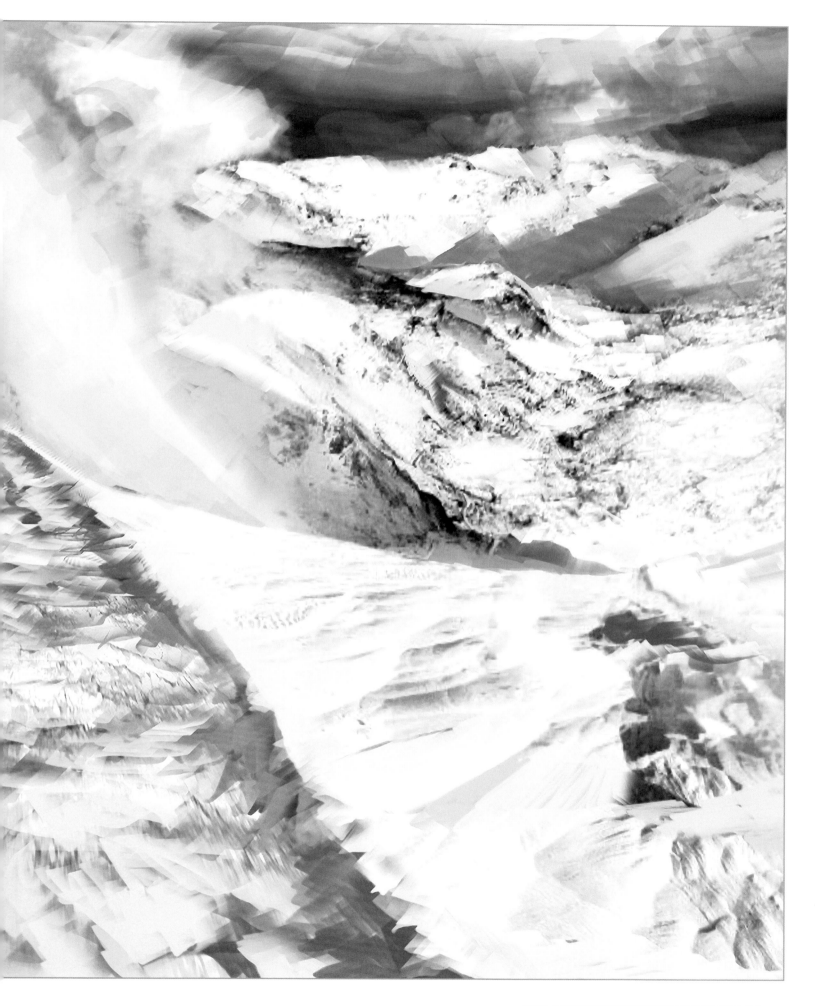

DAM CITY

//

SINGLE PLAYER

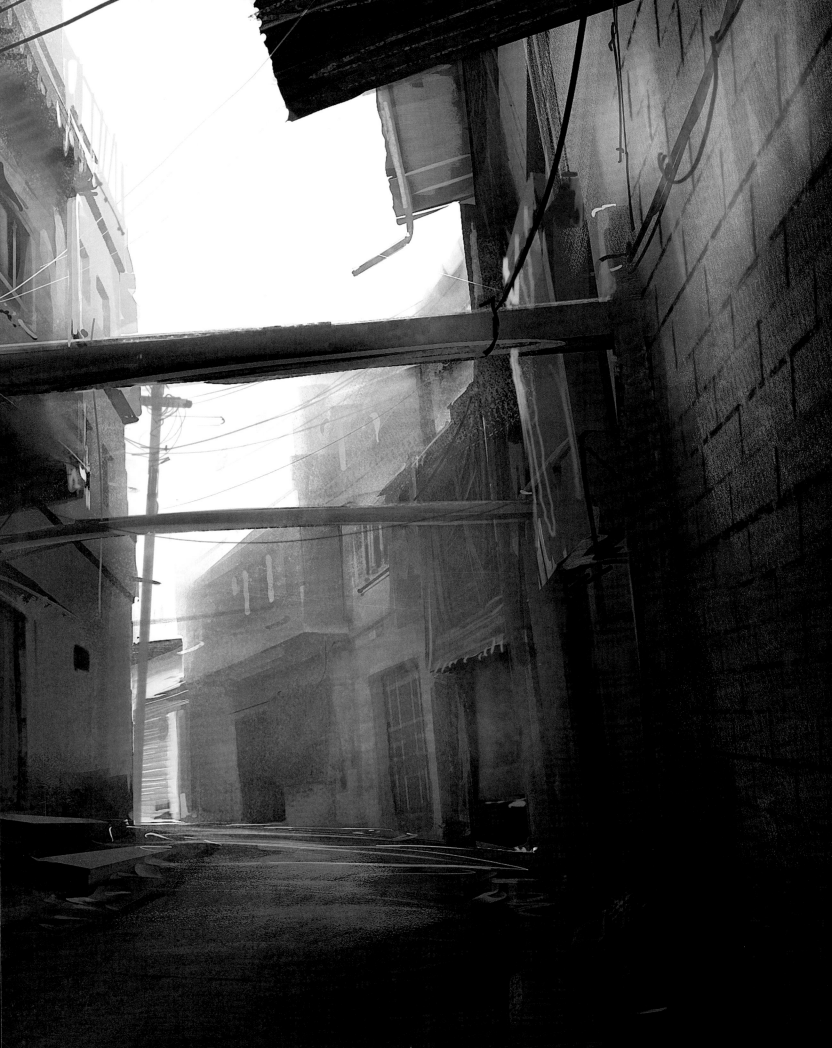

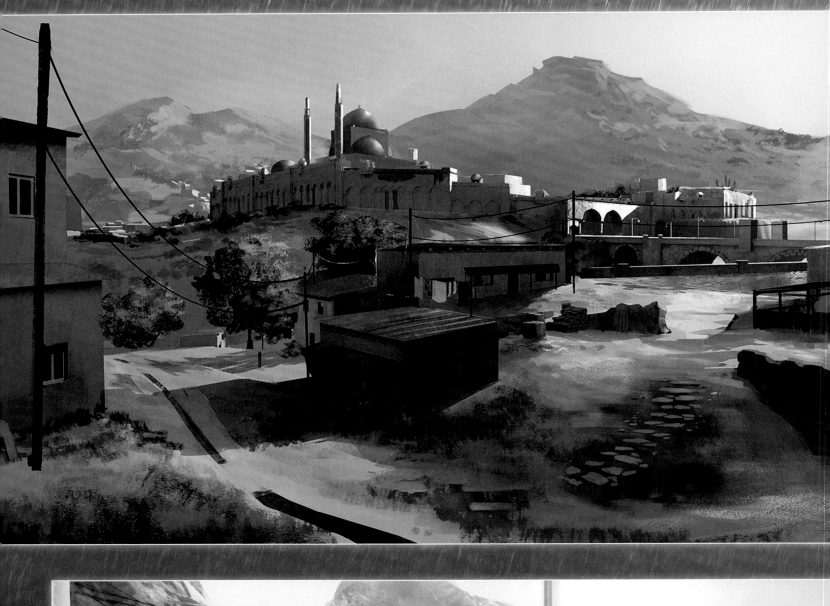
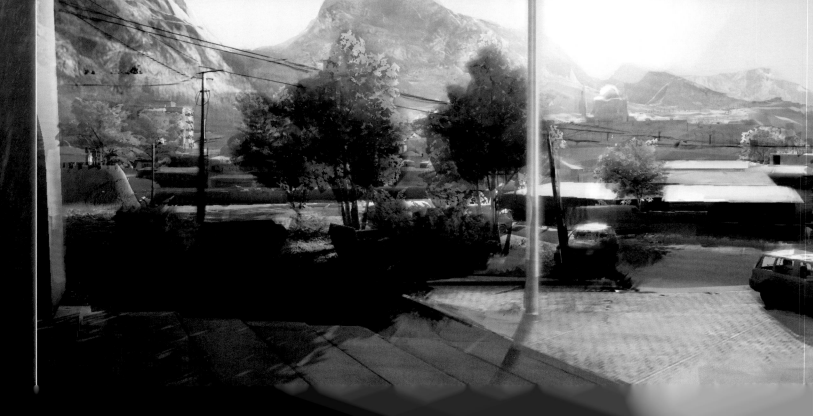

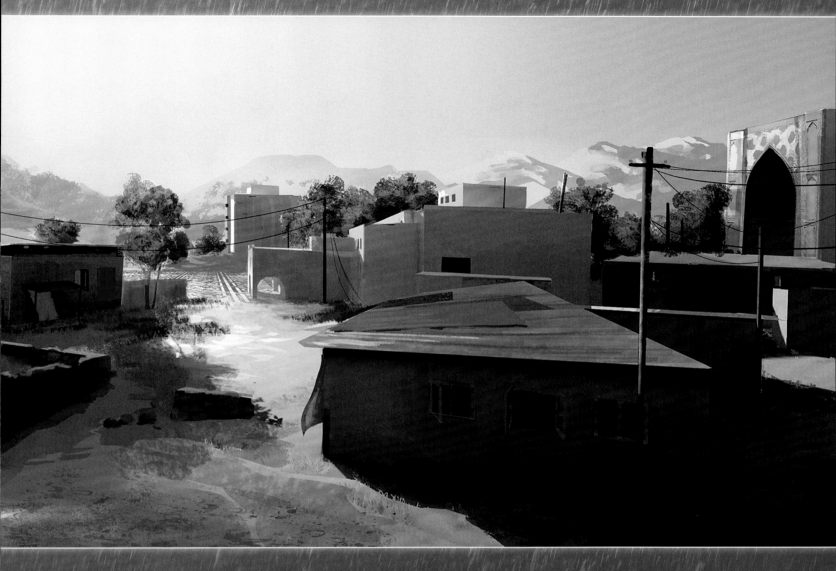

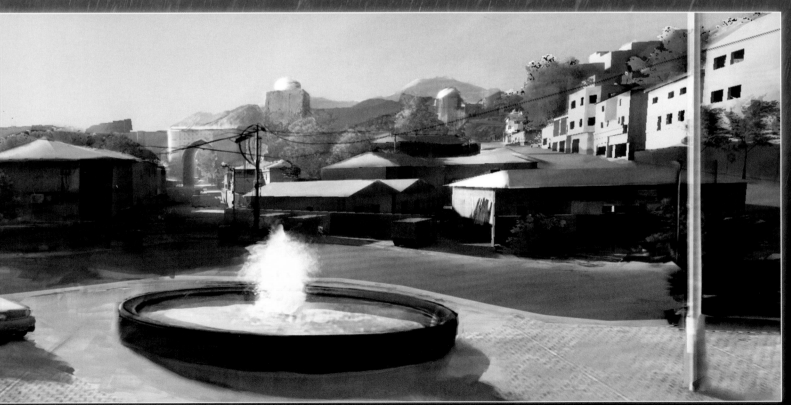

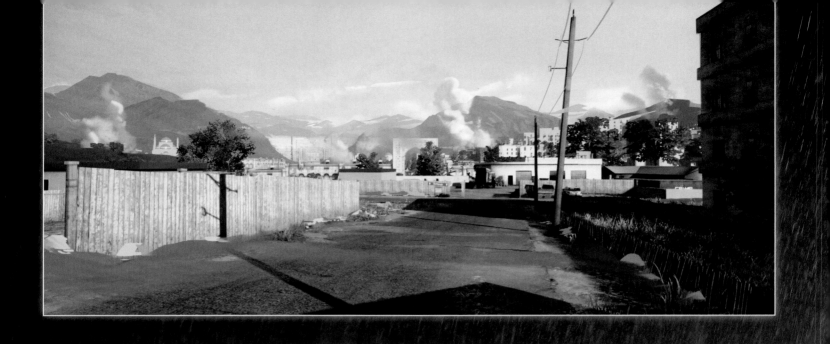

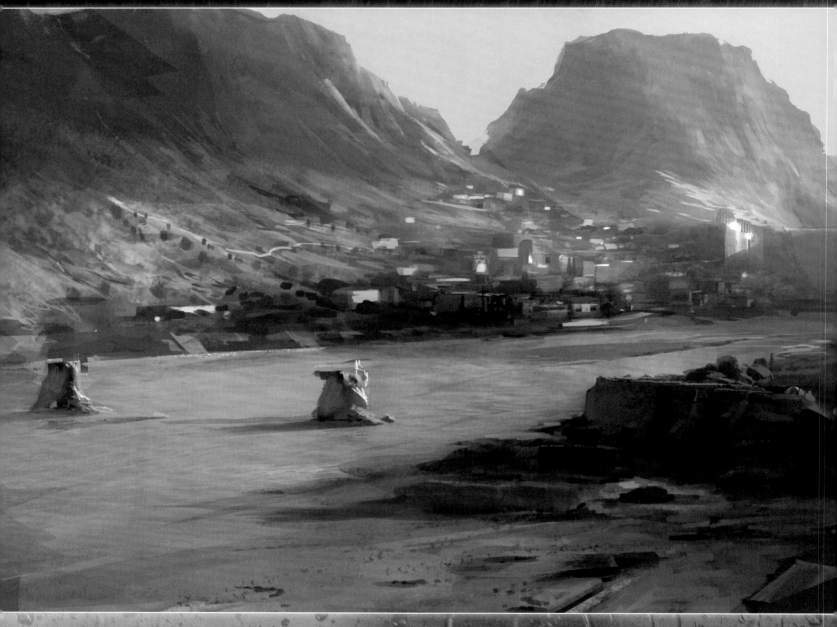

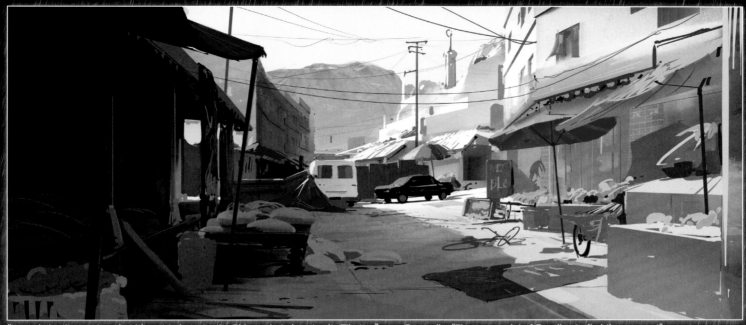

"It needed to be war-torn, but it's got to be not-quite-Chinese but almost-quite-Tibetan," says Sammelin. "There was a lot of Googling to find those areas!"

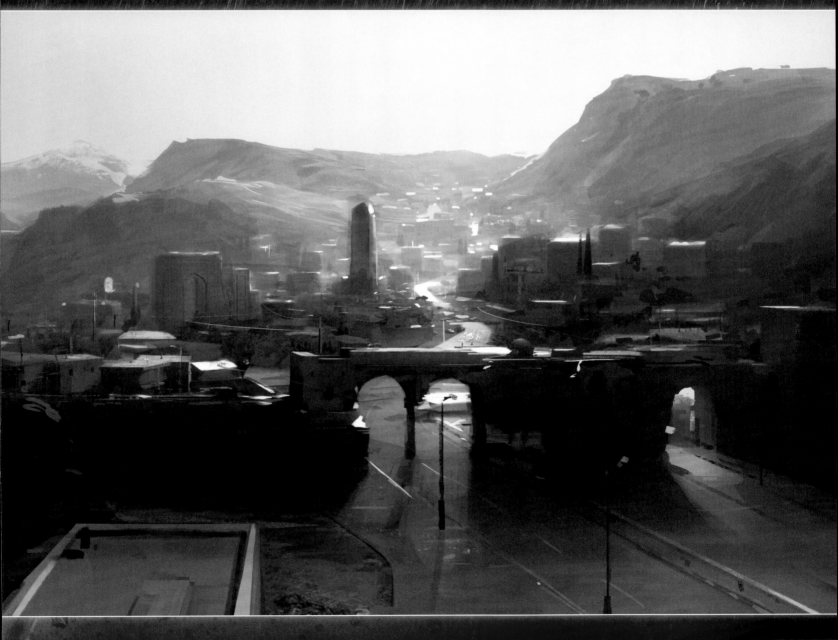

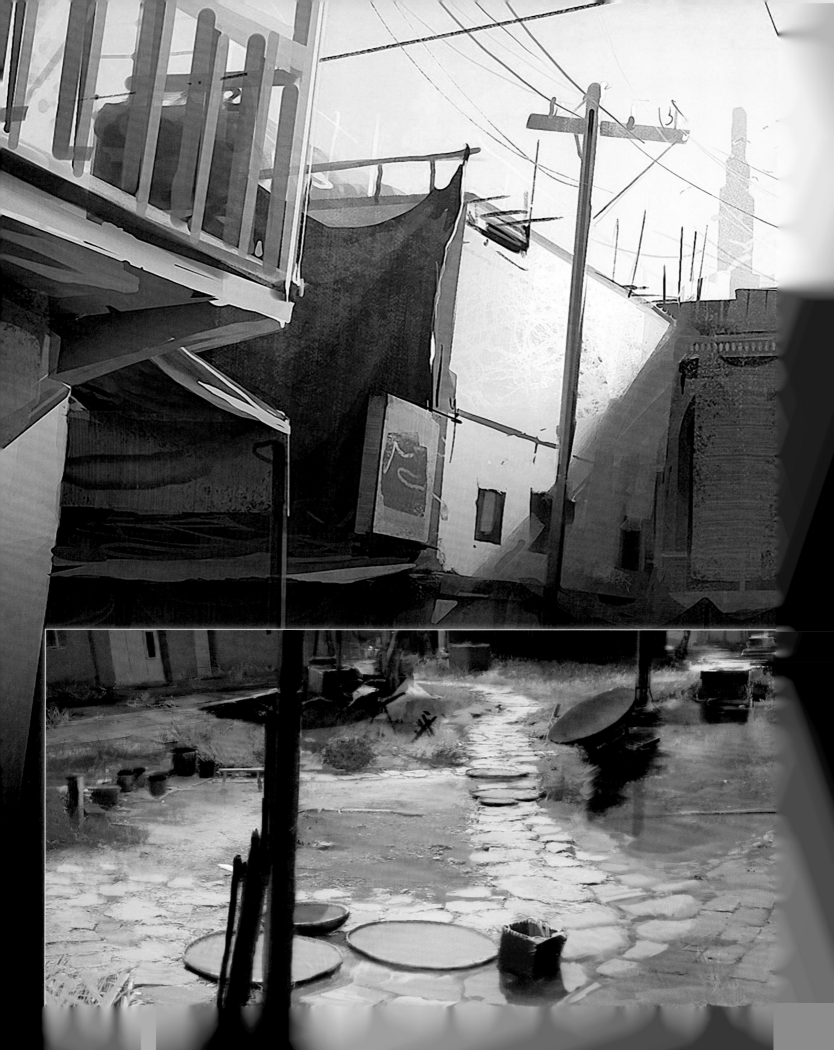

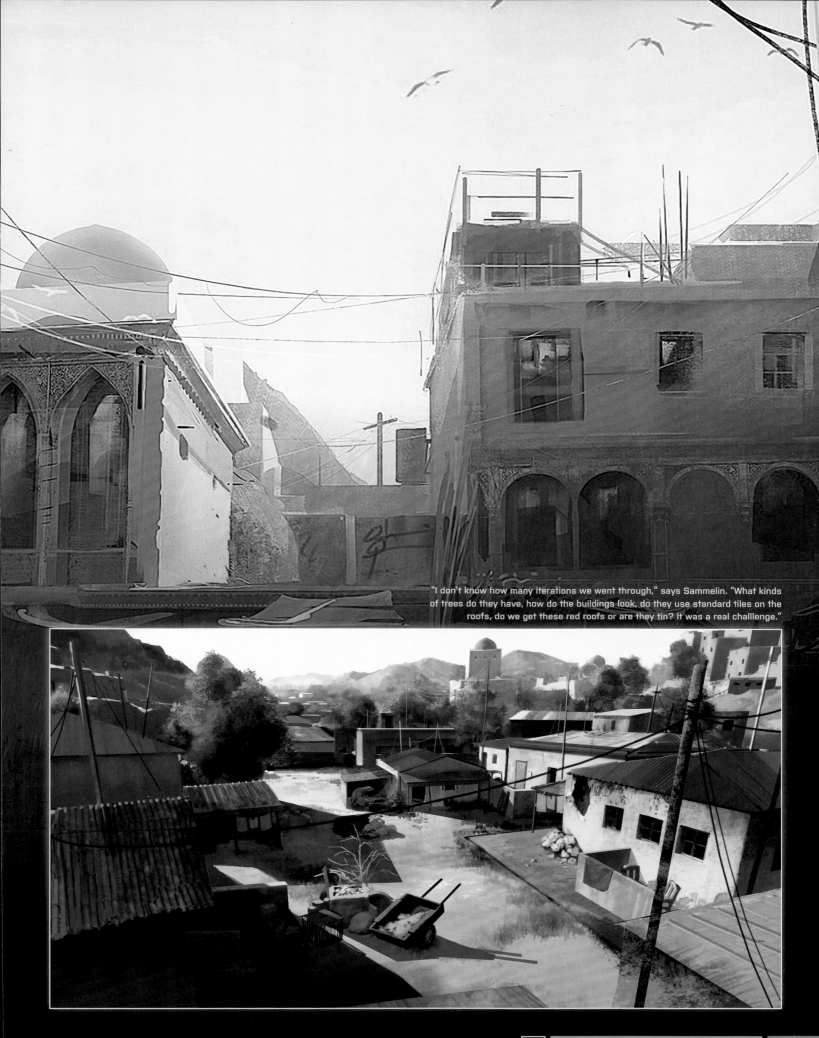

"I don't know how many iterations we went through," says Sammelin. "What kinds of trees do they have, how do the buildings look, do they use standard tiles on the roofs, do we get these red roofs or are they tin? It was a real challlenge."

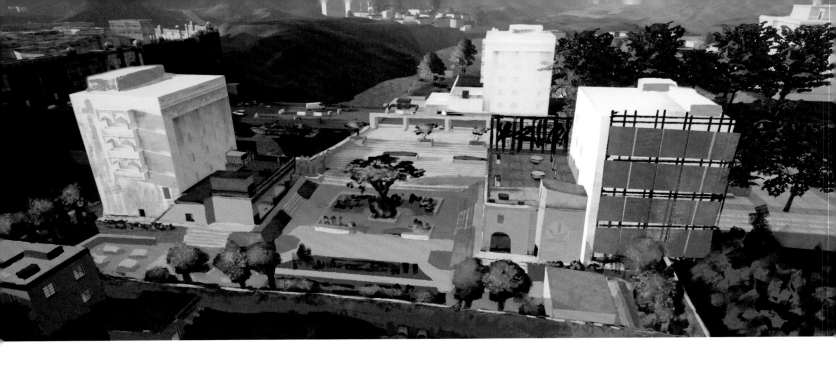

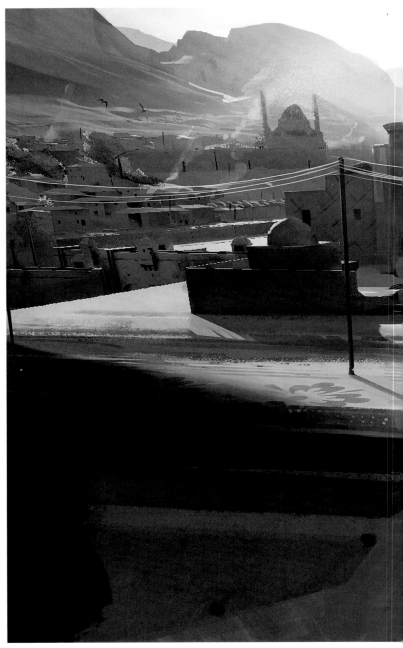

SPEC ▶ It's all too easy to make an area too pleasant so it's important for the artists to remember to put on an authentic layer of dirt. "I got a comment when reviewing the weekly concept art that this was all slightly too idyllic," says Sammelin. "Even though it's completely ruined - so we were almost fully blind to what was fully destroyed at this point."

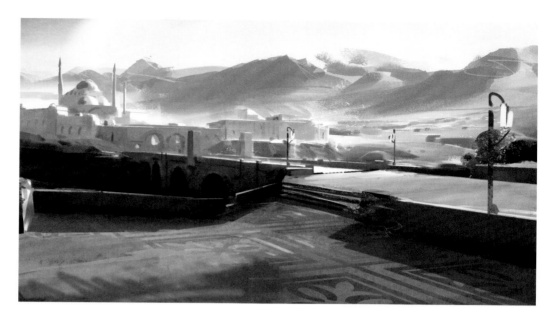

SPEC ▶ *Battlefield 4's* towns are built up like toy sets, prepared in anticiption for the player to recklessly run through them knocking down buildings as they go. You'd have thought such destruction of their work would pain the artists, but the truth's quite the opposite.

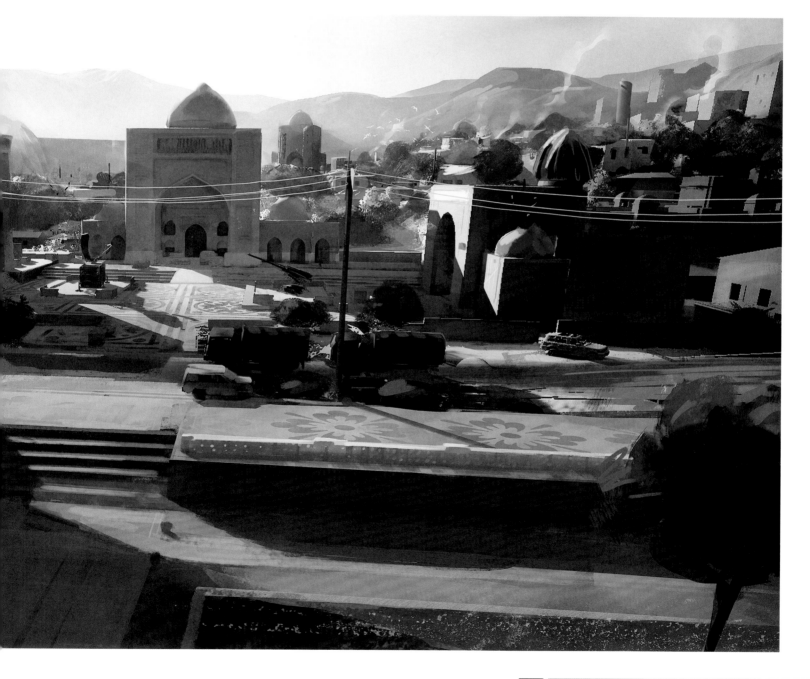

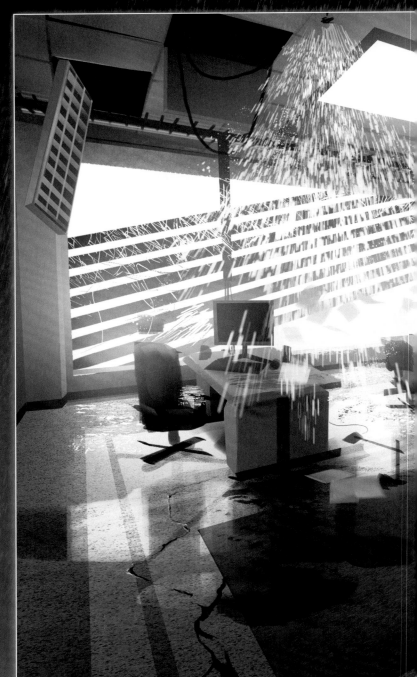

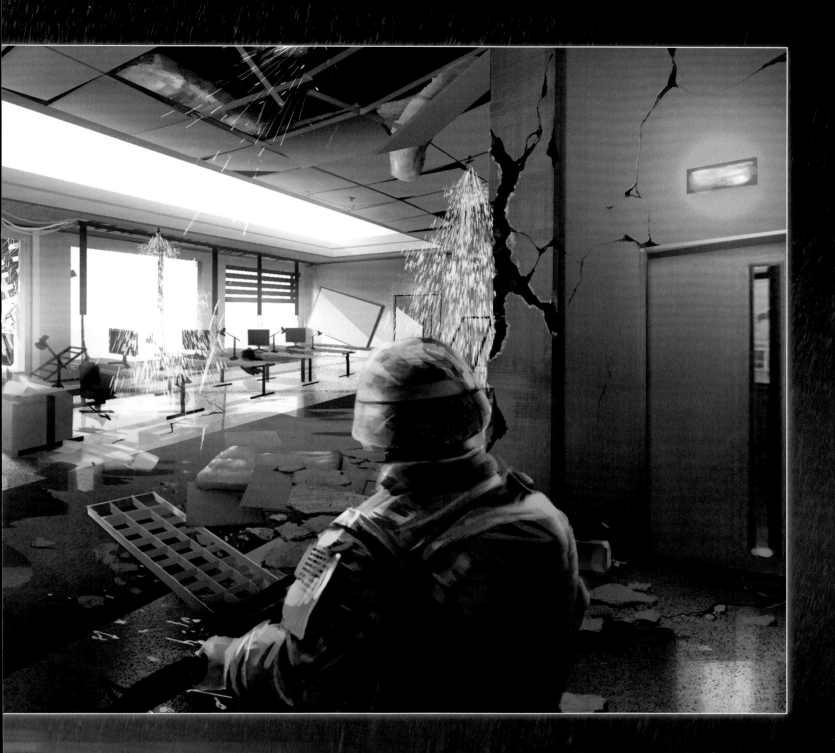

SPEC ▶

Evolving architecture has been a part of *Battlefield* since *Bad Company*, but it makes its most significant advancement in *Battlefield 4*. Here, whole office blocks and skyscrapers can come tumbling down, and quite often with the player still inside them. Capture an enemy squad inside one in a multiplayer match and it's one of the greatest thrills; find yourself inside, though, and it's much harder to crack a smile.

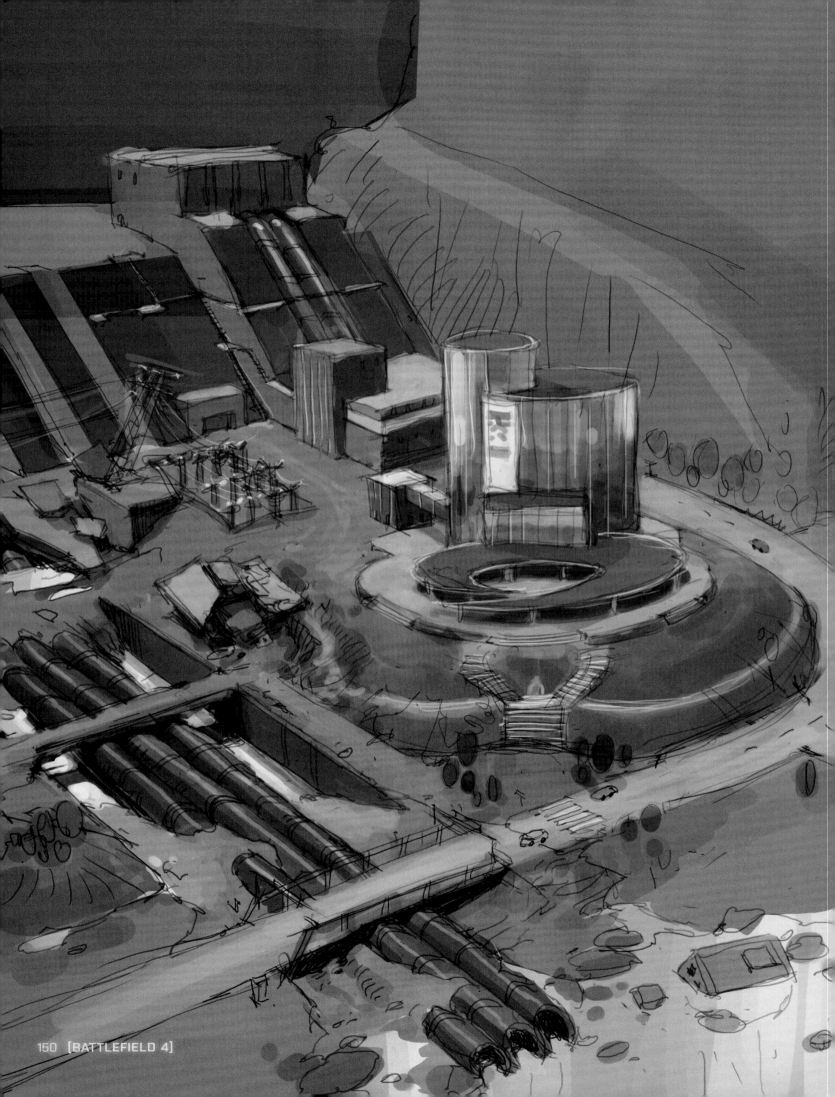

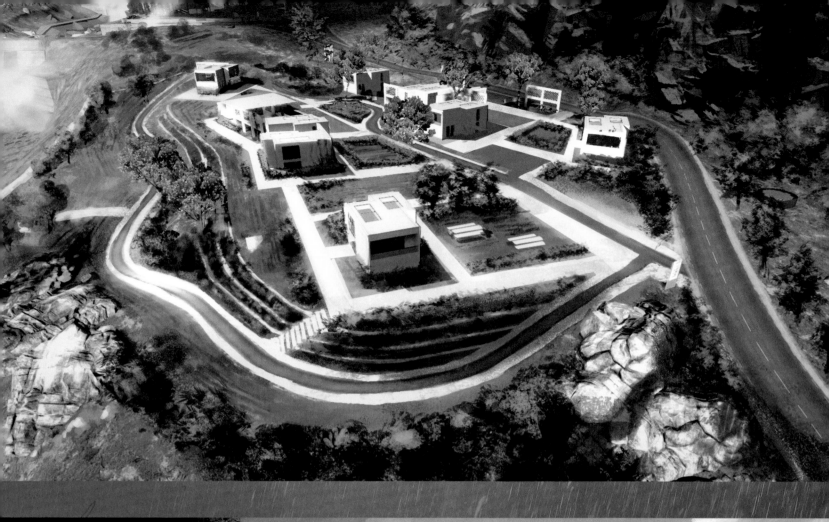

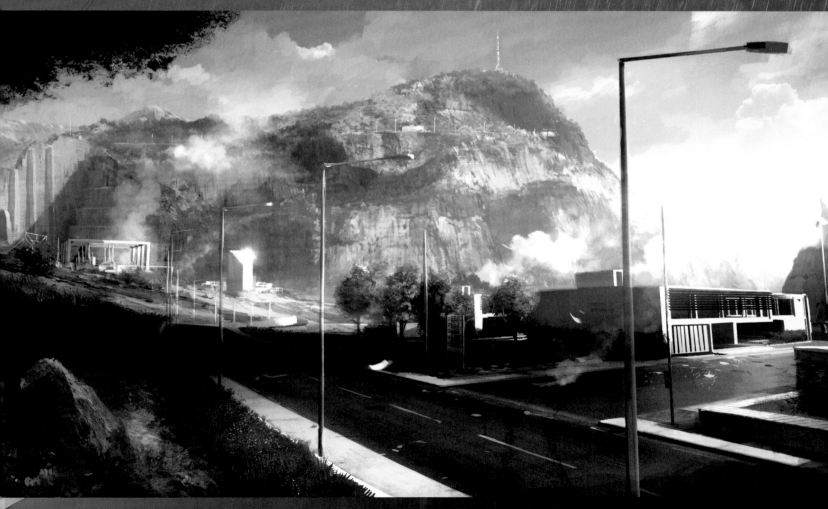

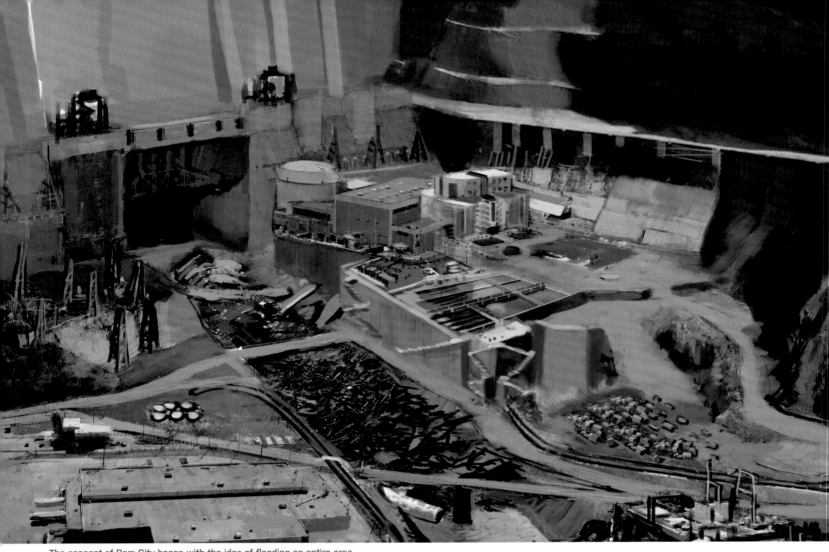
The concept of Dam City began with the idea of flooding an entire area

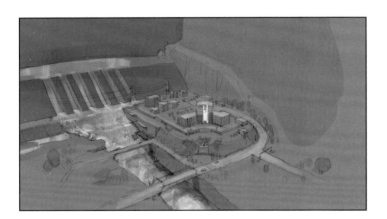
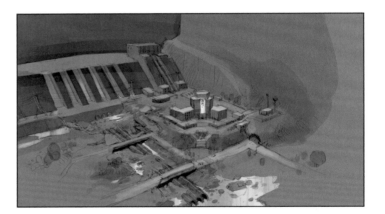
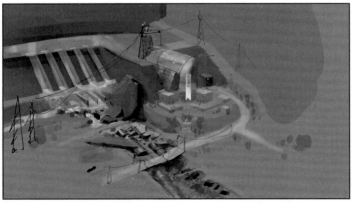
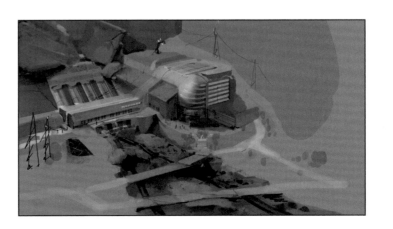

The dam set-piece is one of the most explosive yet seen in the series

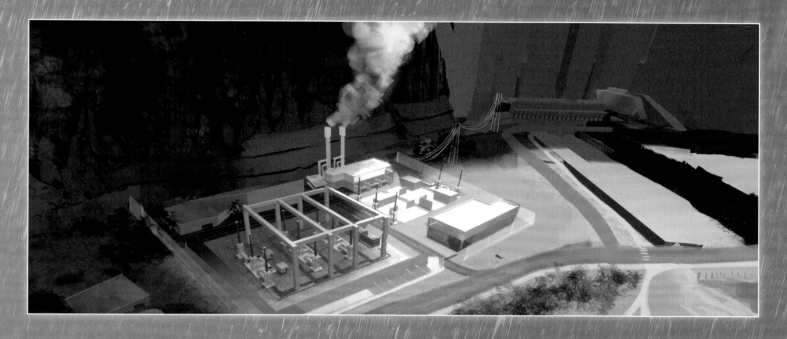

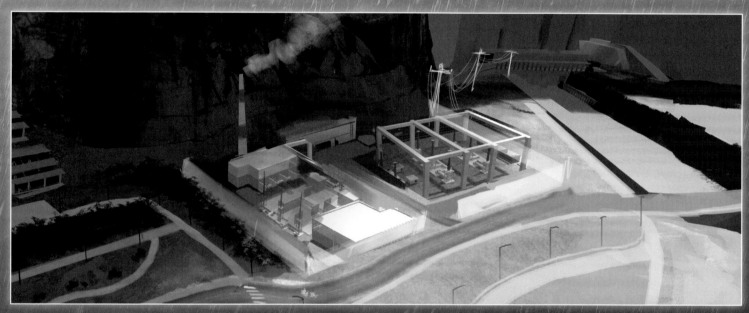

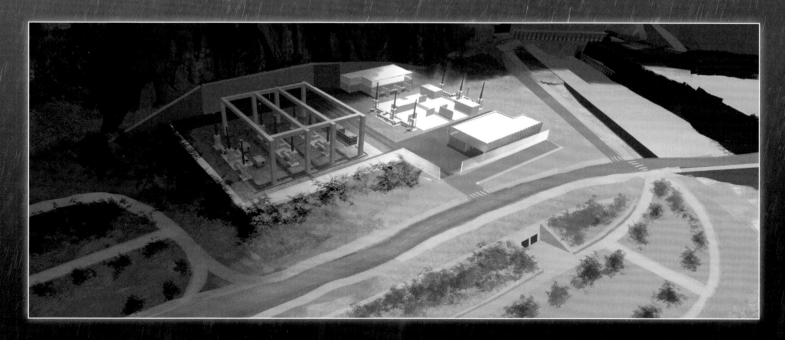

SPEC ▶

Does it not pain the artists to see their work so regularly torn apart in-game? "I think the concept art guys are probably the happiest with the large scale destruction we've got in this game because we tend to have almost a larger-than-life idea of 'what if?'", replies Sammelin. "Creating the before and after is really fun. Nothing is more gratifying than coming up with, and making, something as grotesque as wartorn and destroyed areas. To also make them appealing and interesting somehow is a really difficult thing to do. It's a big challenge, for me at least, and one of the most fun aspects of doing the art."

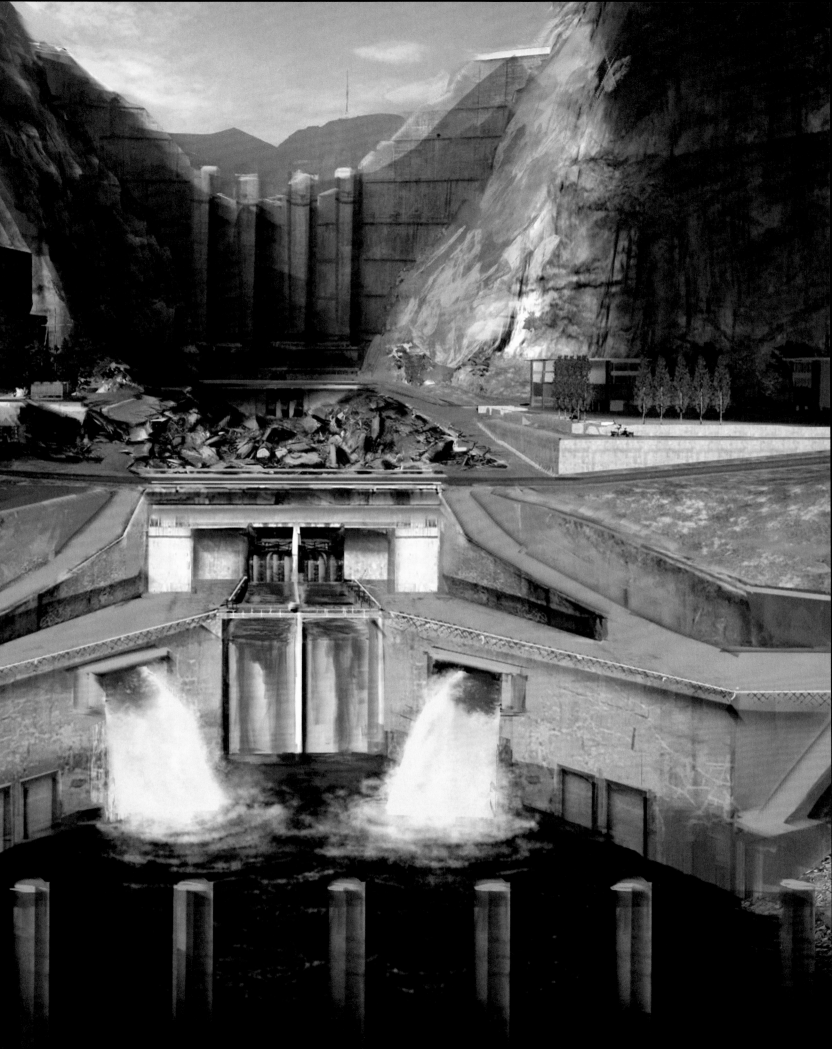

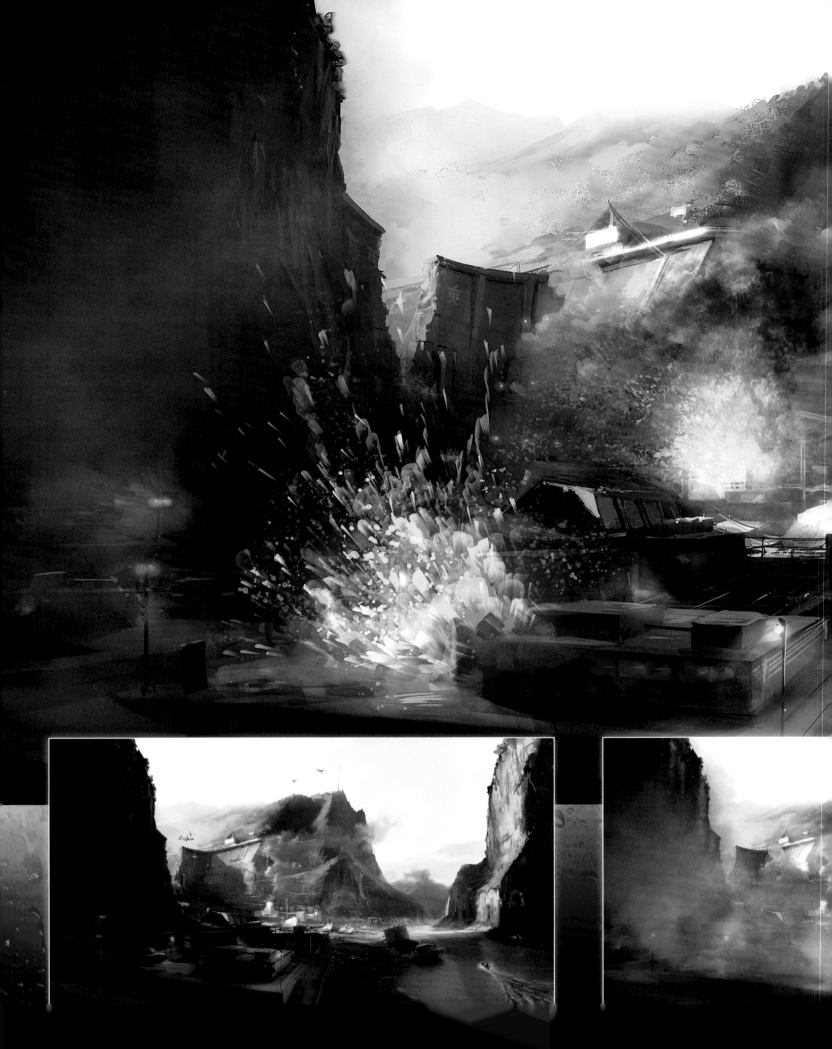

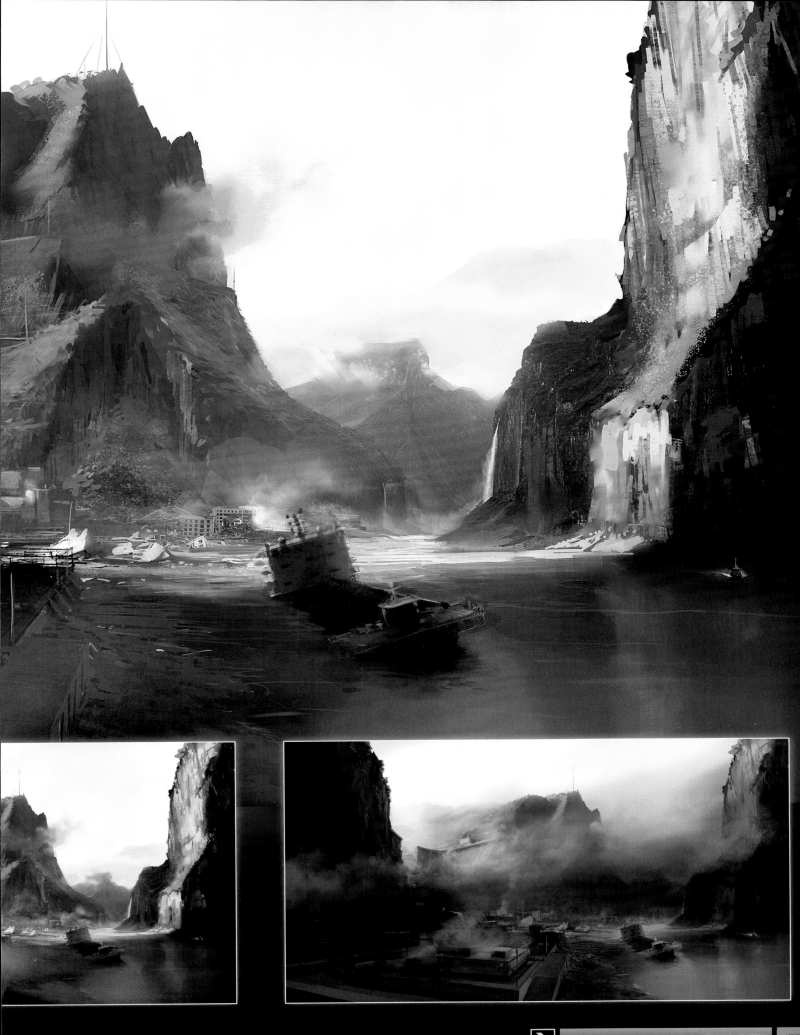

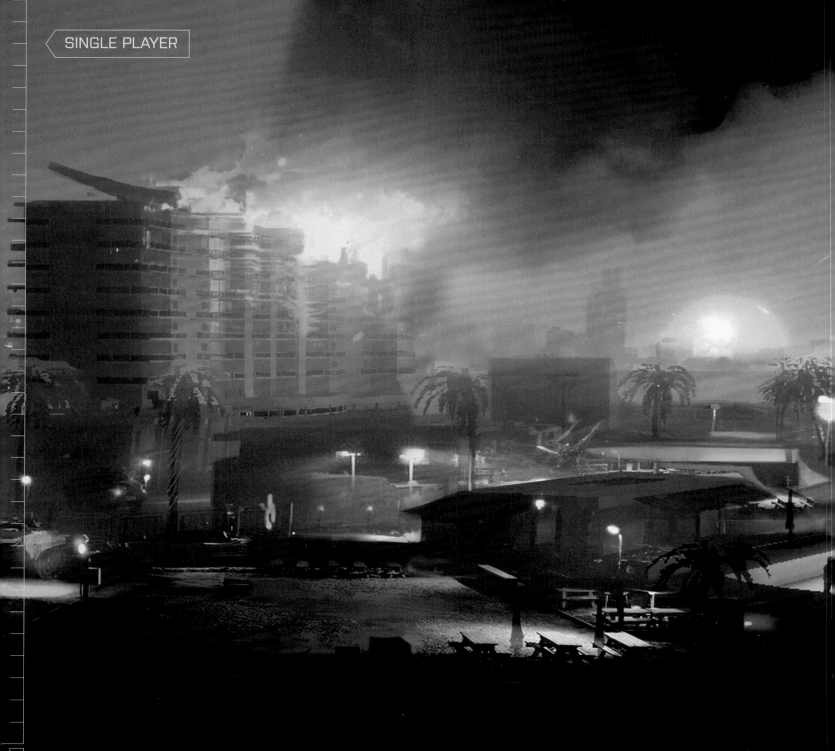

SUEZ

//

SINGLE PLAYER

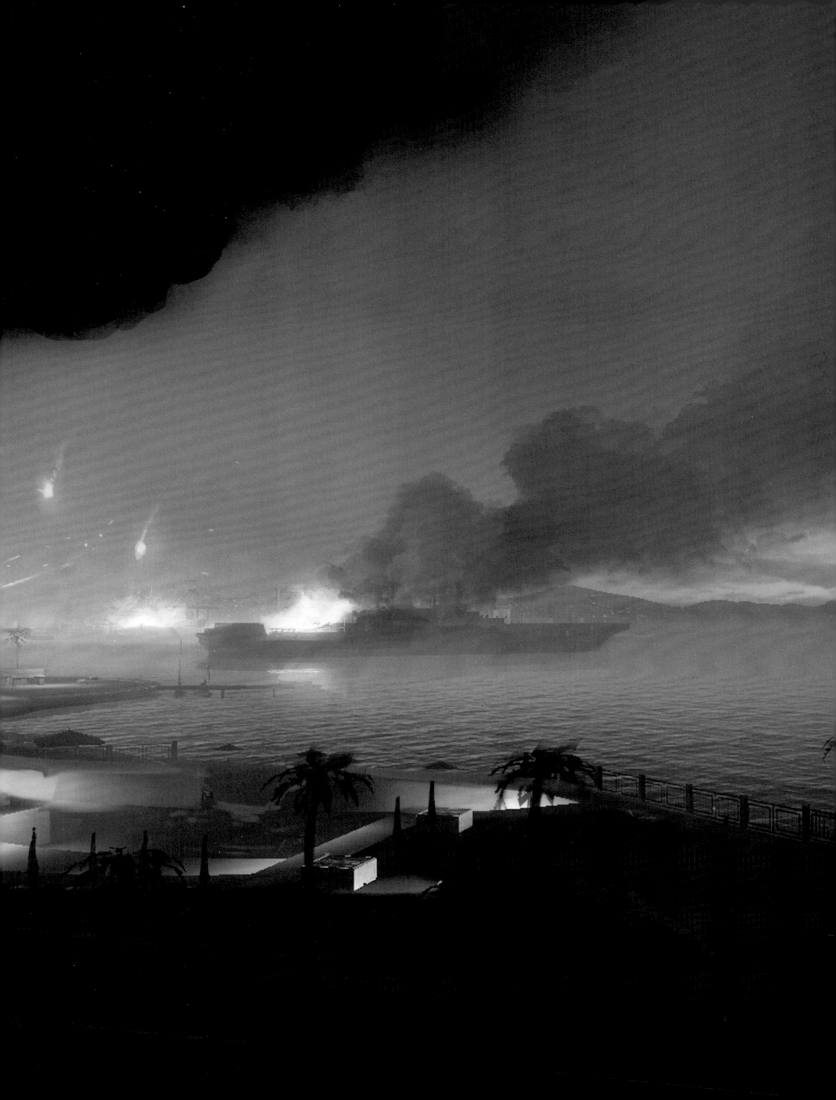

SPEC ▶ With the truth about Jin Jie exposed,
Recker believes the war is won. But the
onslaught continues, and to
make it stop, one final sacrifice must be
made. The climactic final scene is fully
storyboarded, revealing in a sharp comic
style how DICE prepared for *Battlefield 4's*
final moments.

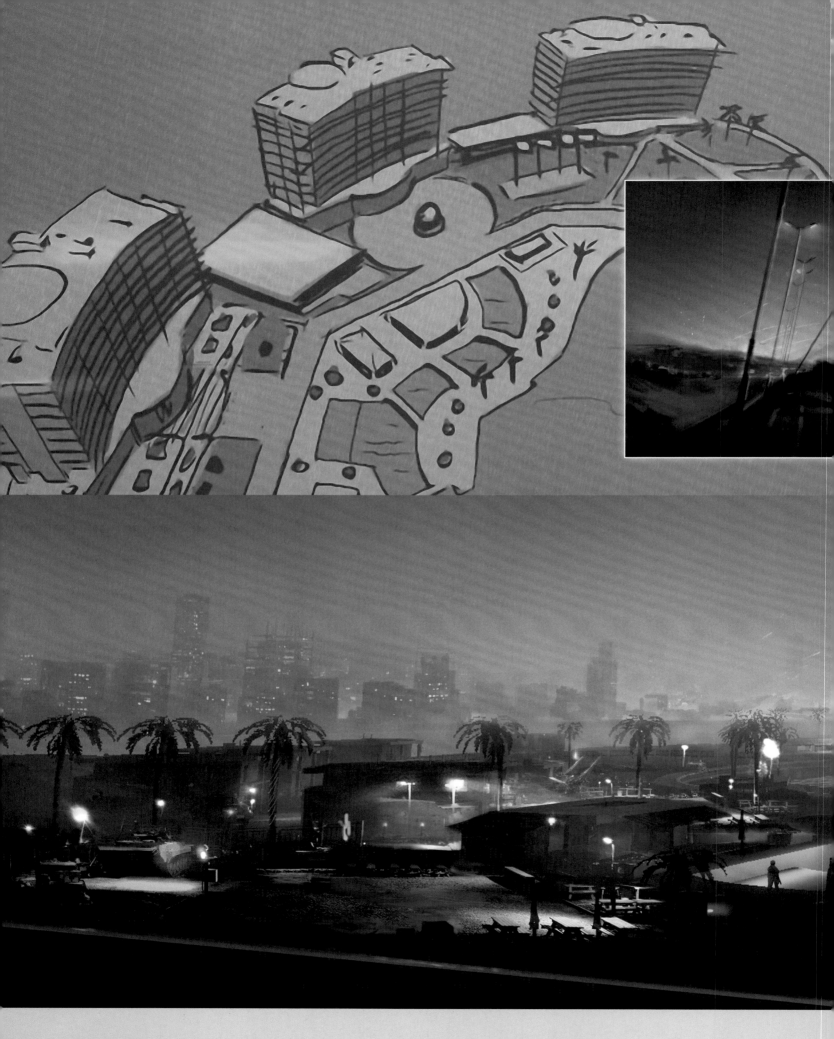

The Suez mission leans heavily on studies of the Egyptian city. "We populated it with some higher constructions," says Sammelin. "We wanted to sell the time of day. We'd not done that many concepts of Suez itself, because early on we'd nailed the early morning feel we wanted, as well as the colors." With the feel of the environment nailed down, the next big task for DICE was to somehow fit the climactic battle with the carrier ship into this authentic vision of Suez.

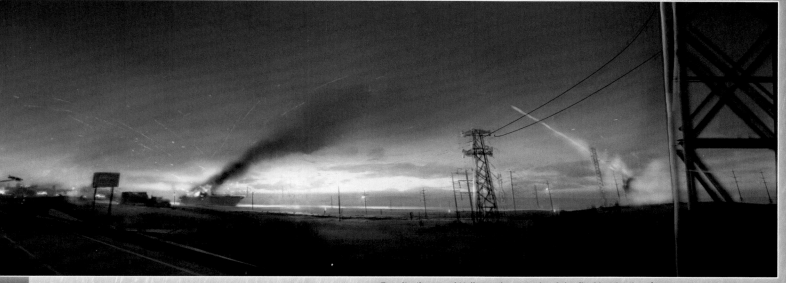

Despite the grand Hollywood spectacle of the final battle, there's a certain authenticity to its depiction: the images themselves look like airbrushed copies of global news reports.

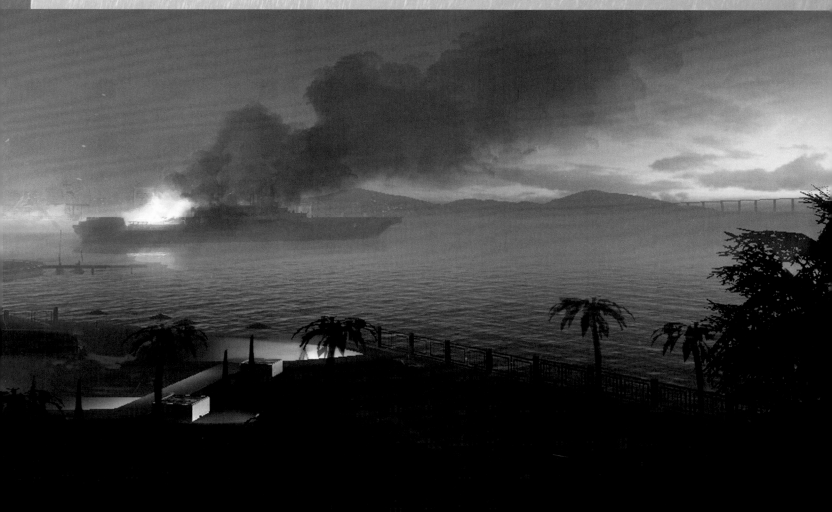

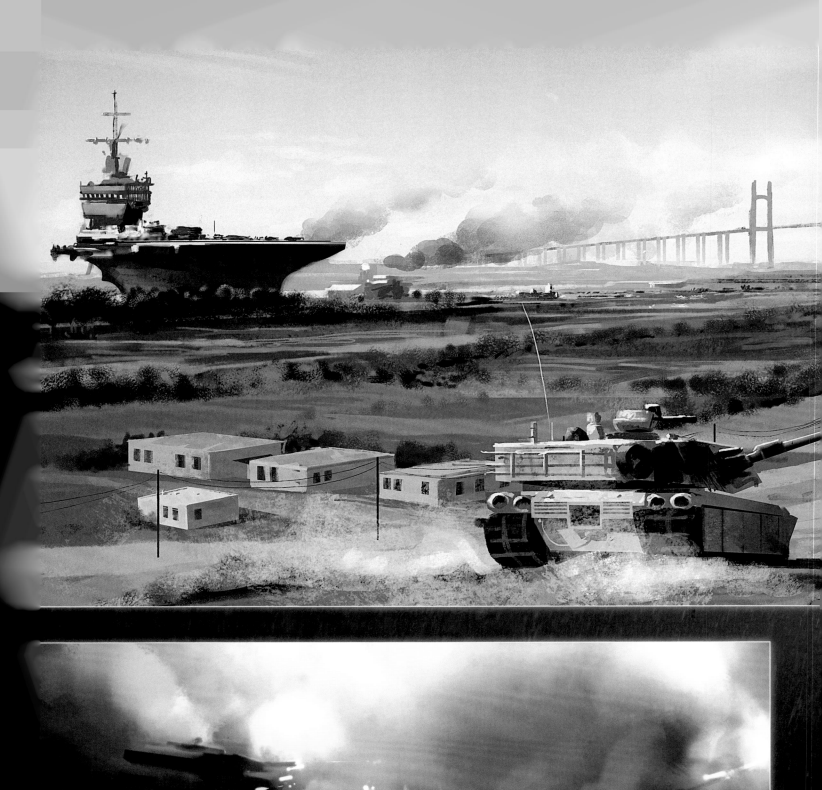
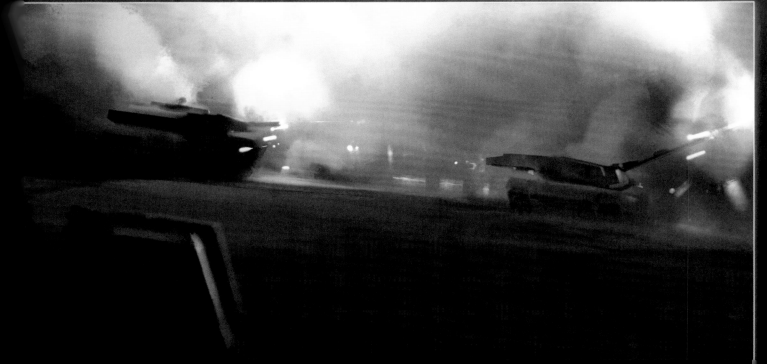

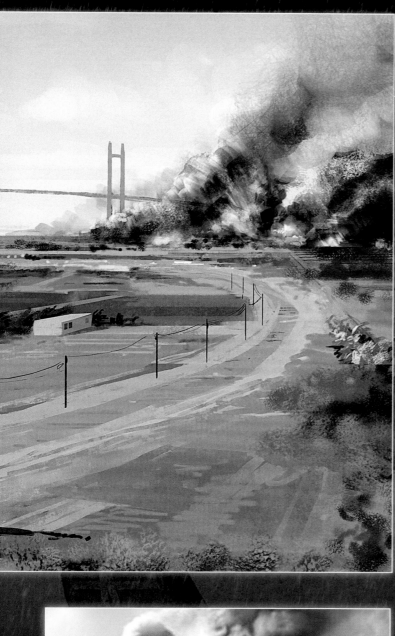

SPEC ▶

Through the dust and destruction the US forces roll out to a city under fire to put an end to the fight. In some of *Battlefield 4's* final moments the dream that began all those years ago at Refraction Games is fully realized - carrier ships send mortar fire raining down on infantry, while tanks rush across the landscape to join the fray. It ends on a note that's so typical of one of the most bombastic video game series ever conceived. "You blow up the bridge," says Sammelin. "Of course we blow something up. That's what we do."

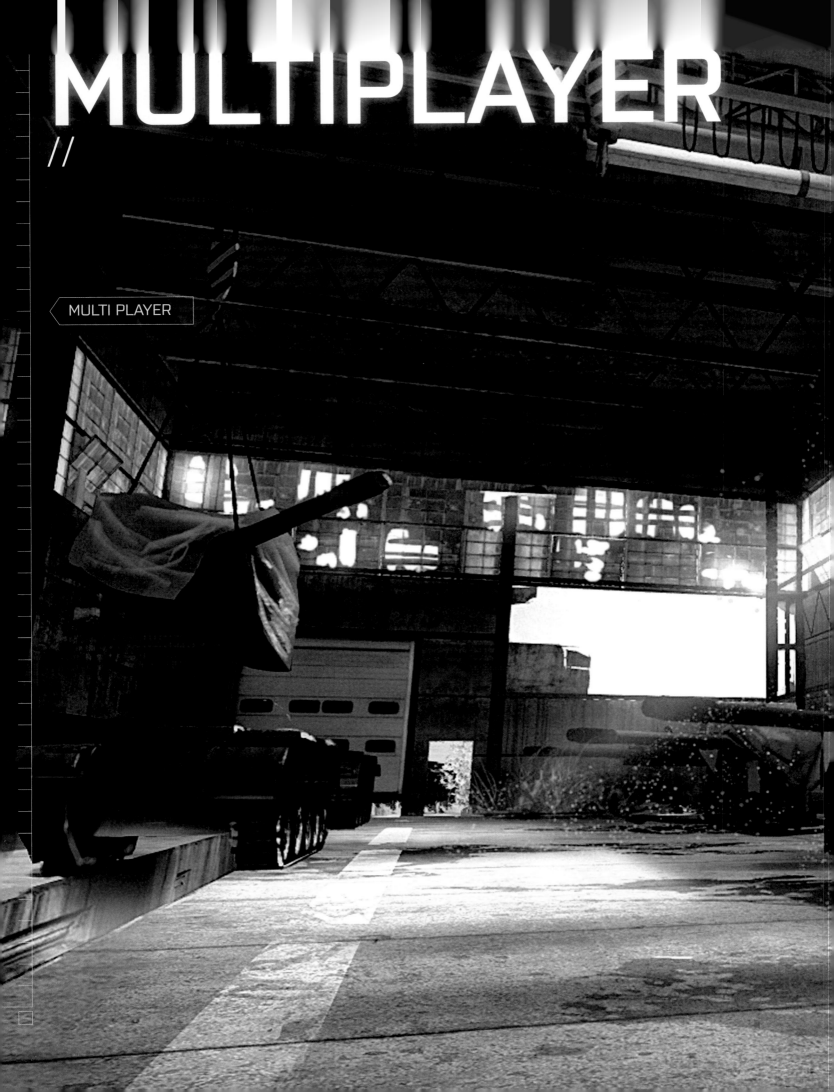

MULTIPLAYER

MULTI PLAYER

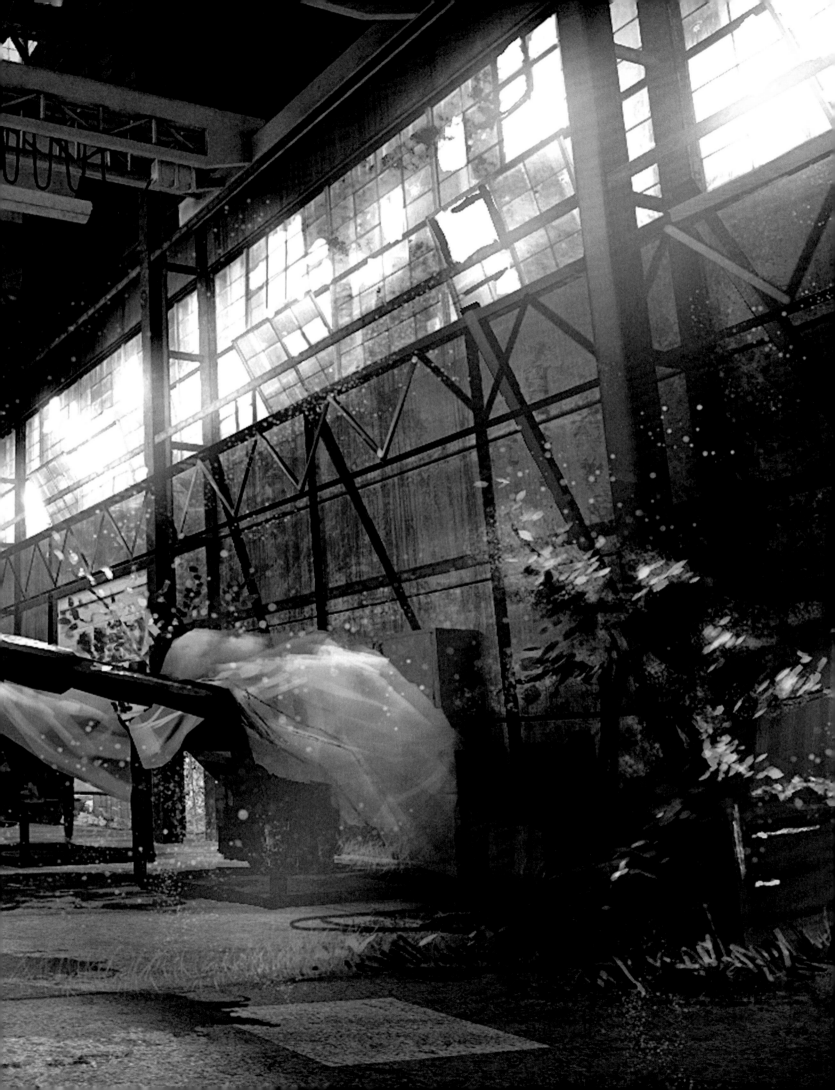

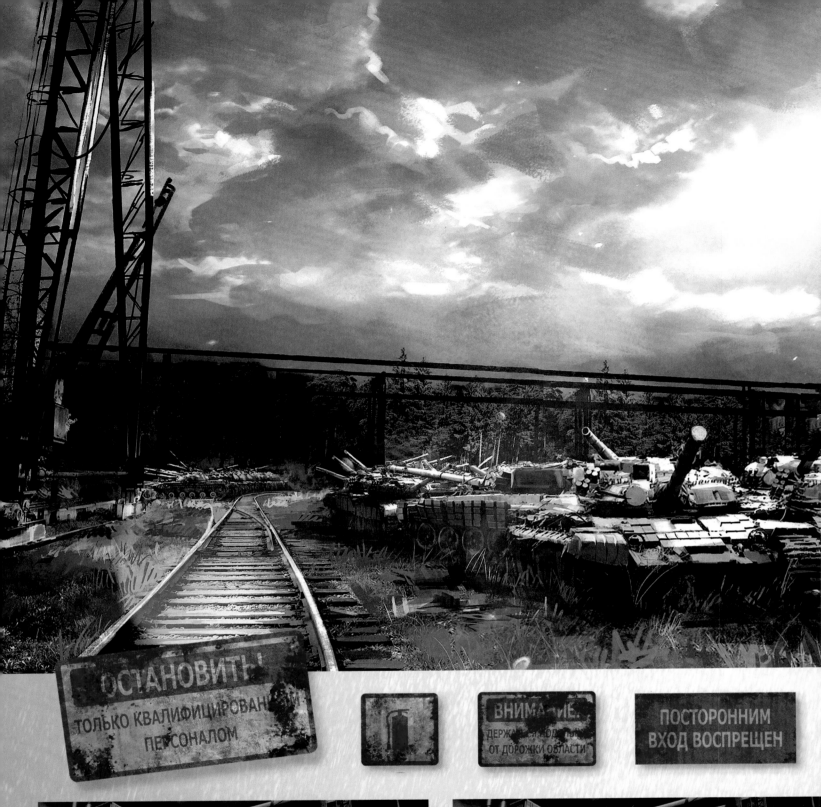

ОСТАНОВИТЬ
ТОЛЬКО КВАЛИФИЦИРОВАННЫМ ПЕРСОНАЛОМ

ВНИМАНИЕ
ДЕРЖАТЬ ВХОДЫ ОТ ДОРОЖКИ ОБЛАСТИ

ПОСТОРОННИМ
ВХОД ВОСПРЕЩЕН

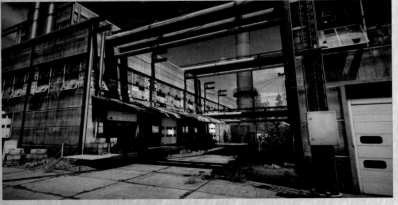

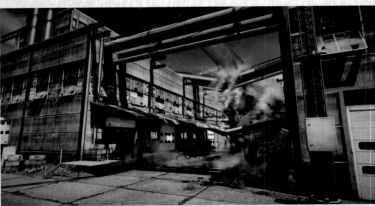

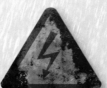

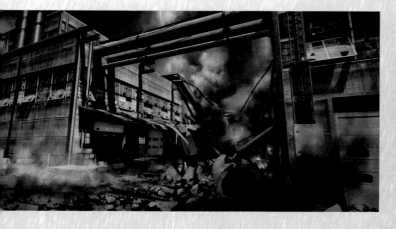
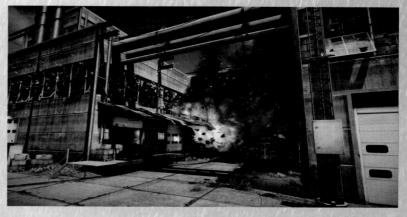

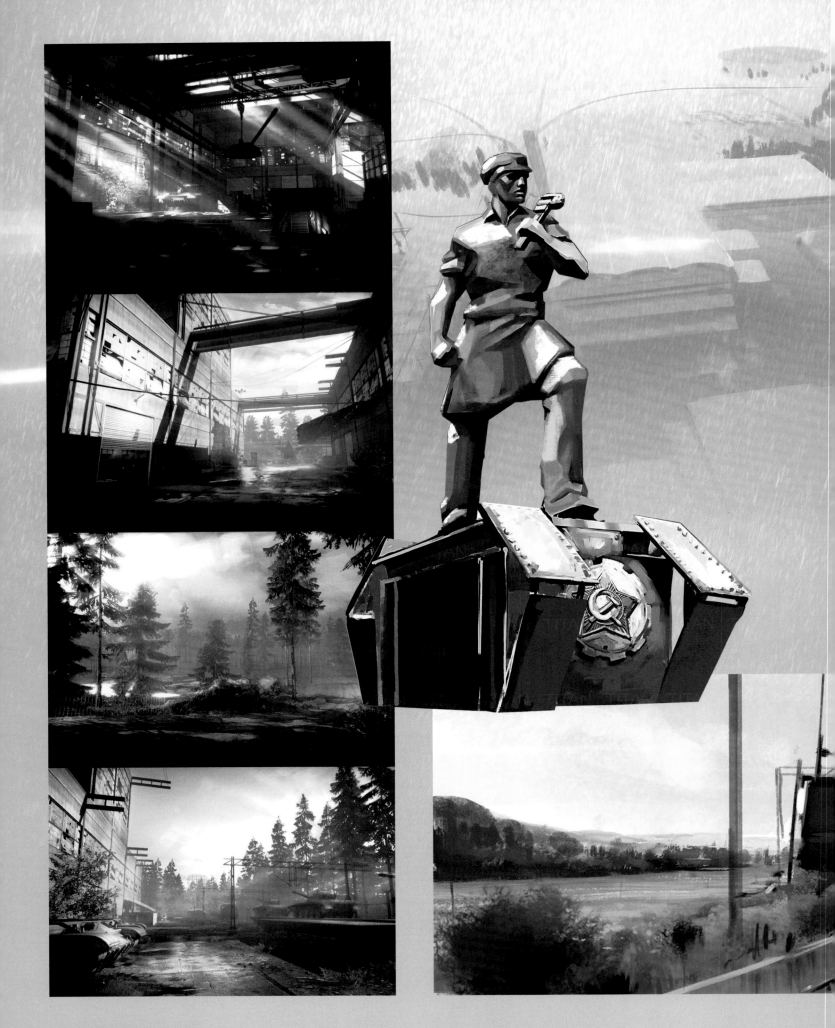

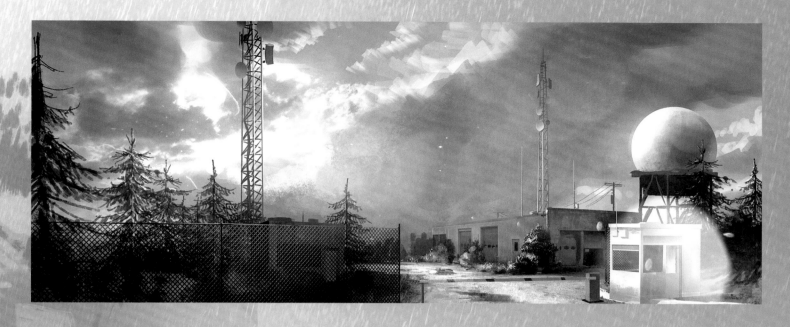

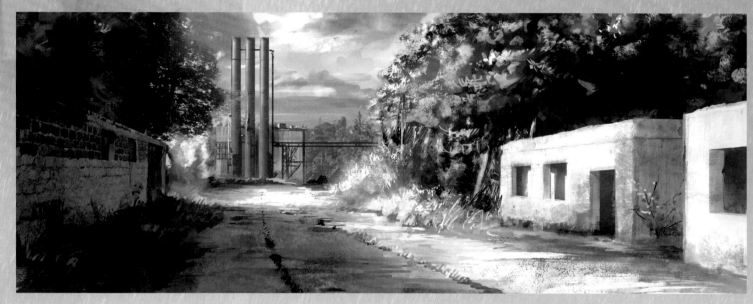

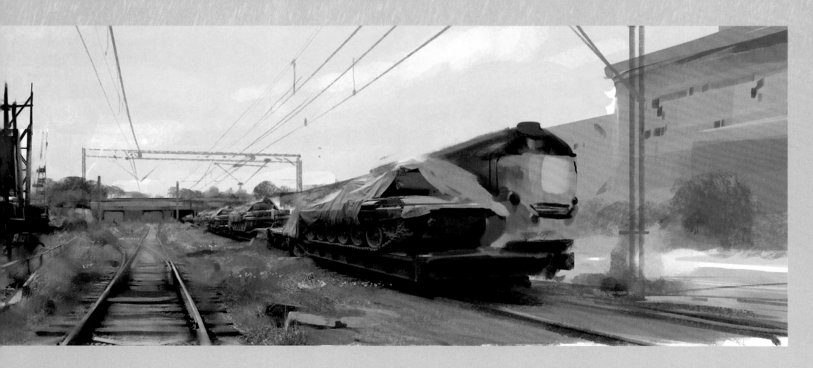

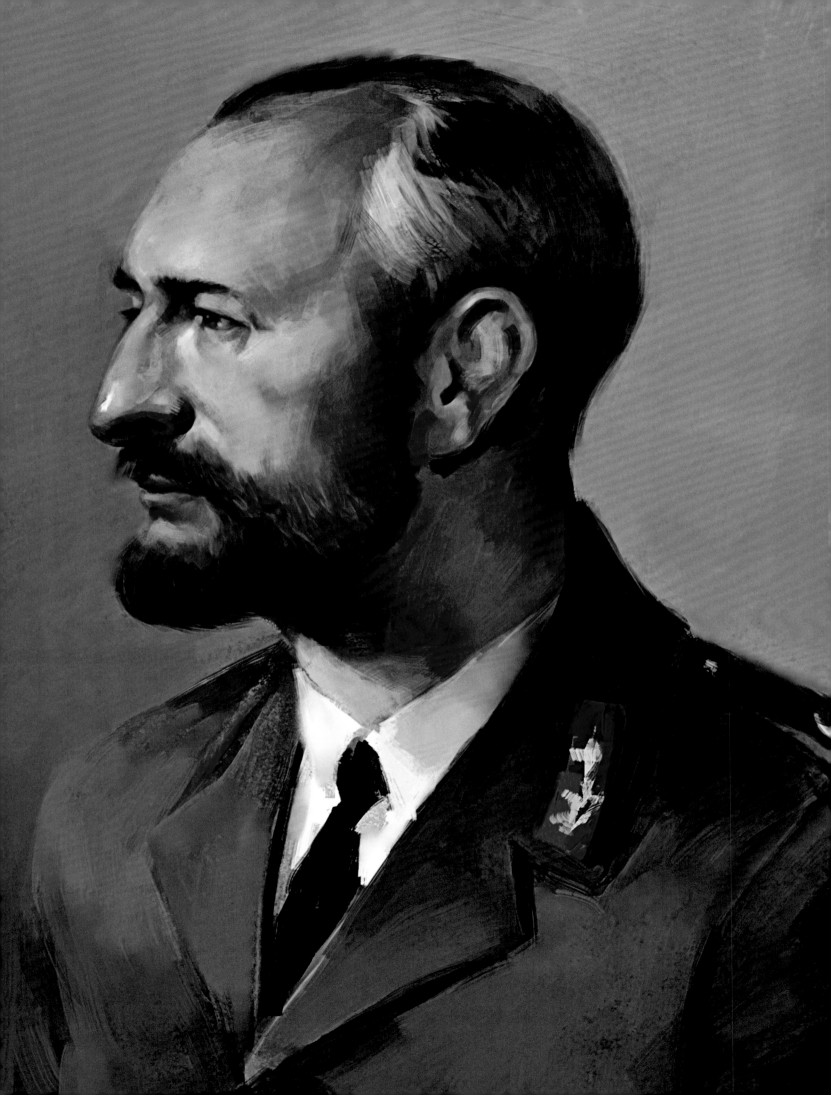

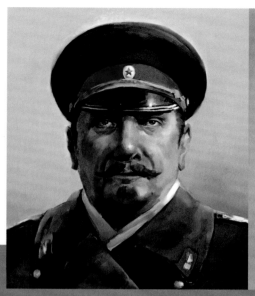
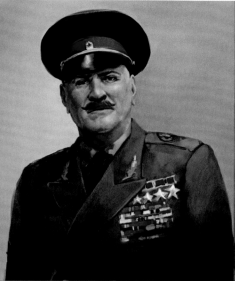
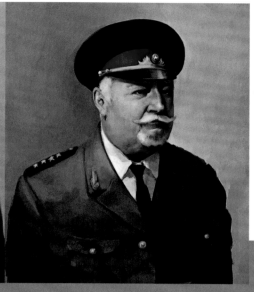

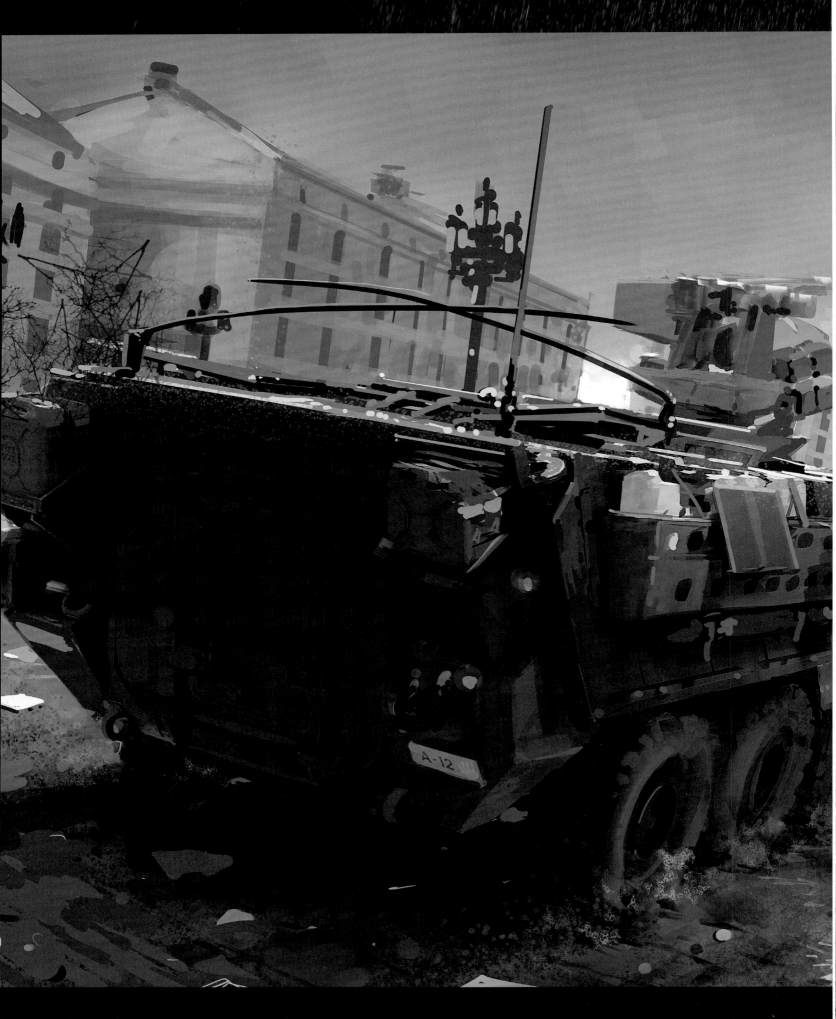

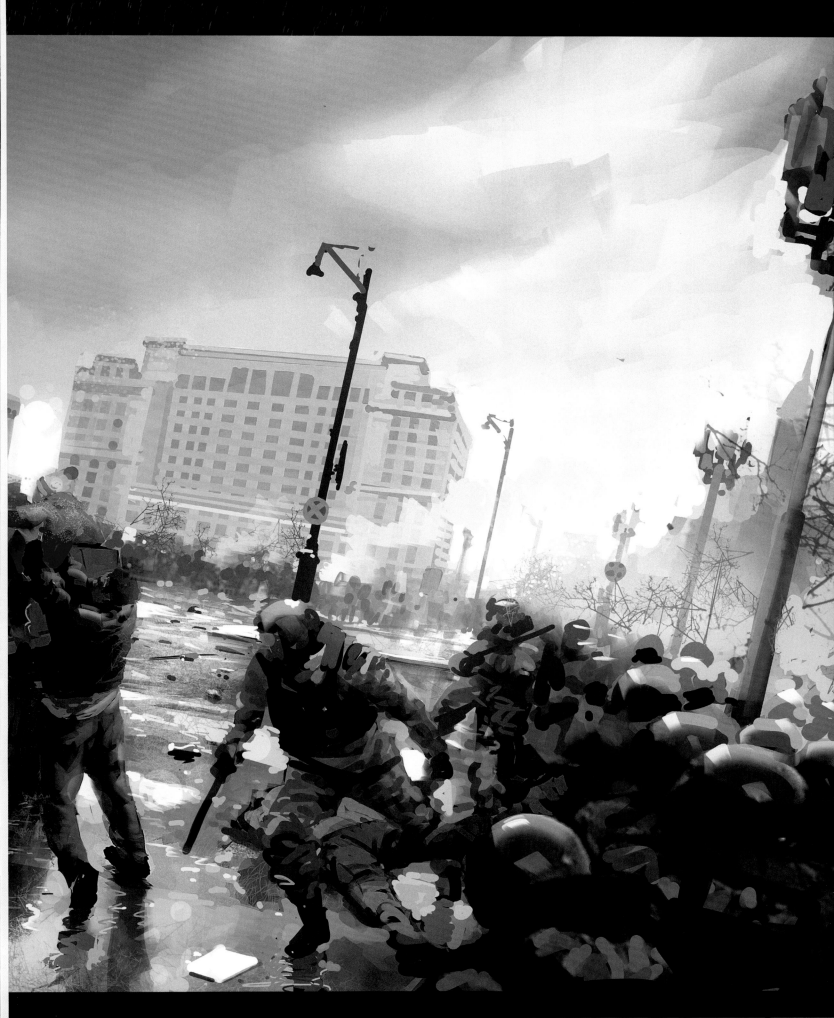

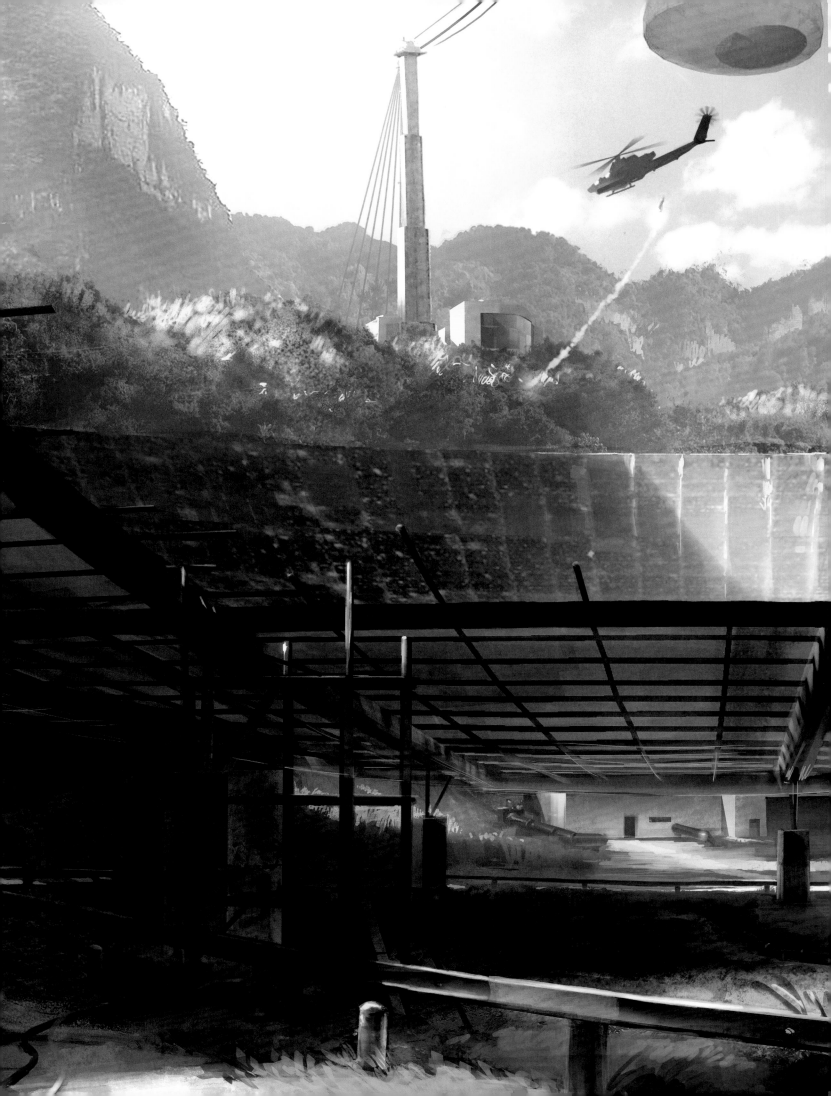

SPEC ▶

Battlefield 4's multiplayer looks to reintroduce the destructibilty that proved so popular in *Bad Company 2*, with certain maps allowing whole areas to be levelled by repeated gun fire. In the cityscapes introduced by the campaign, it makes for some chaotic play. Infantry driven maps, much like *Battlefield 3's* Operation Metro, are reproduced on ground level, but there's more verticality now, resulting in a much more strategic kind of play.

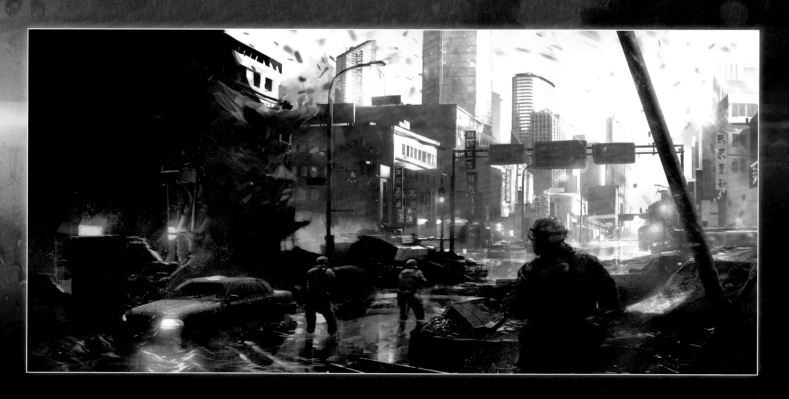

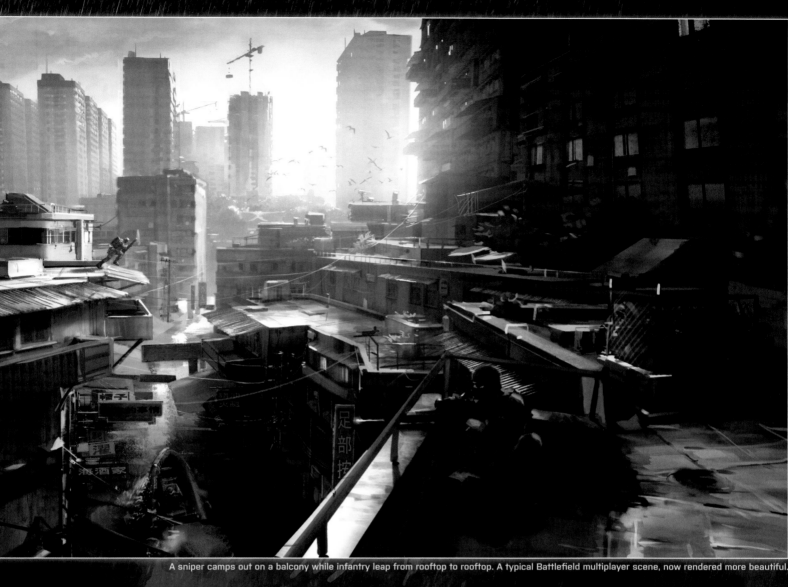

A sniper camps out on a balcony while infantry leap from rooftop to rooftop. A typical Battlefield multiplayer scene, now rendered more beautiful.

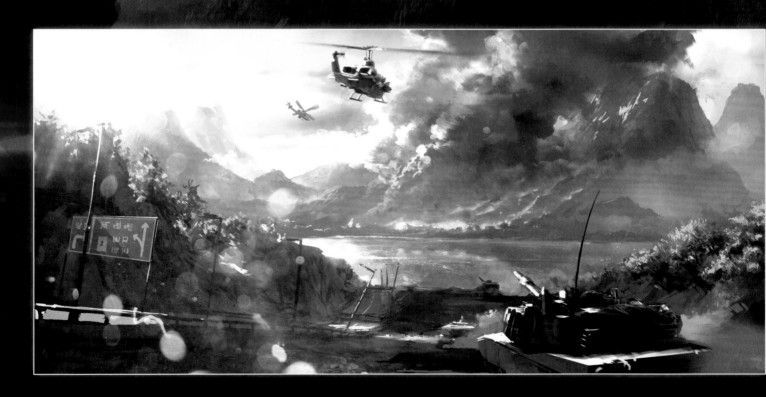

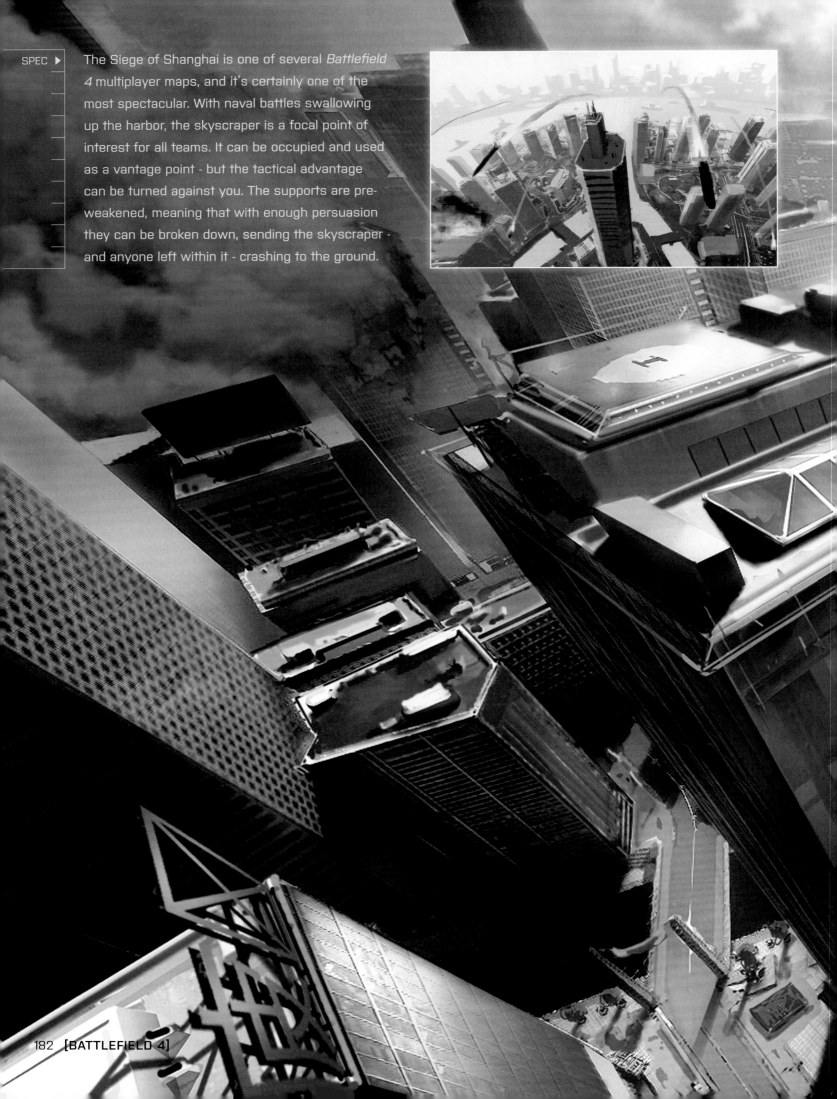

The Siege of Shanghai is one of several *Battlefield 4* multiplayer maps, and it's certainly one of the most spectacular. With naval battles swallowing up the harbor, the skyscraper is a focal point of interest for all teams. It can be occupied and used as a vantage point - but the tactical advantage can be turned against you. The supports are pre-weakened, meaning that with enough persuasion they can be broken down, sending the skyscraper - and anyone left within it - crashing to the ground.

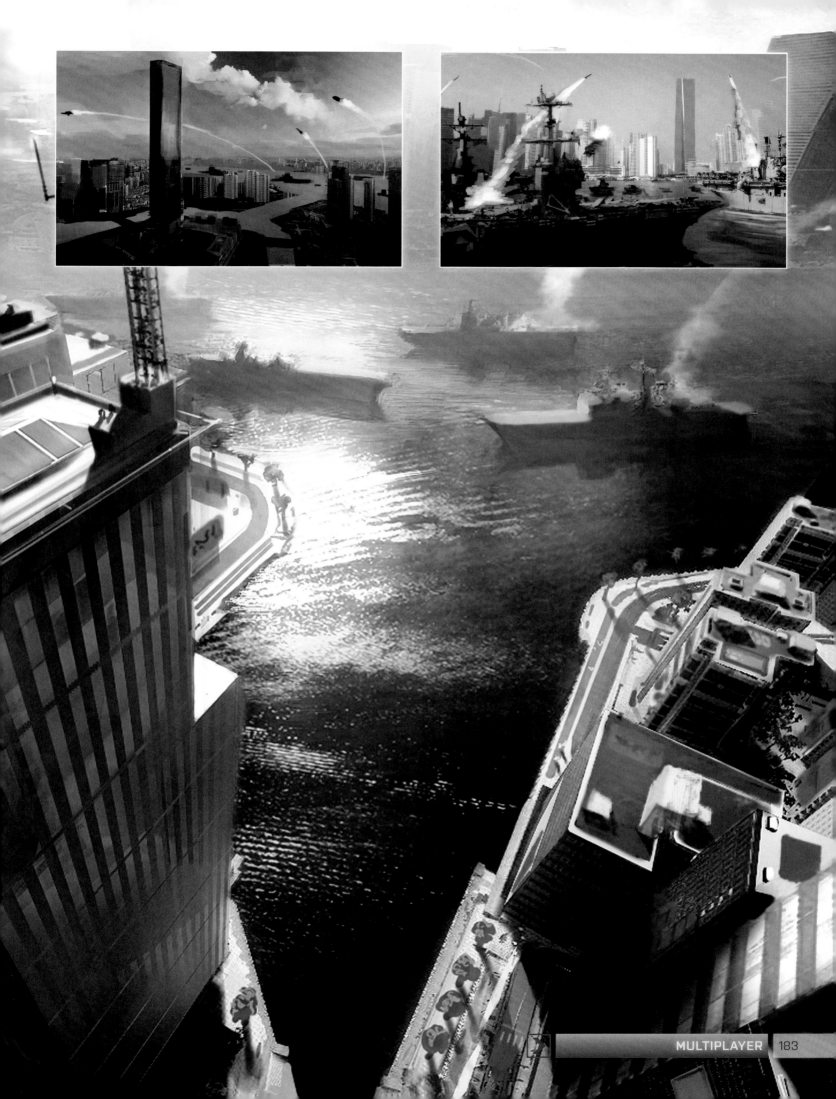

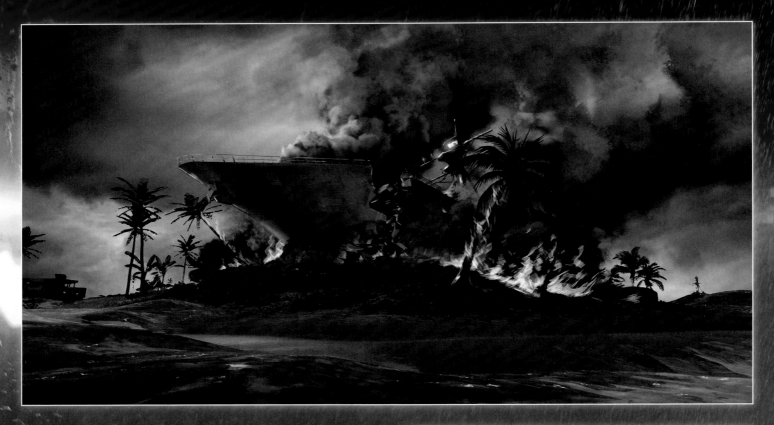

SPEC ▶

It wouldn't be a *Battlefield* without a nod to Wake Island, the classic map that returns in some form for every installment. "When it comes to getting this distinctive *Battlefield* experience, we tend to refer to our previous maps," says Sammelin. "We talked about how to get the Wake Island crescent shape in." It's an iconic layout that returns in *Battlefield 4*.

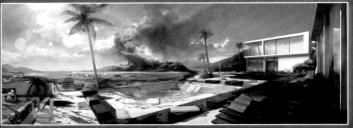

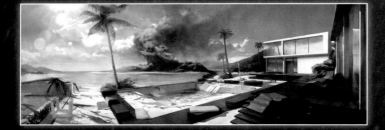

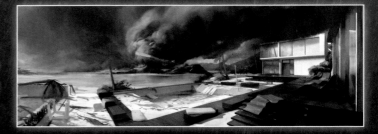

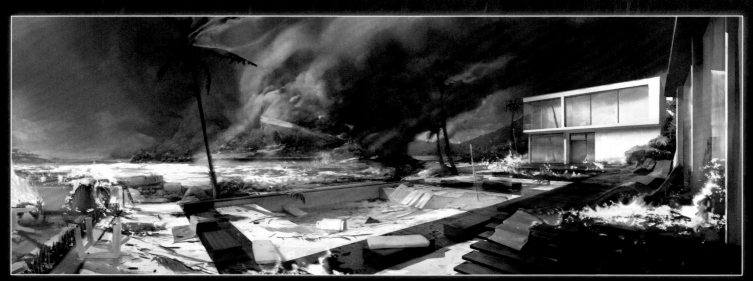

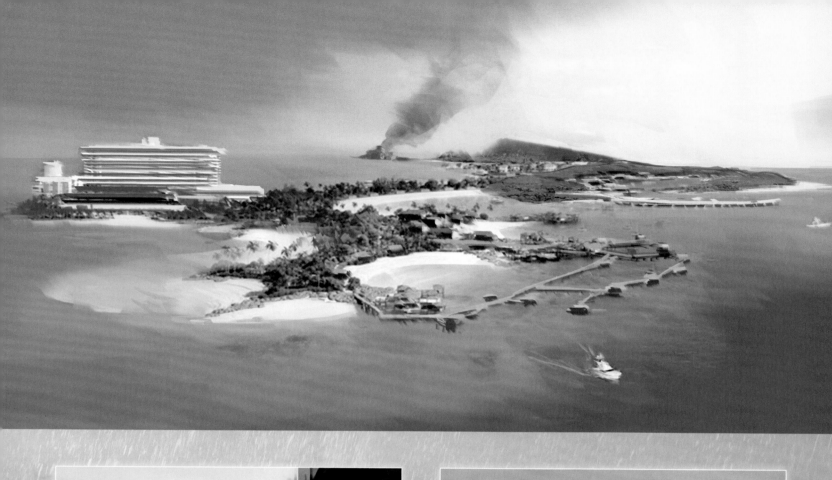

"We have these standard tricks we use and checkboxes we have to have when doing art for multiplayer maps," says Sammelin. "It's about having clear waypoints or clear objects, so wherever you spawn you're not going to be confused as to where you're going."

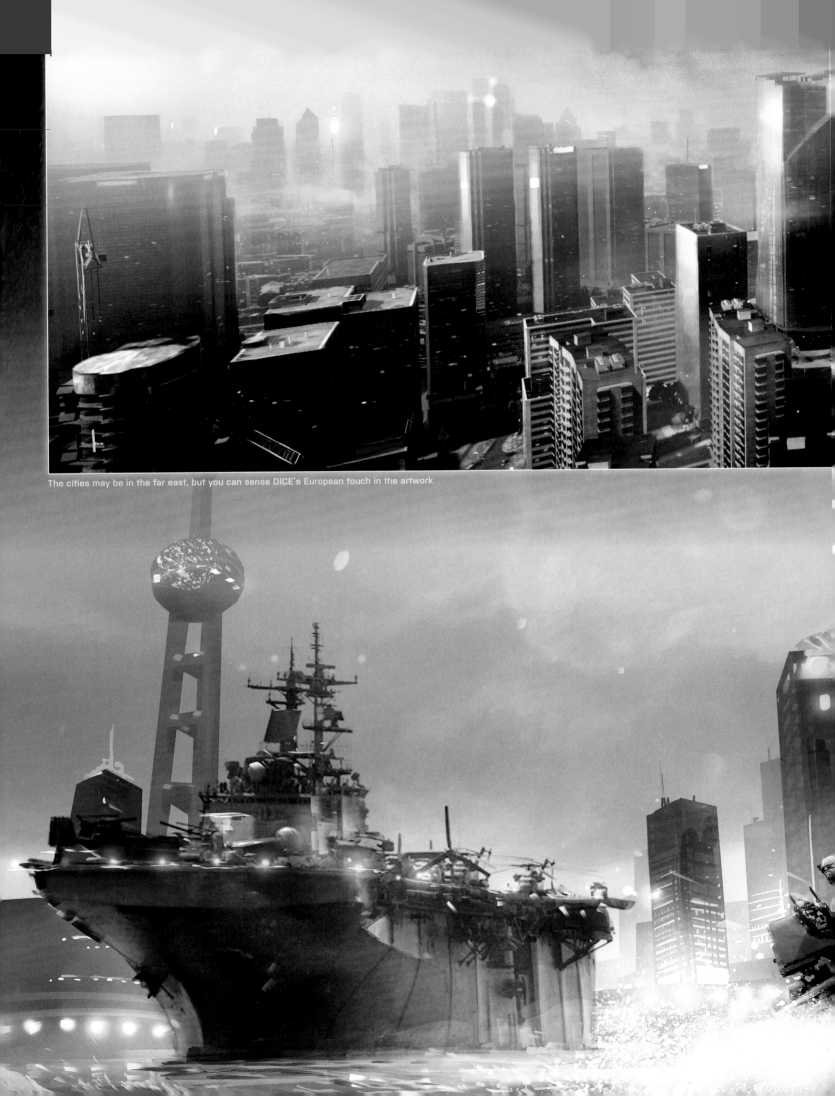

The cities may be in the far east, but you can sense DICE's European touch in the artwork

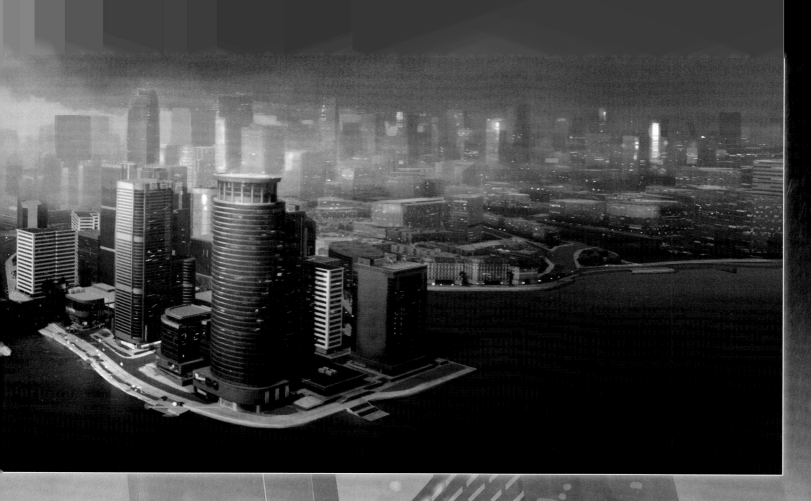

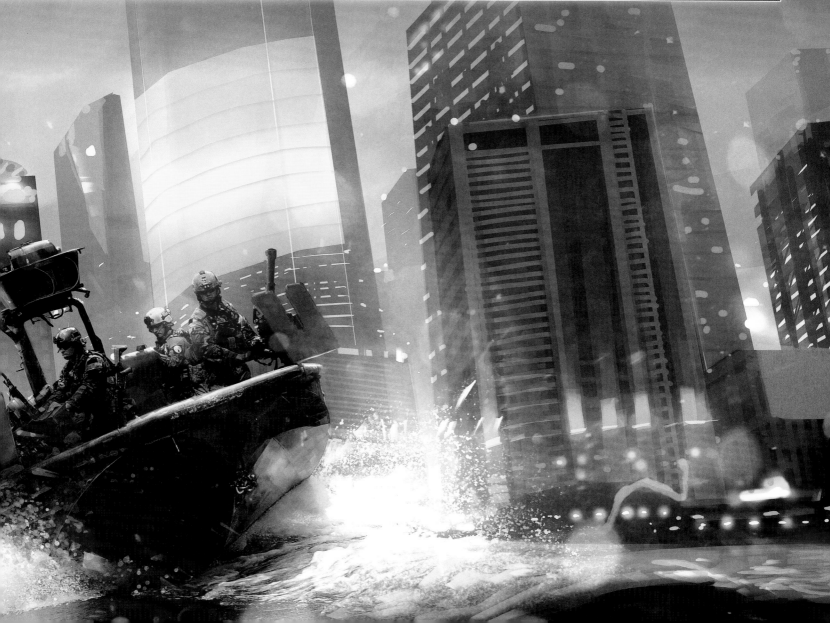

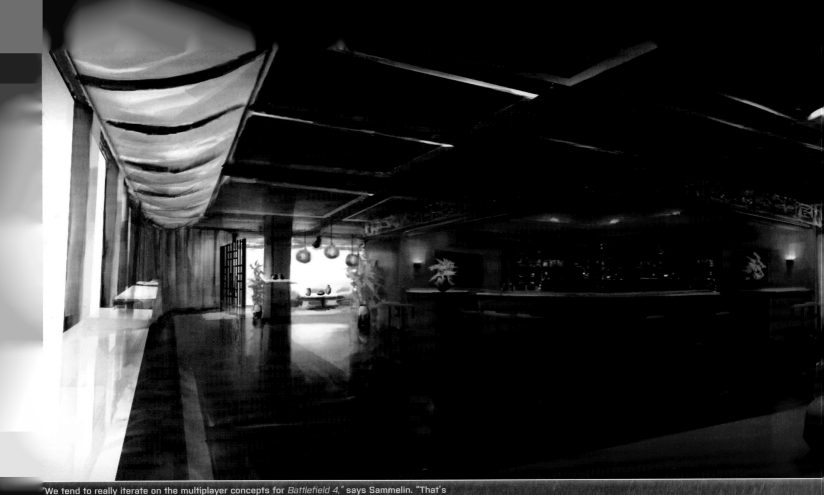

"We tend to really iterate on the multiplayer concepts for *Battlefield 4*," says Sammelin. "That's probably one of the most iterative processes we've had when it comes to the art for maps."

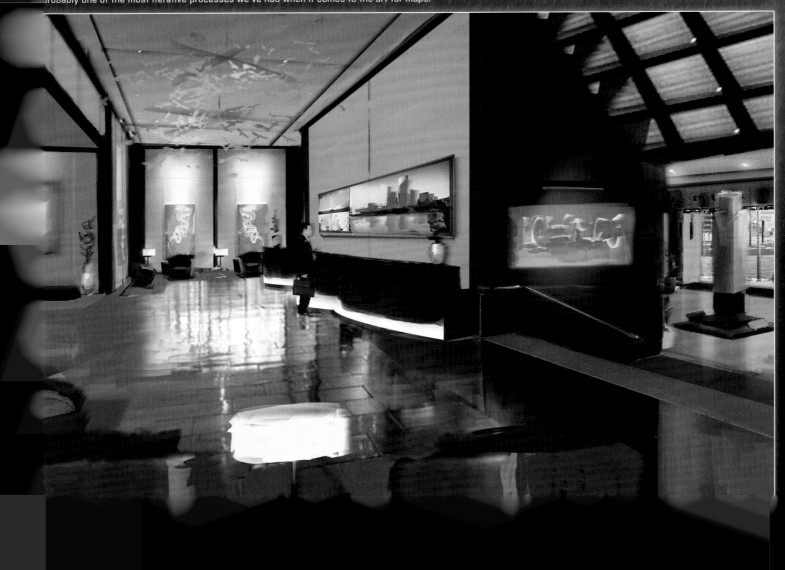

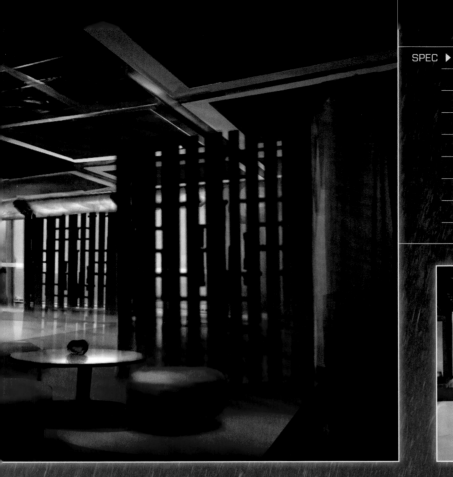

SPEC ▶ Designing art for multiplayer maps requires a different skill to designing single-player ones. "Campaign maps are something in which we can direct the player, we can set boundaries, we can almost funnel them if we want to in certain areas," says Sammelin. "But in multiplayer it's completely dynamic, almost all of it, and some of the maps are absolutely huge, so it is a struggle to address all of these elements in just one image for a map."

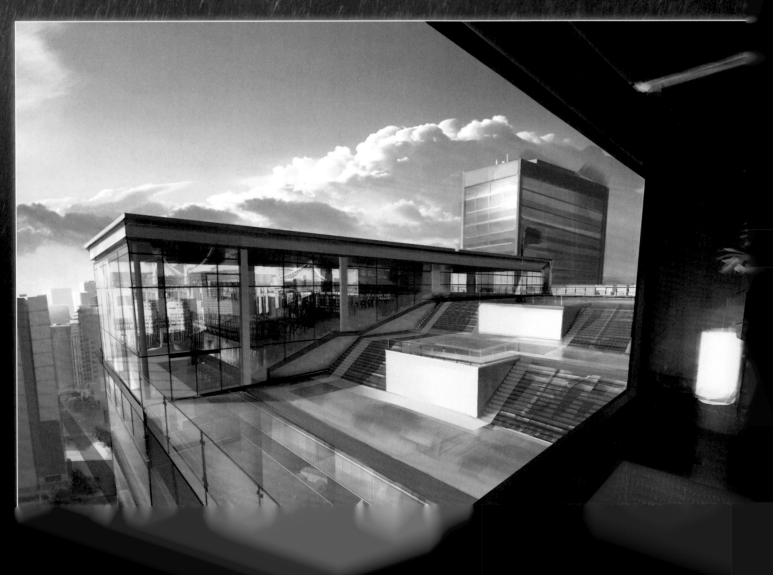

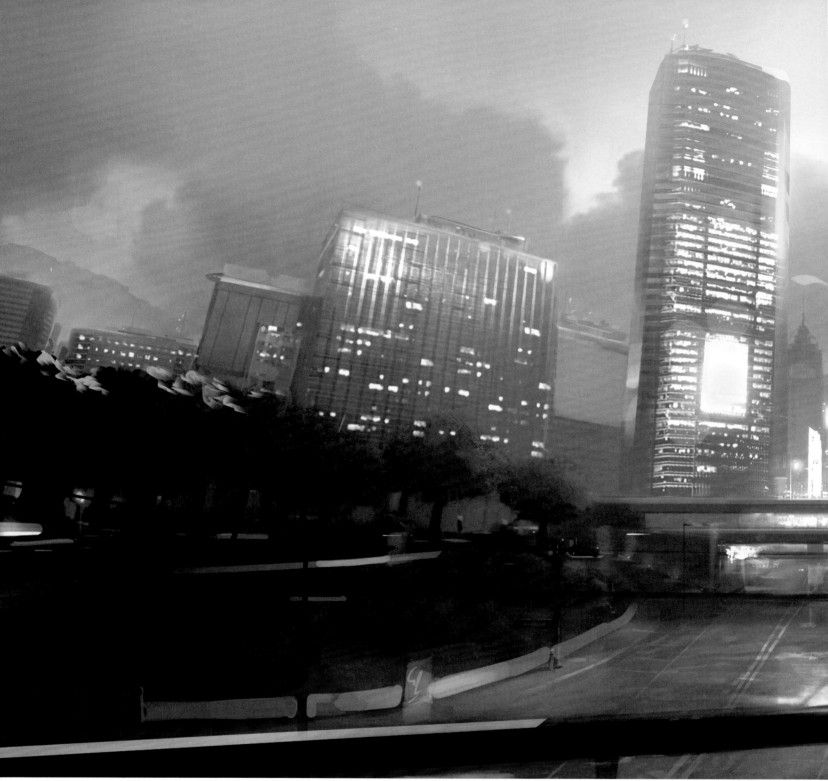

Only to rise again another day. Who knows how many hours, weeks days or years players will spend pounding the virtual streets DICE have created?

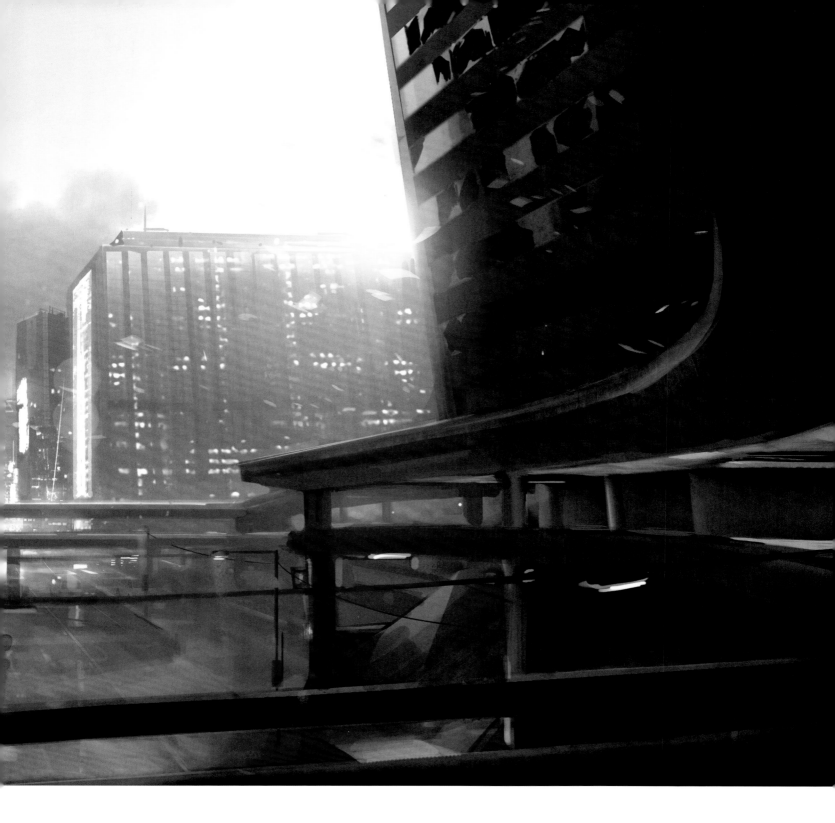

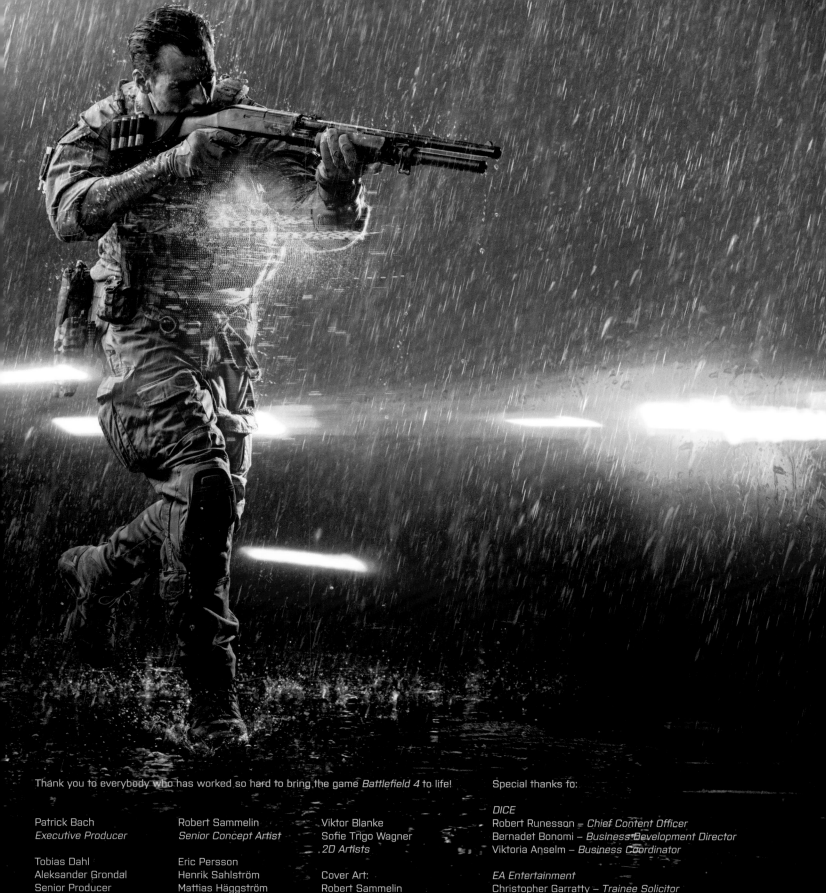

Thank you to everybody who has worked so hard to bring the game *Battlefield 4* to life!

Patrick Bach
Executive Producer

Tobias Dahl
Aleksander Grondal
Senior Producer

Lars Gustavsson
Creative Director

Gustav Tilleby
Art Director

Mattias Kylén
Andreas Chrysovitsanos
Assistant Art Directors

Robert Sammelin
Senior Concept Artist

Eric Persson
Henrik Sahlström
Mattias Häggström
Sigurd Fernström
Concept Artists

Benjamin Walfridson
Fatma Nadide Öcba
Theodora Daniela Capat
Concept Art Interns

Joacim Lindquist
Character Artist

Viktor Blanke
Sofie Trigo Wagner
2D Artists

Cover Art:
Robert Sammelin
Regular and Special Edition

Special thanks to:

DICE
Robert Runesson – *Chief Content Officer*
Bernadet Bonomi – *Business Development Director*
Viktoria Anselm – *Business Coordinator*

EA Entertainment
Christopher Garratty – *Trainee Solicitor*
Patrick O'Brian – *VP, EA Entertainment, Brand & Research*
Stephen Wanigesekera – *Senior Licensing Manager*
Alexander Lee – *Brand Licensing Manager*

To the entire DICE team, whose hearts and souls have been put into making this possible. For you we lift our hats, take a bow and thank you for bringing us this game!

A big thanks goes out to all the *Battlefield* fans. Thank you for enjoying playing our games as much as we enjoy making them.